TIBET

PATRICIO ESTAY

TIBET
LAND OF EXILE

with a Message of Peace by
His Holiness the Dalai Lama

SKIRA

Graphic Designer
Elisa Puccini

Cover
Marcello Francone

Illustrations
Michael Estay

Editorial Coordination
Vincenza Russo

Copy Editor
Emanuela Di Lallo

Graphic Editor
Federica Capoduri

Translation
Gilla Evans and Liam MacGabhann
for Language Consulting Congressi, Milan

First published in Italy in 2008 by
Skira Editore S.p.A.
Palazzo Casati Stampa
via Torino 61, 20123 Milano, Italy
www.skira.net

Printed and bound in Italy. First edition
ISBN: 978-88-6130-572-4

Distributed in North America by Rizzoli International
Publications, Inc., 300 Park Avenue South, New York,
NY 10010, USA. Distributed elsewhere in the world
by Thames and Hudson Ltd., 181A High Holborn,
London WC1V 7QX, United Kingdom.

To Patrizia (my wife), Michael, Leon, Sebastian (my children) and Ottavio

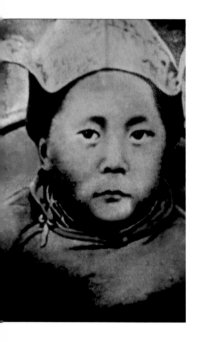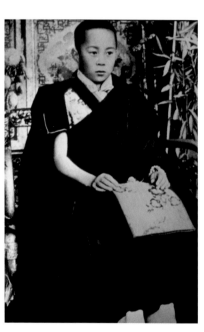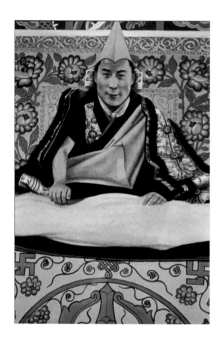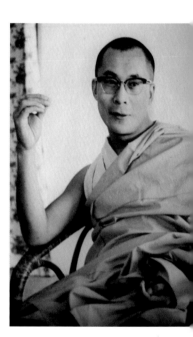

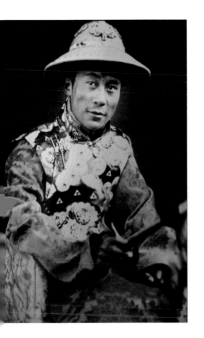 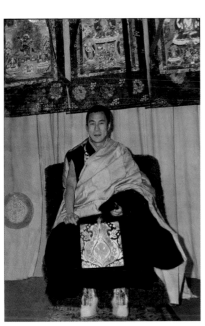 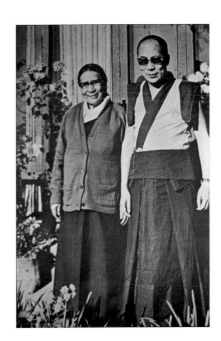 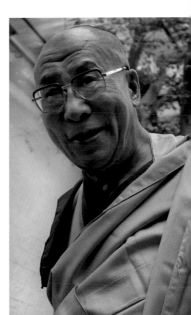

His Holiness
the Fourteenth Dalai Lama
Nobel Peace Prize

FOREWORD

THE DALAI LAMA

FOREWORD

The collection of photographs presented in this book, which Patricio Estay is also showing as part of a travelling exhibition, are important for the reality they reveal about Tibet today. Many other books have displayed the breathtaking beauty of Tibet's magnificent landscapes and the resilient charm and good nature of the Tibetan people, but few have had the courage to show the changes that have also taken place in recent times.

Tibet today continues to be an occupied country, oppressed by force and scarred by suffering. The immense destruction and human suffering inflicted on the people of Tibet have affected our very way of life, our institutions, our education system and even our environment and wildlife. For nearly five decades, we have struggled to keep our cause alive and preserve our Buddhist culture of non-violence and compassion. It would be easy to become angry about what has happened. Labelling the Chinese authorities our enemies, we could self-righteously condemn them for their brutality, but that is not the way to achieve peace and harmony.

Still, we cannot pretend that what is happening is not taking place. Every year, the Chinese population inside Tibet is increasing at an alarming rate. If we take the example of Lhasa, which features clearly in this collection of photographs, there is a real danger that Tibetans will be reduced to an insignificant minority in their own homeland in the foreseeable future. I am concerned that the Tibetan people and their valuable cultural heritage should not quietly vanish from the face of the earth. Therefore, I am seeking genuine autonomy for the Tibetan people within China, which I believe will be to our advantage.

Tibet is a very poor country. Although it is spiritually advanced, we still need shelter, easier communication and other material facilities. Because we want to modernize Tibet, we can achieve many benefits from our relationship with China. However, it is also a matter of simple justice that we should have meaningful autonomy, so that our unique cultural heritage, our rich Buddhist tradition and our fragile and delicate environment can be effectively protected.

Life is very difficult for Tibetans living under Chinese control, because protest invariably provokes a harsh reaction. And yet if the Chinese are serious about wanting to normalize the situation in Tibet, I believe they need to recognise the grave problems that exist there, as well as the genuine grievances and deep resentments of the Tibetan people. We may live in a distant and remote land, but like everyone else, we Tibetans want to live in peace and happiness and like everyone else we have a right to do so. I am grateful to Patricio Estay for the dedication he has shown to our cause and hope readers of this book, and others who view his photographs, may also be inspired to lend us their support.

ROBERT THURMAN
AUTHOR OF "WHY THE DALAI LAMA MATTERS: HIS ACT OF
TRUTH AS THE SOLUTION FOR CHINA, TIBET, AND THE WORLD"
JEY TSONG KHAPA PROFESSOR OF INDO-TIBETAN BUDDHIST
STUDIES, COLUMBIA UNIVERSITY
PRESIDENT, TIBET HOUSE US

Patricio Estay's photographic essay, *Tibet: Land of Exile*, is deeply moving to me. His work has great beauty and yet he is not merely trying to present some more pretty pictures of that magnificent land. His motivation clearly is to reveal the truth of the "cultural genocide" being perpetrated in Tibet by the Chinese Communist Party, whether or not he loses visa access and other things some people worry about. His perceptive eye and giving heart shine through this work, sources of its beauty and unflinching honesty.

The heart of Tibet for the last fifty years has been His Holiness the Dalai Lama, born in Northeast Tibet, in the province of Amdo, in 1935. Estay begins the book with a series of eight images of His Holiness: as a baby, around the time of his discovery as the son of prosperous peasants in a house with turquoise roof-tiles revealed to his regent in a vision vouchsafed in the Goddess Soul-lake (Lha moi Latso); upon first installation on the Lion Throne as boy Dalai Lama in 1940; upon assumption of political responsibility at the time of the Chinese invasion of Kham in 1950; a relaxed portrait in his early twenties during the eight years from 1951 to 1958, when he tried to get along with the Chinese Communist Party's government, the People's Republic of China, trying to believe in their assurances that they would only assist the "local" Government of Tibet in modernizing and developing the country, without interfering in its Buddhist culture and society; a formal portrait as a Chinese "National Teacher", from the time in 1954 when he spent a year in Beijing in dialogue with Mao, Chou and Deng, being "brainwashed" by Communist idealism, as he humorously says today; a formal portrait taken in India shortly after his escape into exile there in 1959; a family picture of him standing with his mother some time in the 1980s; and finally a recent picture of him in the midst of his travels around the world as a World Teacher of the Dharma, a Nobel Peace Prize Laureate – a man without a country, homeless as a simple Buddhist monk, in exile as a citizen of Tibet, and the foremost spokesperson for his endangered people.

How can an entire land be "in exile?" By 1959, the Chinese leaders had broken every single one of their promises outlined in the 17-Point Agreement imposed on the Government of Tibet in 1951 and revealed their real intention to destroy the Tibet of indigenous Tibetans and absorb it

into China as a Communist colony. The Tibetan people then rose up in fear that their heart, their Dalai Lama, the living icon of their Buddhist way of life, would be captured and imprisoned by the Chinese troops occupying the area. There ensued a doomed uprising centred in Lhasa, after which the Chinese government admitted to 87,000 Tibetans dead, and the Tibetan exile government counted many more than that during years of investigation painstakingly done by cross-checking exit interviews of refugees. The Dalai Lama himself under cover of a freak sandstorm managed to escape through the Chinese lines and flee over harsh terrain and some of the most difficult mountain passes in the world to freedom in exile in India. Around 100,000 Tibetans followed him right away, settling in Nepal, Bhutan and India, and by now there are probably 250,000 Tibetans living in exile in over forty countries around the world. So there are many Tibetans living in exile.

Estay sees that clearly, but he very profoundly sees further and understands how the land itself is exiled, the "home" of its peoples' "homeland" shattered by more than half a century of military occupation. People's Liberation Army extractive businesses ignored Tibetans' own age-old, sustainable management practices and embarked on ruthless, unsustainable resource exploitation; they cut off 75% of the rich primeval forest cover (worth an estimated 115 billion 1980s' dollars) of the eastern region of Kham, cleverly carved away from having been Tibet for millennia into being the "Tibet Autonomous Prefectures" of Sichuan and Yunnan; they continue to strip-harvest the precious high-altitude Tibetan herbs for compound medicines; they took borax, uranium, copper, iron, gold and other minerals with no regard for environmental impact of the crude mining; they slaughtered 90% of the Tibetan wildlife, birds and beasts, some for medicines, some for meat for their occupying troops, some just for fun. Although in 1951 Mao vowed to have 100,000,000 Chinese living on the vast million-square-mile Tibetan plateau by 1960, the distance and the altitude held his government to only around 8,000,000 until the last two decades. Then, in the early 1990s, Deng Hsiao-ping became alarmed at the break up of the Soviet Union and their losses of the Baltics, Ukraine, Kazakhstan and so on, and began to divert the accruing wealth of China's export boom into a full-scale effort to colonize Tibet. Again the PLA businesses got the no-bid contracts to build large population centres, roads, railways and all infra-structure projects, and the Beijing government heavily subsidized Chinese from other regions to move into Tibet. The huge investment the Chinese made in Tibet in the last fifteen years, which they are so proud of and expect the Tibetans to feel grateful for, was thus not for the benefit of the Tibetans, but rather in order to move Chinese settlers right on top of them, truly driving them into exile in their own land. No wonder the Tibetans are not happy, living in exile in their own land.

Knowledgeable Chinese individuals, such as some of the democratic dissidents abroad, who are not completely sold on Chinese Communist Party propaganda on Tibet, will admit the

genocidal assimilation campaign being enforced on the Tibetans. Yet some will still pass it off as an inevitability of history and point to the Native American peoples in North and South America, who almost completely have been living in exile on their continent for almost five centuries. As a Euro-American, I always acknowledge their point, responding that no one is saying that they are worse than us. We can only say that they are just as bad, but more importantly that they are doing it now, in these generations – it is not something they are inheriting from ancestors who still thought that conquest and genocide of indigenous peoples was legitimate practice. China is now member of the United Nations, signatory of the Universal Declaration of Human Rights, and participant in a world order in which genocide is a crime against humanity and colonialism is supposed to be obsolete. Therefore today there are movements in the Americas towards reparations for the Native Peoples, such as Canada's return of the huge area called Nunavut to the Arctic people, the honouring and repair of treaties long ago broken, such as payments and land grants to the Tlingit and other Northwest Pacific tribes. It is a faltering, slow, and imperfect process, but it does go on and will continue as we are in a new phase of history.

Why should the Chinese nation make the same mistakes our ancestors did, commit the same crimes, only to pass on their negative consequences to their own future generations? Why can they not learn from our mistakes? It is the same in our relationships to the earth. We "Westerners" pillaged and plundered and polluted and are only imperfectly beginning a turn-around and a process of environmental repair. Of course we may be doing too little too late, but that doesn't make it any less urgent for those of us with some consciousness of reality and some conscience to make more effort to restore the planet for our future generations. Today the Chinese are caught up in a frenzy of industrialization, moving all sorts of polluting and destructive industries from Europe and America to their once beautiful homeland and poisoning their air, their waters, their soils, and overheating their environment. Why do they have to repeat our mistakes? If they are the highly intelligent, hard-working, and wise "Central Country" persons they wish to be, why can't they go on better than the "Western barbarians" who didn't know any better? Why don't they go straight to a post-colonial, networked "United States of China", giving their minorities and neighbours real benefit and good reasons to join with them in union? Why not go straight to a clean, green, post-industrial economy and put the gas-guzzling America and their imitators to shame? If they want to be world-leaders, why not lead the world in the realistic direction it has to go, if it is to remain a survivable home for living beings? Why lead the world in obsolete nineteenth-century colonial imperialism, or self-destructive twentieth-century predatory superpowerism?

The Dalai Lama is himself in fact the one world leader who is leading in the right direction. Even though he is in exile, his people are in exile, his land is in exile, his monks and spirit are at home in that exile. He lives with great diligence and teaches with great eloquence non-violence,

forgiveness of enemies, dialogue with opponents, inner and outer disarmament, contentment with the sufficient and restraint of greed and exploitation, concern for the environment and all living beings. The Tibetan people, not perfectly but in the main, are keeping their reactions to genocidal oppression nonviolent. Standing up in unarmed protest and bearing severe blows, even unto death. Under the Dalai Lama's inspiration, they are making peacefulness their path as well as their goal. They are willing to return to China benefit for harm, they mainly still support His Holiness' "Middle Way" approach of seeking autonomy at home but remaining in union with China. They want to help China, if China would realize it is harming itself by harming them and would decide to cease and reverse their policy. If others in this endangered world of ours would follow the Dalai Lama and Tibetans' example, all conflicts would soon be resolved, and the huge resources currently poured into armaments, conflicts and wars would be freed up for investment in life's necessities for millions of people.

Estay tells this story eloquently in his pictures. After the collage of scenes from the Dalai Lama's life, he begins in his Lhasa–China section with the Tibetan highland in exile from itself, the centre of its mandala of universal compassion, Avalokiteshvara's Potala Palace, empty and sterile with a giant People's Republic of China flag in front of it, a blood red flag with five yellow stars, a big one representing the Chinese people and four little ones held in thrall, standing for the Tibetans, Uighur Turks, Mongolians and Manchurians, the four main "minority nationalities". All the striking images of this section of the book juxtapose Tibean life under the imagery of their colonial overlords, the Yuan note with Mao's picture on its left on altars, an Om Mani Padme Hum prayer wheel in an old hand with MA and NI syllables showing and a Chinese symbol of long life inserted in between, and monks and laity trying to be Tibetans under the harsh glance of Chinese soldiers and police, with the monasteries more or less reduced to ghost towns, museums of themselves.

On to Lhasa–Kathmandu, with the swirling movement of exile – yet there is a more vibrant flutter of prayer flags, a child casually resting his hand on the knee of a stone Buddha. Then in the Dharamsala section we see that the heart of Tibet is still beating – there is freedom in exile: the Dalai Lama's face smiling in a picture with Potala and mountains in a shop window, carved Mani-stones in lively heaps, the Dalai Lama at prayer, new refugees, children escaped across high mountain passes to get a Tibetan education, Jetsun Pema, the Dalai Lama's sister, foster mother of thousands of Tibetan orphans with a few of her charges, the children smiling and energetic, gaggles of monks in all sorts of activities, the young Karmapa Lama, the Dalai Lama smiling and eating a cake, collages of Tibetan faces, young, old, lamas and laypersons, and two Shakyamuni Buddhas in the very centre of the book. From that point the visions burst into glowing colours, and the vivid liveliness of Tibetan culture stands out.

Finally Estay returns to Lhasa, now in colour, and this time there is a dash of hope, somehow still surviving amid what has now become a frontier military town's vulgarity. There is a nomad

woman in front of the Potala this time. The living heart of Tibet in Dharamsala somehow bleeds its vitality back up into the oppressed and exiled land. There is an eloquent expression on the face of the small Tibetan homeless boy in a cardboard box, whose elder brother seems busy carrying a battered shoeshine box. The smiles of the Chinese and Tibetan prostitutes are business-like and in-your-face shocking, and the nightlife scenes are frenetically streaked with garish industrial colours. Stiff police in their vehicles are smugly confident and purposefully intimidating.

May the wind of time and wisdom blow the prayers of love and compassion across the land in exile and invite back its loving deities and free its suffering peoples, not only the oppressed Tibetans but also the unhappy Chinese forced to be there by unrealistic and ill-informed leaders, themselves imprisoned in the role of oppressors there in the high altitude land they cannot understand and in which they cannot freely breathe! May the prayer carved on the stone treaty monument from the eighth century in front of the Potala be once again realized: "May the People of China be happy within the land of China and the people of Tibet be happy in the land of Tibet!" And if that ancient treaty solemnly concluded between two emperors and their councillors were once again honoured, why could there not be a fruitful union freely entered upon by the two great peoples?

Woodstock, New York, 27 May 2008

Jean Paul Ribes

What the Eye Hears

Borges, who was an expert on Buddhism, states at the end of his essay "The Wall and the Books": "Music, states of happiness, mythology, faces worn by time, certain twilights and certain places want to tell us something, or have said something we should not have missed, or are about to say something; this imminence of a revelation which does not occur is, perhaps, the aesthetic experience." It is a sentence that applies doubly to the work of Patricio Estay.

However harmonious or surprising they may be, his images leave with us the responsibility of revealing or becoming the "developer" of what they want to convey to us.

My father, a photographer in the era of the silver image, kept a bottle next to his Leica in his darkroom with this, to my childish eyes mysterious, word "developer" on its label. I later understood that chemistry was not enough to bring forth, under the red light, the full meaning of an image, no matter how skilfully it has been taken. The true developer is me, the onlooker...

You have to put something of your own into it, not let it be imposed on you by the "aesthetic experience", to discover what it conceals, what it says. If it remains silent, perhaps it is because the pretty photograph has failed. It may perhaps have given us a fleeting emotion, a vague piece of information that we immediately forget, swamped by the mass of images.

But if, on the contrary, it starts to speak, how are we to hear it?

Let us turn for a moment to the Tibetan tradition of scroll paintings, called thangkas. These fine, hieratic, colourful paintings are however only a medium for the activity of the person who contemplates them: what they depict is worth only what the person meditating sees in them. It is through the quality of his concentration, his ability to generate in himself the spirit of awakening that the divinity, which is itself only a form, will come to life and convey its grace, unutterable compassion and infinite wisdom.

Here, it is essential for the mind, word or actions to accompany the image that you have taken the time to listen to, to taste and let roam in order to finally shine within you.

Take for example the portrait in the middle of the book of the young monk meditating during a New Year ritual. Under his half-closed eyes, reality is taking new shape. Every being is there, bathed in the light of the Lord of Heart (nying je), the great compassion that lies within us all. Thus there is no more exile, for anyone, when we become capable of receiving in ourselves all the suffering in this world.

When the Lord Buddha chose to call bikkhu or "mendicants" those who took vows to follow him, he gave them three rules: to depend on the generosity of others in all things, to dress in clothes made

from rags, to live always the life of a wanderer. To exile themselves from the world in order to do away with exile, to take refuge in the Buddha, the law, the community and to become in the process a refugee.

Today the fate of the Tibetan people seems to be forcing it to take this perilous and noble path. In order to survive it has become mendicant, dispersed and lost. Its finds its refuge in one man, himself fleetingly in this world, who embodies the great compassion which, as I was saying, inhabits us all.

But it is not a matter of resigning oneself; compassion has nothing to do with passivity, with the cult of salutary and redemptive suffering. Anyone who one day hears the voice of the Dalai Lama, his laughter, can find in it strength, passion and encouragement to set out into the world, without fear, with the courage to give and to receive.

When, right at the beginning of our meetings, on my return from Tibet, I asked him what to do, he immediately replied "tell, inform, question your politicians!"

And this is what we have done, and the response has been very low-key. Certainly, plenty of generosity has been expressed, even in the very peculiar sphere of men of power. But in the end, what faint-heartedness!

The strongholds of power, obsessed by the multitude and the new wealth of China, do not care about the disappearance of a strange little nomadic mountain people. They are wrong. The balance of the world requires this diversity, this spice. Amputating this part of the human community puts in danger the entire body.

Vaster even than our humanity, this geographical space, with its lakes, its mountains, its forests and all the creatures that live there. The ancient Tibetans saw here the "Lha", deities living in the upper spheres, the "Lu", which populated the waters and the earth, and finally the "Nyen", the mountain spirits. They all require our homage, our respect and our generosity. The complementarity of the Sky and the Earth is omnipresent in Tibet. The same goes for politics.

Seven and a half centuries ago, in response to the threat of the warlike Mongolian horsemen from the north, a deliberate and powerful agreement was established between the two neighbours. A kind of total alliance in which each side had its role to play, the benefactor by his material wealth, the spiritual master by the scope of his compassionate wisdom. A metaphor for an interdependent world, which was meant to be pacified and beneficent. A metaphor, admittedly, since the agreement was not sufficient to prevent quarrels and skirmishes. But the principle, adopted subsequently by the Manchu emperors, was sufficient to prevent the worst.

The Chinese conquest in the early 1950s distorted the game, shuffling the cards and the peoples to mask a brutal and selfish material greed. Massacres, death camps, torture, destruction, the corruption of elites and prostitution are all ingredients of the tragic cocktail, the signs of which Tibet still bears today, disguised as a devastating imported modernity.

"Thanks to the Chinese motherland, become modern", the Han Chinese shout in the ears of the Tibetans. But they persist in wanting to carry into this modernity the treasures they have inherited. Spiritual treasures but also earthly treasures that they have managed to preserve underground and on the surface.

When the Dalai Lama, addressing China, speaks of his country, what is he asking for?

A respectful political system, modern in its democracy and in its social justice, peaceful, respectful of the environment, offering those who desire it the benefits of a spiritual life acquired over centuries. It is just as valid for the billion Chinese as for the six million Tibetans, for it is not about shutting themselves up within the frontiers of an independence, which he has relinquished. Instead, a genuine autonomy, the only kind capable of relieving the chaos of untamed and in some ways deadly economic development, has to be established.

Is it this system, closer to people and more attentive to individual happiness, that makes China so fearful? Or at least its present leaders, because increasing numbers of free and courageous Chinese citizens are daring to speak out and are saying how inspiring they find the word of the Exile.

The image, with a humour that has to be listened to, expresses this hope of a return to that convivial wisdom taught by history. Thus it is indeed in the form of an imperial and monetarist Mao, that anonymous benefactors, some of them doubtless Chinese, pay homage to the symbols of Buddhist Tibet, by placing their offerings at the feet of this monk who, on the floor, is reading out loud the sacred texts (p. 45).

Exile, finally. Imposed by history as a means of survival. This half of oneself taken away all of a sudden and which never ceases to call for the other half that has remained behind in the country. Patricio's images also speak to us about this. They tell us that joy can still be there in the heart of grief, with smiling kids and laughing monks. They speak to us of study and solemnity, as though it were necessary to be prepared both to hold on for decades or to go home tomorrow.

"Exile is a hard trade", said Turkish poet Nazim Hikmet, who knew what he was talking about. For the tens of thousands of Tibetans who have crossed the Himalayas, survival has sometimes come at a high price. How not to lose yourself in the temptation of the West, how to preserve, along with your life, that spark of identity, as you become "global nomads", to use the expression of one of my young Tibetan friends, and still keep contact with your native land?

Indeed the "Precious Protector", joined in 2000 by Gyalwa Karmapa, who seems to be his spiritual son, has managed to create around him footholds, temporary havens, at Dharamsala and in the friendly country of India. But the dilemma remains in all its cruelty: to stay, go further away, or return to invaded and occupied Tibet, to live this day-to-day resistance there with the immense majority of his compatriots? To do it in spectacular fashion, drawing the eyes of the world to his probable sacrifice? Or to take his role in a discreet but infectious resilience even among the invaders? The very beautiful Tibetan text that follows is perfectly illustrated by Patricio's images. It is remembered in a counterpoint in which the words and the faces make sense.

But let us make no mistake, this memory with which we are momentarily entrusted, at one time or another, carries a very specific message which requires us to take up our responsibility without delay, in action.

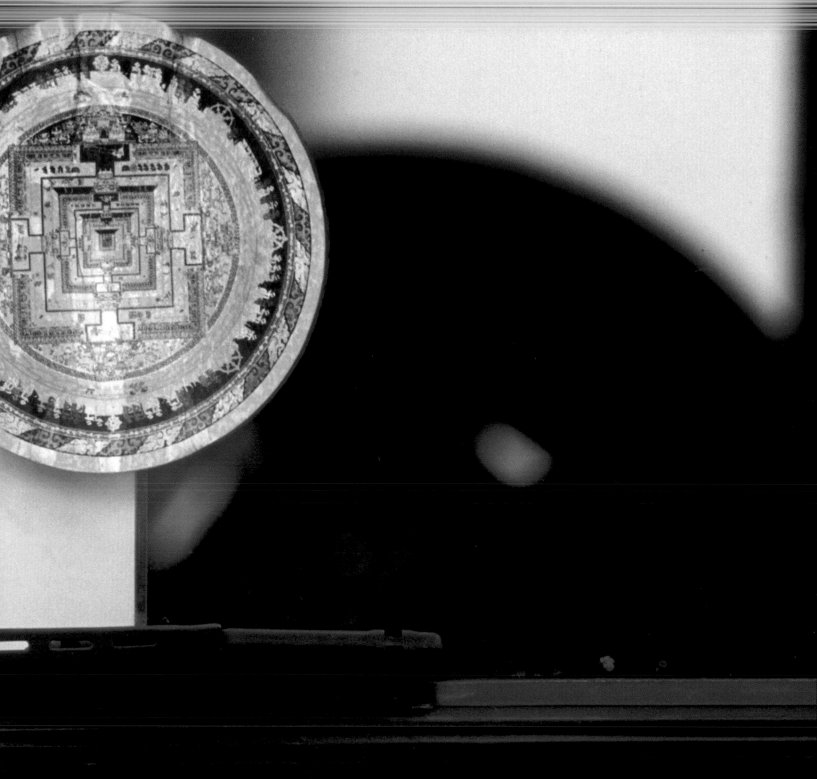

Gen Sherap

Lhasa Calling: Why We Must Escape from Exile

Time has come for us to return. Night follows day, and day follows night. Exile, too, if meaningful, is followed by return. For the very goal of going into exile is but to refill our water bags and restock our armoury so that we might return home to finish the fight with renewed vigour.

But in the case of our exile, something else happened: we came, we saw, we stayed.

It is understood that there was much wisdom behind our escape to India in 1959 following the Chinese invasion. There was also much wisdom behind our leadership's farsighted plan to develop strong institutions and establish stable communities in India and abroad in order to prepare for the eventuality of a prolonged exile. It goes without saying that today the exile Tibetan community is one of the most successful refugee groups in the world.

The flip side of this success is that we have become blind to the very reason we came into exile in the first place. Our communities have grown roots in foreign lands, and our houses have grown tall against foreign skies. The comforts of a privileged exile have made us forget our brethren inside Tibet; in fact, some of us have even grown to cherish our position as default beneficiaries of the Chinese occupation of Tibet. Thus we extended our stay in India, Nepal, Europe and America, swinging like a pendulum between delusion and despair – the delusion that Tibet would be free if we can preserve enough culture and generate enough publicity, and the despair that Tibet would never regain its sovereignty, no matter what we do. After fifty years of waiting, we are still here – essentially waiting. Waiting for what?

Some are waiting for a free Tibet! Strange as this may sound, there are many chest-thumping patriots in our community who routinely bang the table and scream, "I will return to Tibet only when it becomes a free country!" These people, in an attempt to sound patriotic, are unwittingly displaying their selfishness by implying that Tibetans inside Tibet should do all the work and pay the price for freedom, and then at the dawn of victory the exiles will march in amidst pomp and ceremony. If you are one of these people, you should be ashamed to claim even a square inch of land in a future free Tibet!

Then there are those of us who believe that Tibet can be freed by fighting from exile, that we need not be on the battleground to win the battle. This line of thinking is dangerously flawed. A freedom struggle cannot be outsourced. A movement that is outsourced quickly loses its legitimacy and effectiveness: imagine what would have happened if Gandhi's Salt March to Dandi had taken place on the sandy beaches of California! Sadly, the Tibetan freedom struggle increasingly resembles a manufacturing company, except in this case the jobs are being transferred from Tibet to India and the West. This is partly due to the current lack of political space inside Tibet and partly due to the global community's enduring sympathy for the Tibetan cause.

But instead of working to increase political space inside Tibet, we have so far chosen to bask in the warmth of global sympathy while passively waiting for the miracle of a free Tibet. Gandhi would find our Tibetan-style passive resistance quite strange – very passive, hardly resistant!

The movement in exile and the accompanying global sympathy are of course necessary and helpful, for they deny China the legitimacy and global acceptance that it so desires. But the main role of an exile movement is to provide a megaphone to the resistance inside, to engage and bring in outside groups and countries as allies, and to provide financial and moral resources to the resistance inside Tibet. Without an organized resistance inside Tibet, an exile movement has no foundation to stand upon. Any victory that we accomplish in the battle for global public opinion merely serves to blow fire at China without setting it aflame. Raising awareness through films and talks, visits to the parliaments of foreign countries, petitions and news headlines, and storming of embassies are all effective and necessary tactics, but they remain tragically incomplete unless there is substantial mobilization inside Tibet strategically aimed at removing the pillars that support China's occupation. Hence there is a crying need for a grassroots movement across the three provinces of Tibet that will give the beleaguered masses the hope and the means to wrest power from the hands of the oppressor.

Our brethren in Tibet are the ones who best understand China and its weaknesses. They are the ones who have the practical ability to plan and execute a non-violent Satyagraha movement that can sever the limbs of China's rule in Tibet. However, due to the sinister infrastructure and ruthless methods China uses to silence dissent and prevent rebellion – some of which put even the futuristic, Orwellian tactics to shame – the potential leaders who are most likely to organize such a movement inside Tibet end up either jailed or killed. A favourite lament of many critics is that there are no grassroots political leaders among Tibetans – on the contrary, there are hundreds of thousands of them. Unfortunately, they are all in jail or in exile. The Chinese government knows that exiling an activist is as effective as imprisoning her or him; both diminish the effectiveness and relevance of the activist to the movement inside Tibet. This in part explains why China shows little hesitation these days before releasing political prisoners so long as they are put aboard a plane out of Tibet.

This, then, is the reason why we must return. Every activist living in exile is an activist absent in Tibet. Every Tibetan who crosses the Himalayas to become a refugee deprives our brethren in Tibet of an actual or potential leader. The hundred thousand Tibetans in exile are in fact a hundred thousand Tibetan leaders missing from Tibet.

Exile Tibetans who return to Tibet can play a pivotal role both in laying the socio-economic foundation and in organizing the actual resistance. In spite of all the shortcomings of the exile community, there are many virtues that the exiles can contribute to the cause: knowledge of similar non-violent movements around the world, familiarity with modern communication technology that will form the bedrock of mobilization, and the vision of a future democratic Tibet.

This is not to say that the homeland Tibetans lack these virtues; rather this is to emphasize that exile Tibetans have yet to pay their dues and now it is time for them to serve on the battleground, whether by teaching at a school, or helping at a clinic, or mentoring at an orphanage, or assisting the start-up of a local business. In the beginning, our initiatives can – and often should – be social and economic rather than overtly political. But these tactics must fit into a long-term strategy of creating

more and more socio-political capital in Tibet, which will become the raw material of political mobilization when the opportunity arises in the form of a change or crisis in Beijing.

Some will cite China's strict borders and visa restrictions as insurmountable obstacles. But obstacles exist so they may be overcome. Already many young Tibetans residing in the West have entered Tibet with relative ease as tourists, students or visitors. Some even live there now. Whether we go as tourists or returnees, more and more homeland Tibetans are expressing their belief that our return can play a pivotal role in changing the course of our nation.

Let this be a call to all Tibetans, young and old, residing abroad in India, China, Nepal, Europe and North America. Time has come for us to return. Our armoury is full and our water bags have been refilled. Board a plane, ride a bus, cross a river, or climb a mountain! Before time brings our memory to rust, let's find our escape from this exile.

Phayul, 18 January 2007
Gen Sherap is writing under a pseudonym for many reasons, some of which are obvious
and some of which are not.

Patricio Estay
PHOTOJOURNALIST

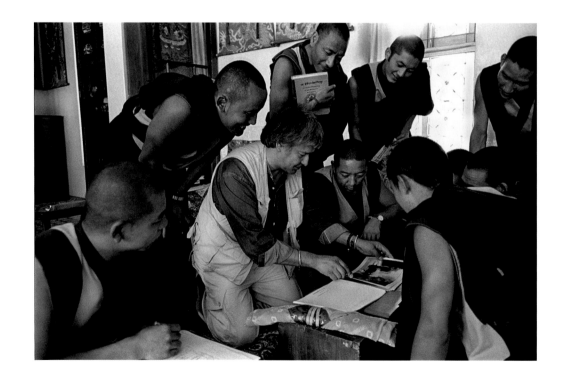

My exile from Chile, following the coup d'état in 1973, and my work as a photojournalist have led me to far off places where I have come into contact with exiled peoples. One such people are the Tibetans: it was thanks to them that I discovered Buddhist philosophy. This is why I have devoted the last seven years of my activity as a photo-reporter to "painting" a complete image of Tibet and its exiled community. This micro-society is animated with a vitality that is typical and rare, common to those who possess a strong identity and powerful faith. Through the sum of my long labour I hope to bear witness to the resolute calm with which the Tibetan people undertake the arduous task of perpetually affirming their ideas and spirituality.

Through the medium of photography, faces, ceremonial rituals and fragments of life from the heart of the temples delineate a world where moral issues, spiritual fervour and the depth of the soul go hand in hand with kindness, joy and enormous generosity.

The background to this existential canvas is the contrast between the harsh mountain peaks, the severe climate and the austere lifestyle and the intense joy of celebrations such as the Losar (Tibetan New Year) in Dharamsala, this little Tibet recreated in India. Despite the dramatic socio-political reality in which the Tibetans struggle for survival, the celebrations of their New Year continue to exist also in Lhasa.

This reportage, dedicated to Tibet, has come to its conclusion. From a former exiled man to an exiled people, the volume *Tibet Land of Exile* is my modest contribution to the Tibetan cause and the freedom of Tibet.

"With neither homeland nor compass, exiles are condemned to compulsory journeying;
they recognize and encounter each other..."

This thought, a heritage left to me by Henri Cartier-Bresson during an unexpected meeting in Paris, has been ever present in my mind during this long project among the Tibetan community.

Acknowledgements

His Holiness the
Fourteenth Dalai Lama
Patrizia Benedetti-Estay
Walter Veltroni
Piero Pelù
Jetsun Pema
Tempa Tsering
Kirti Rimpoche
Laura Vallarino Gancia
Vanity Fair's Team
Giovanni Cocco
Dharamsala's Tibetan
Community
The Tibetan People

Contents

LHASA - CHINA

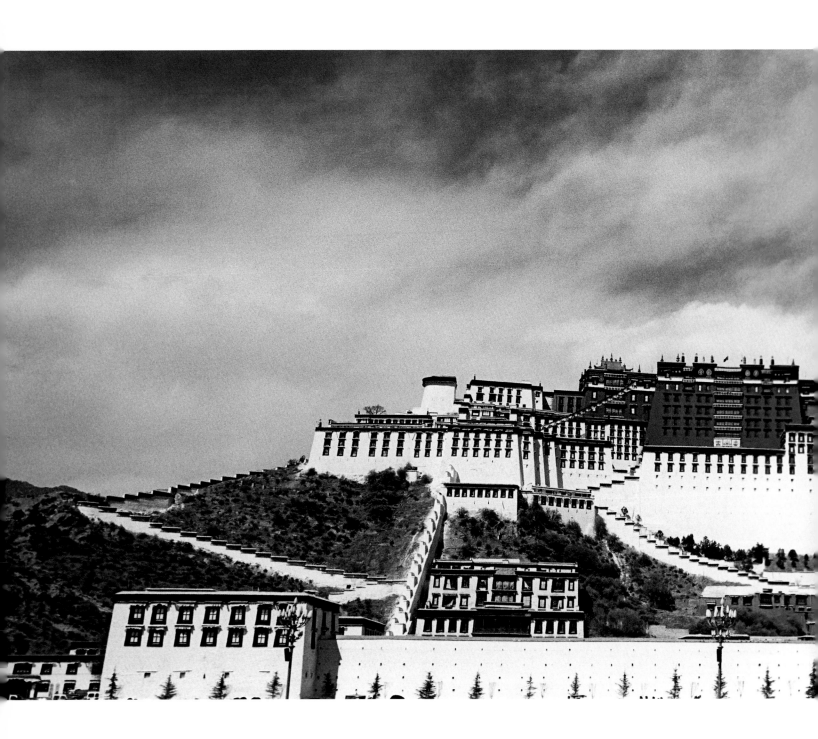

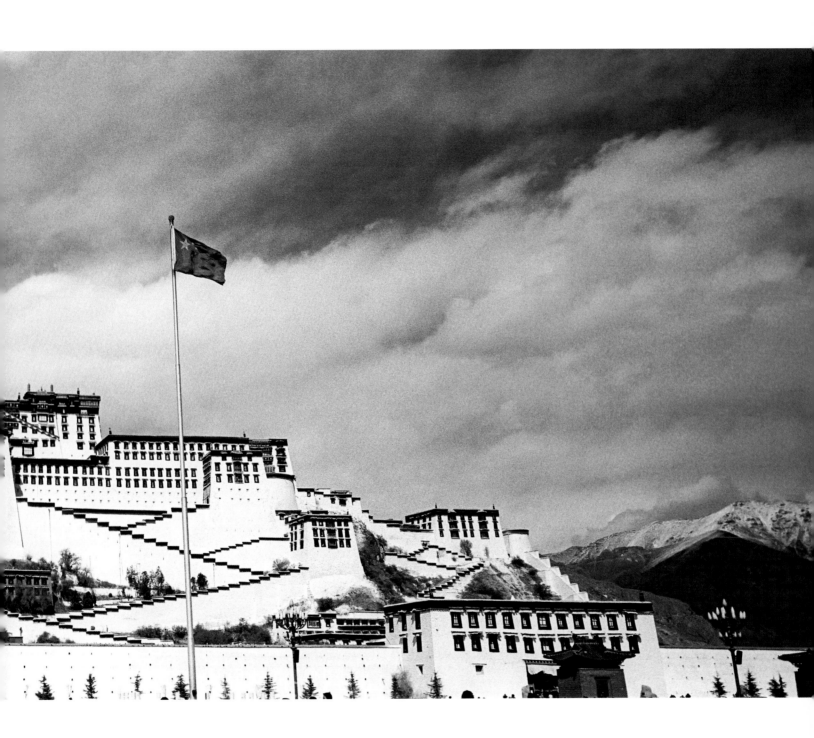

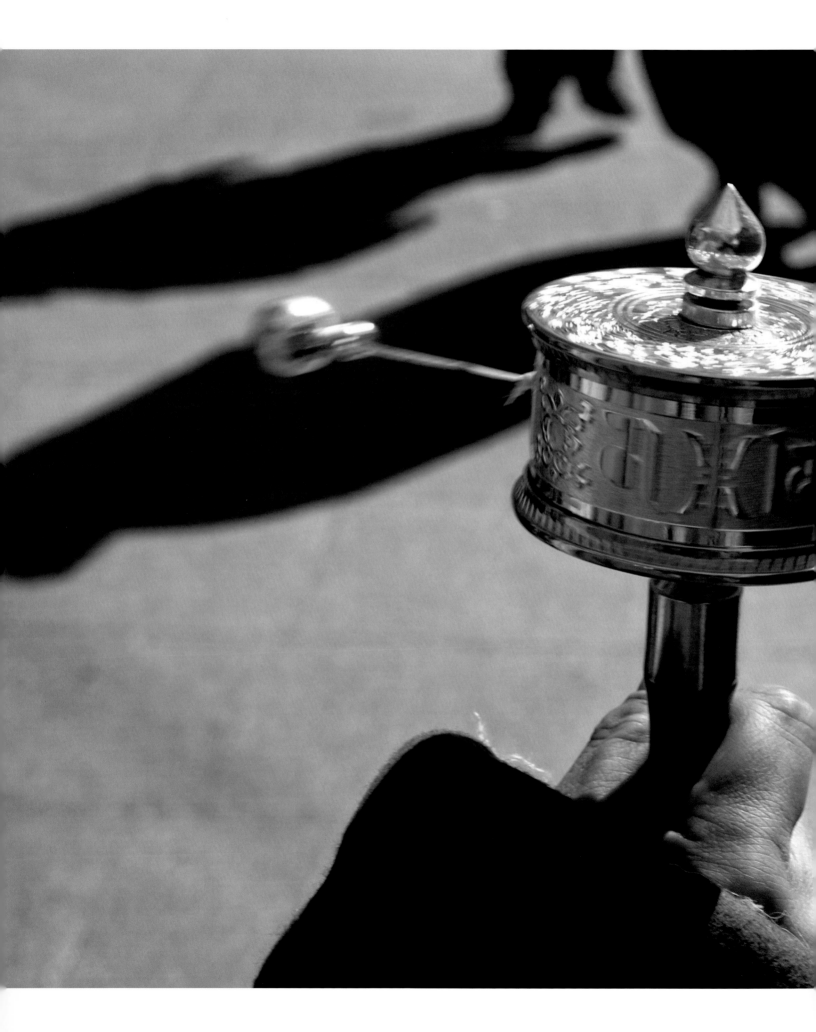

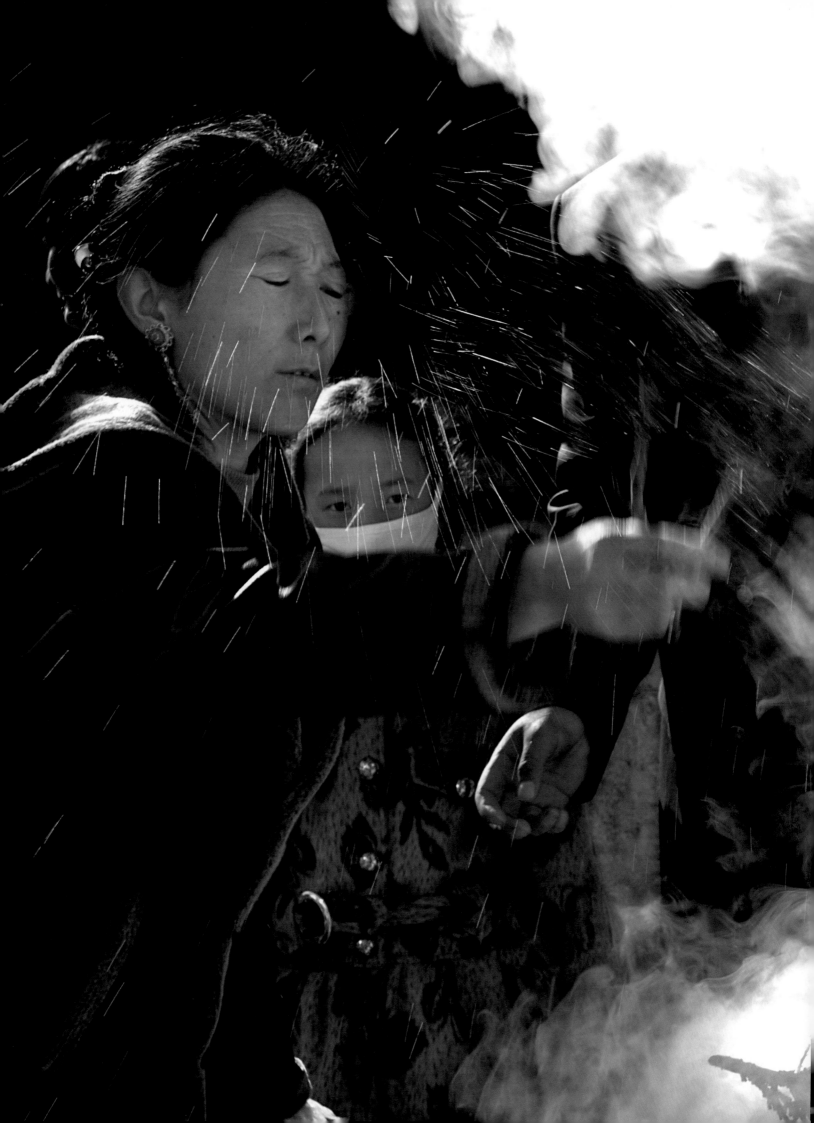

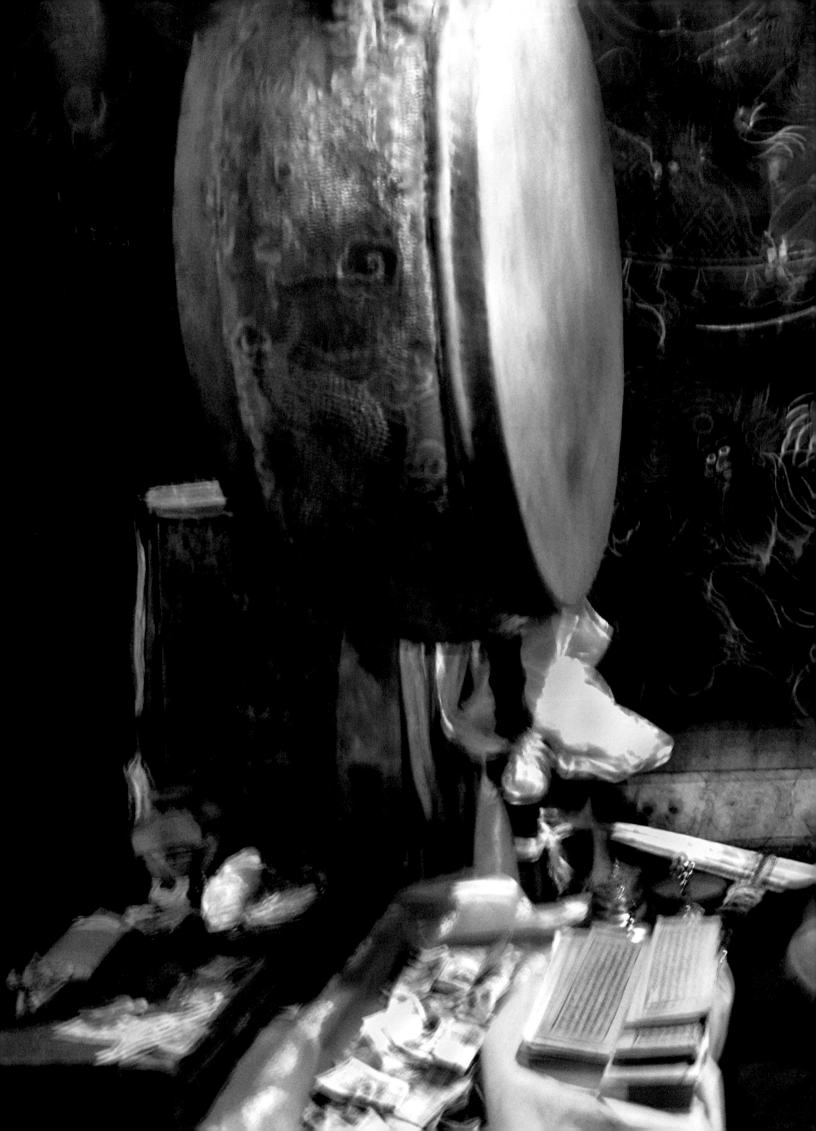

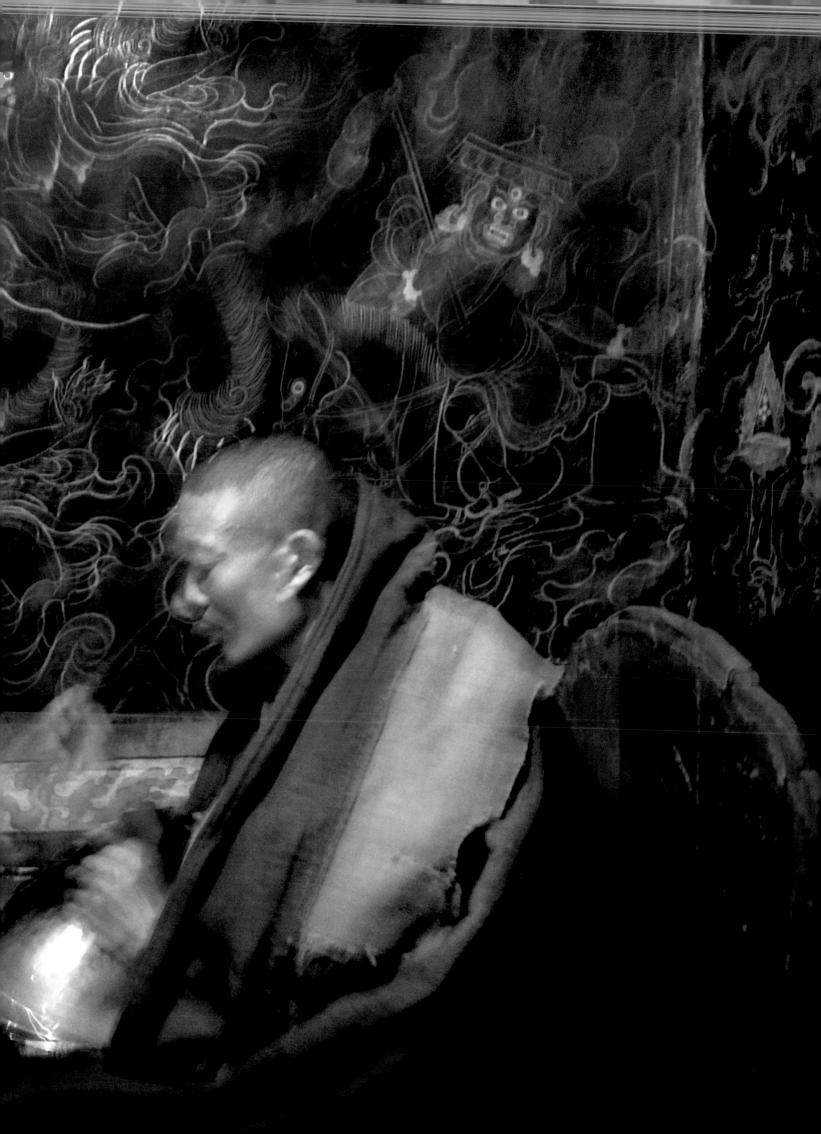

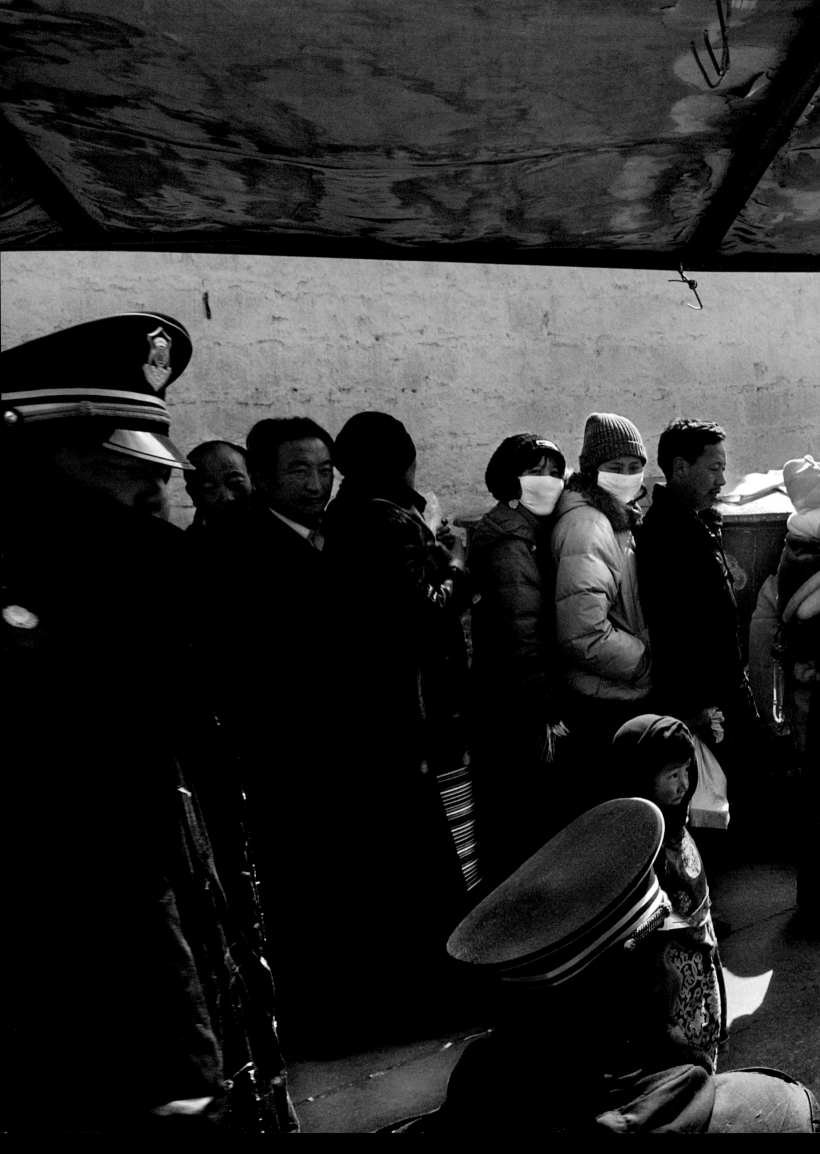

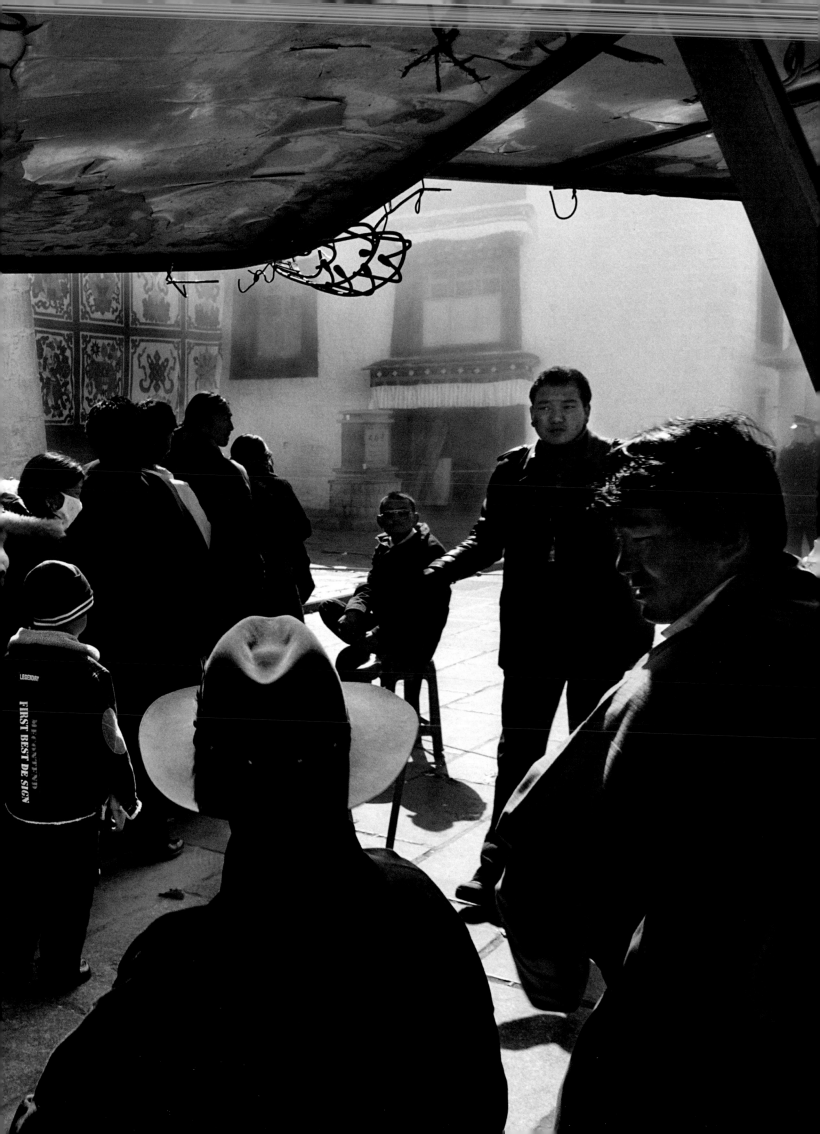

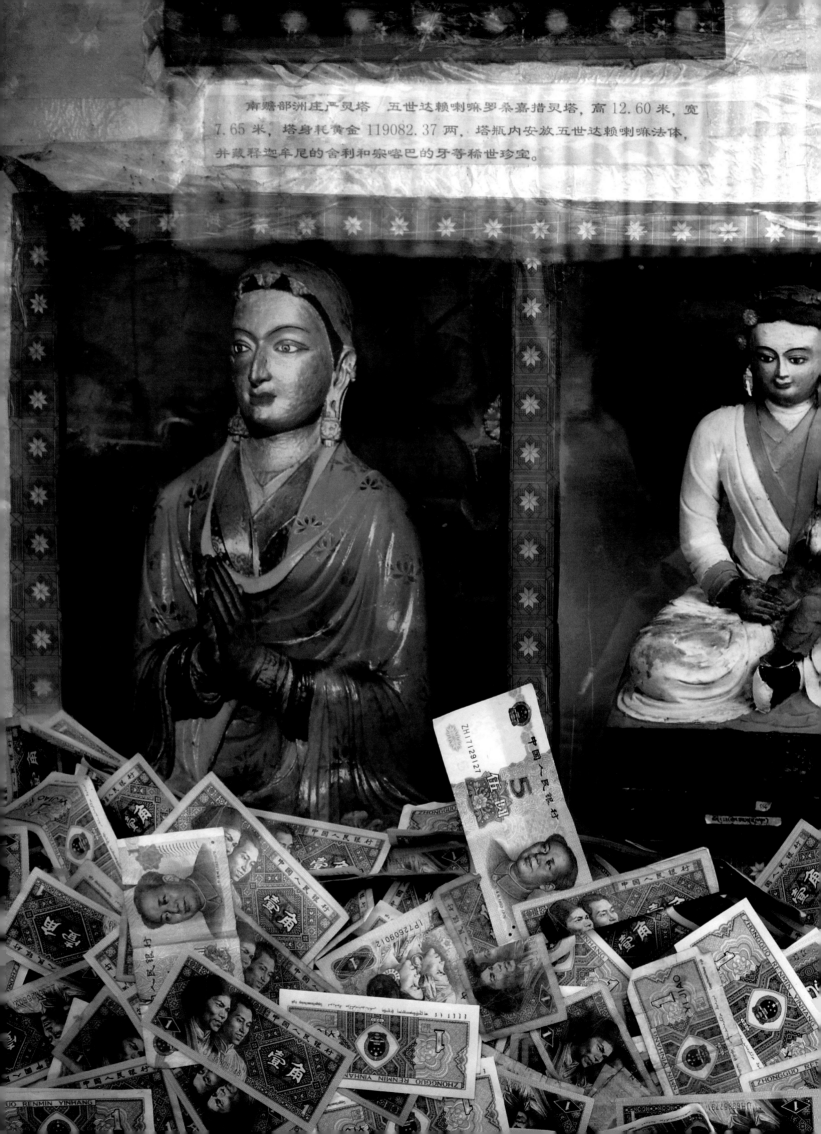

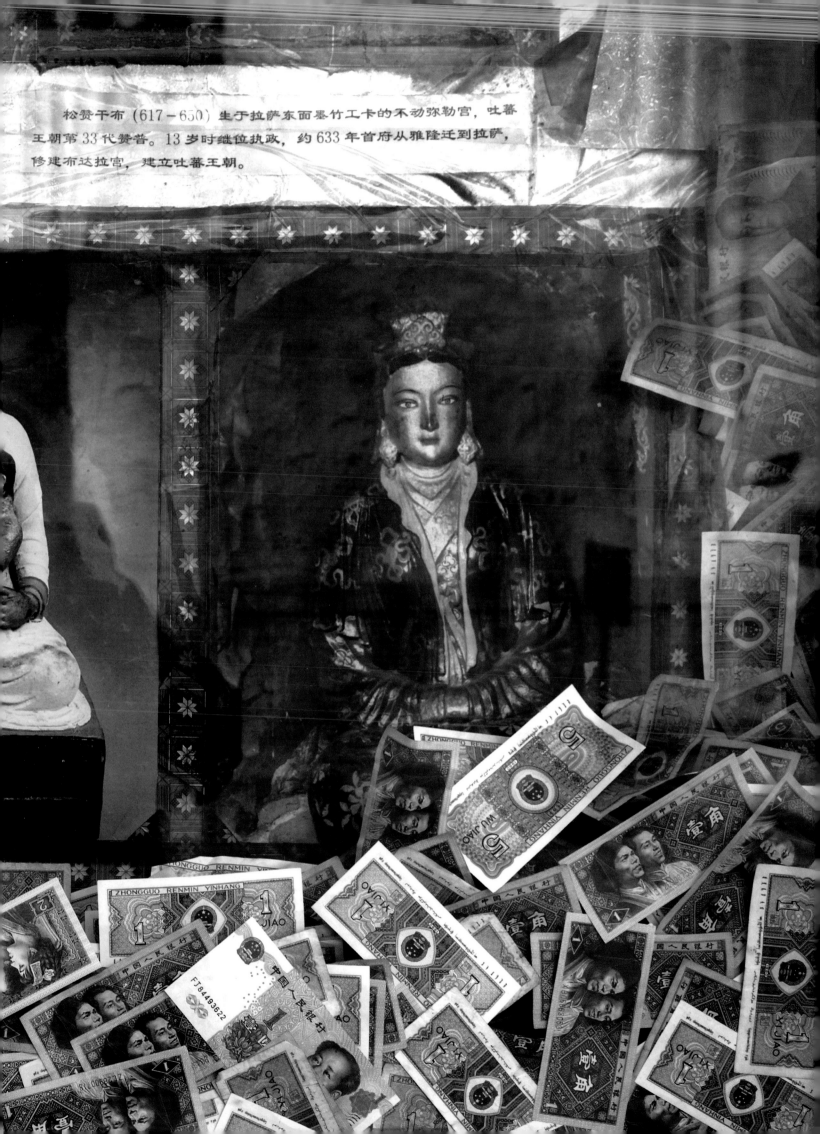

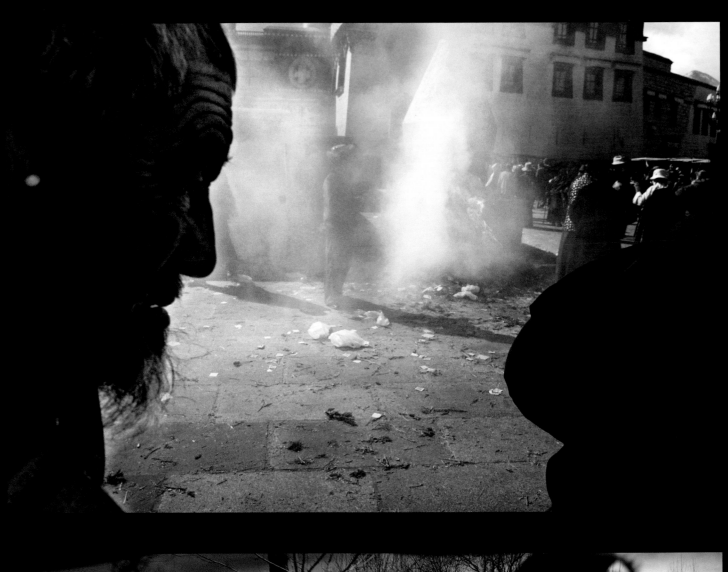
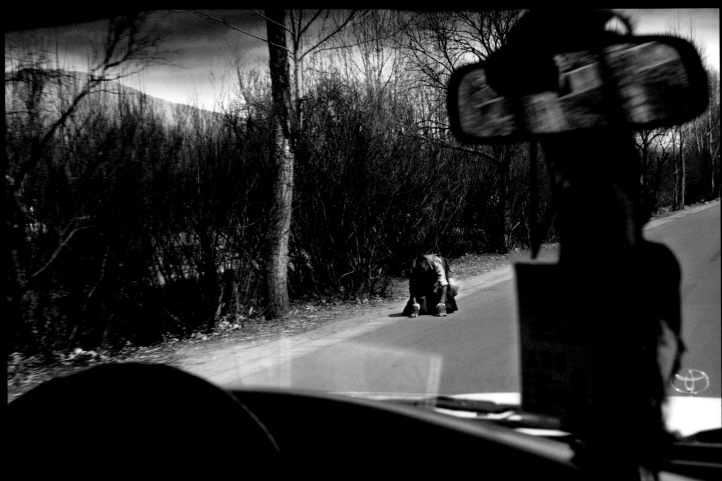

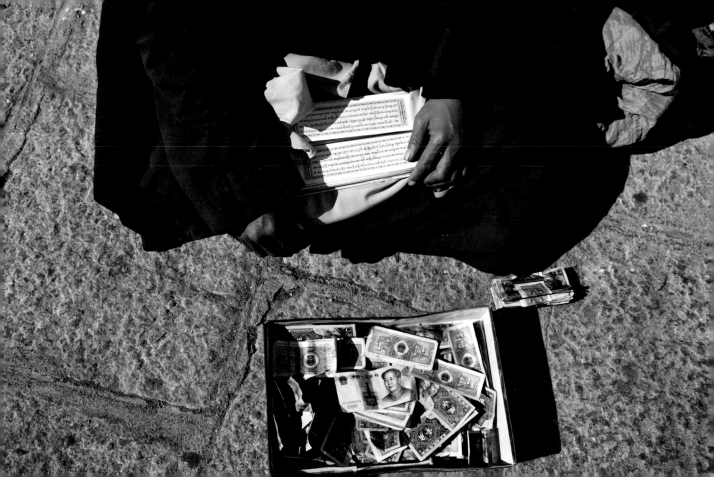

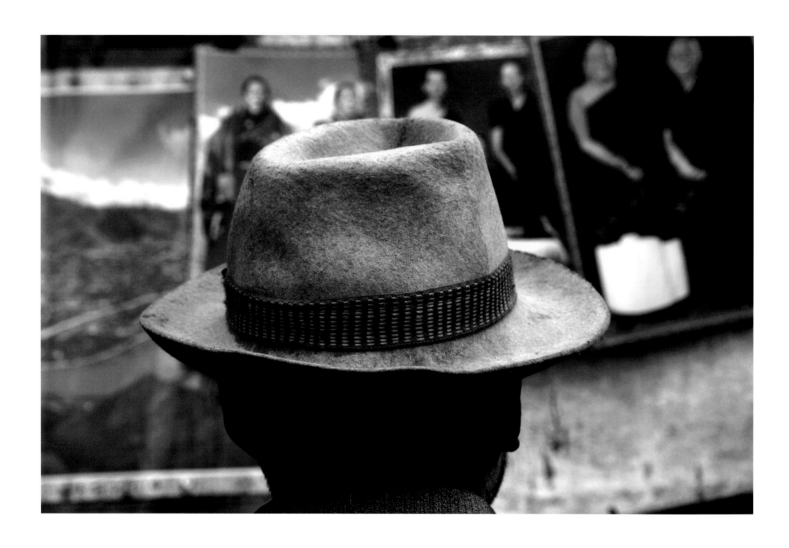

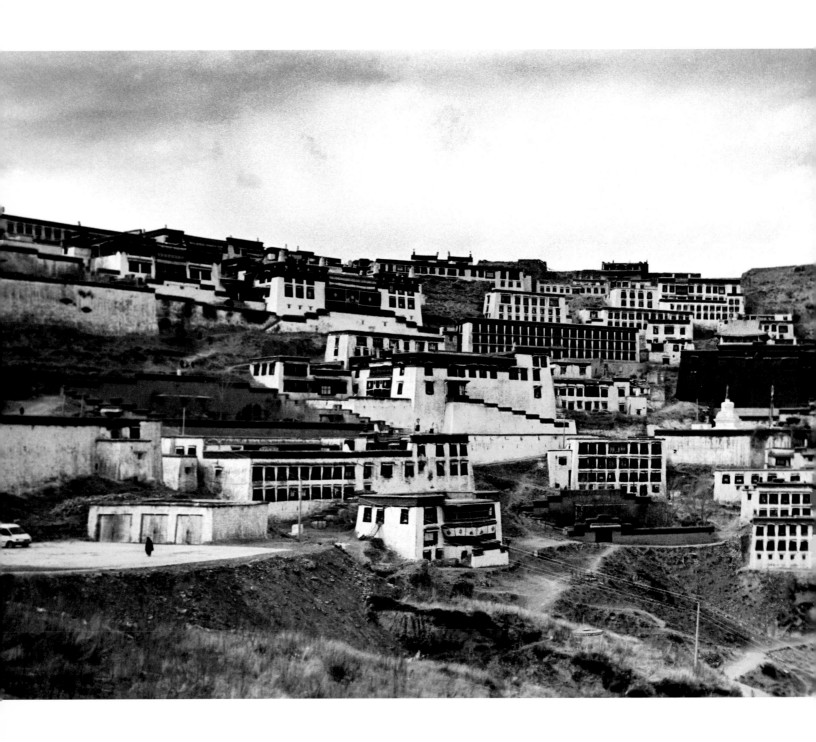

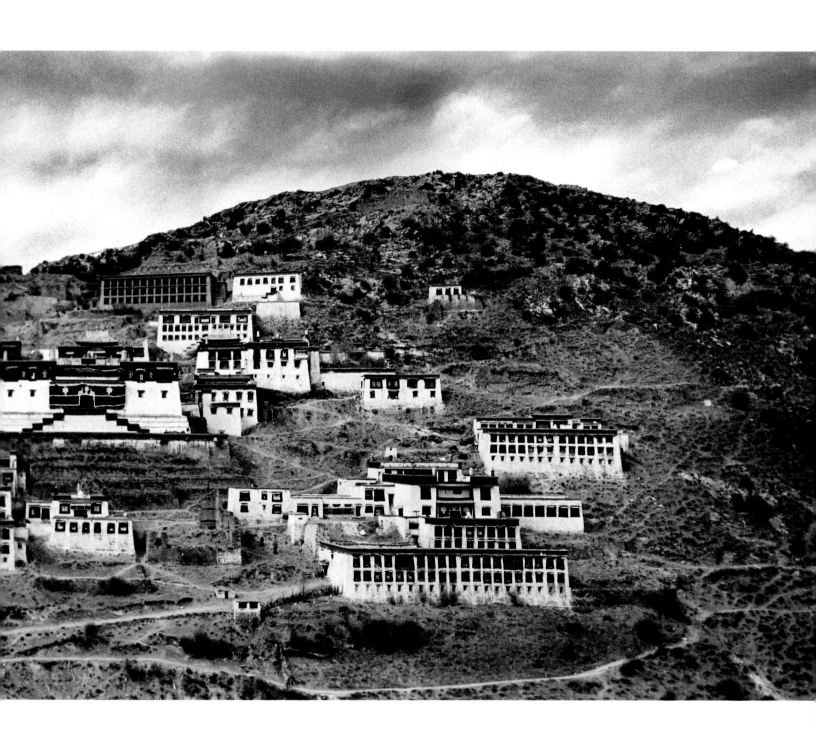

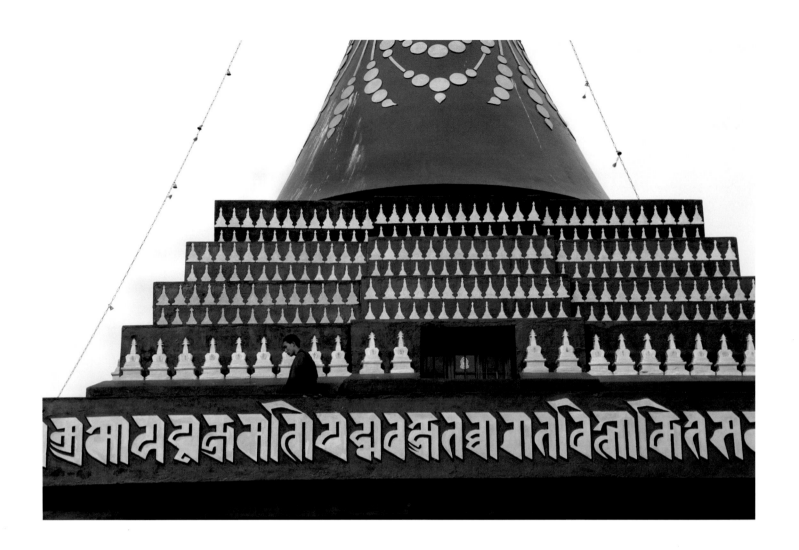

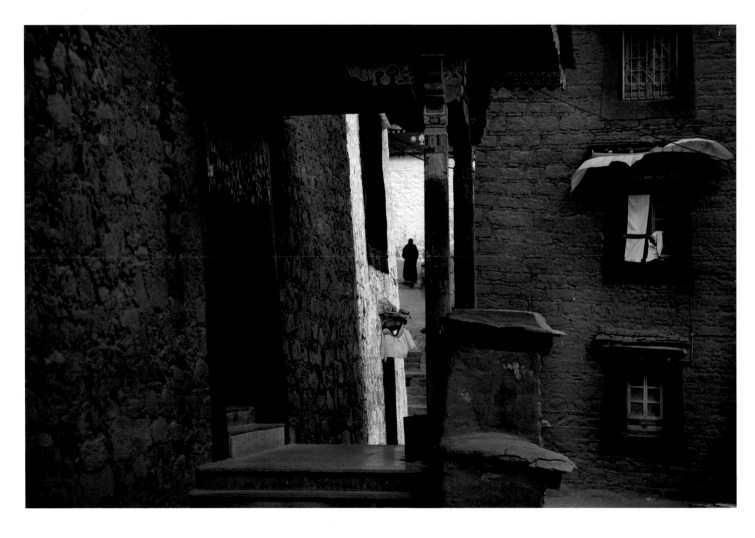

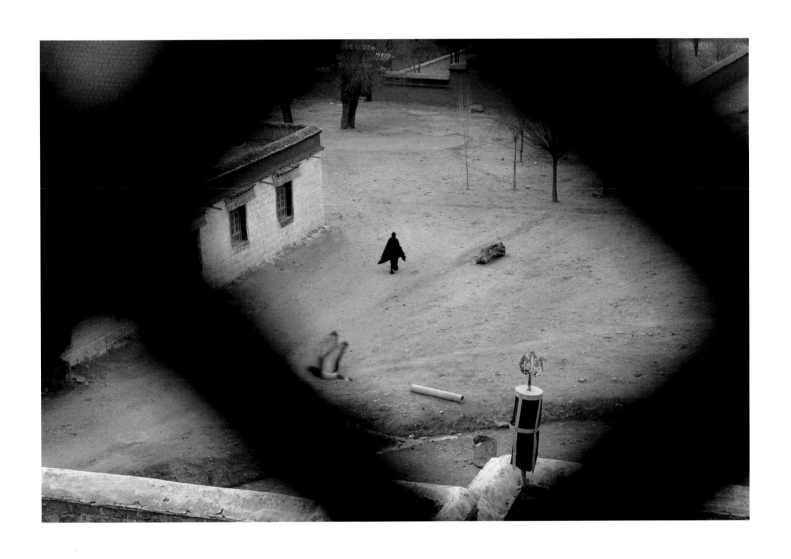

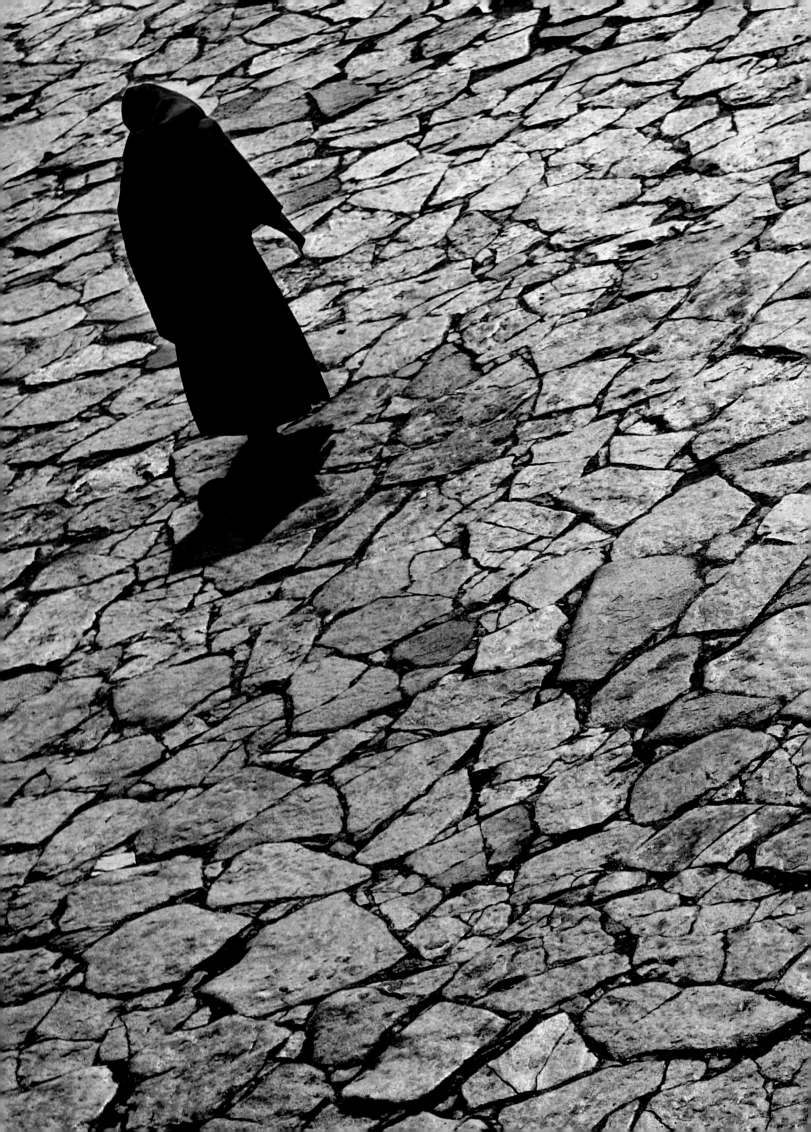

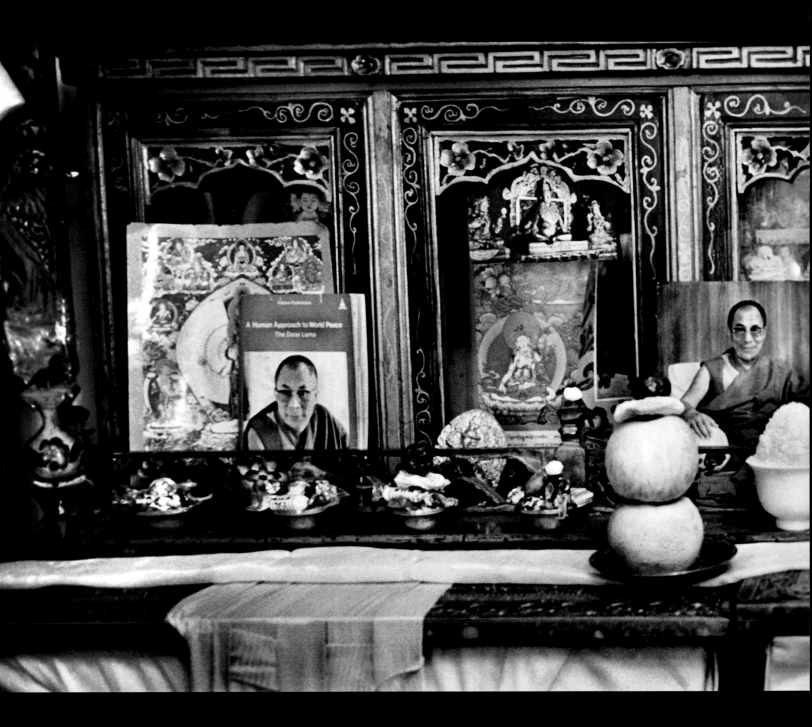

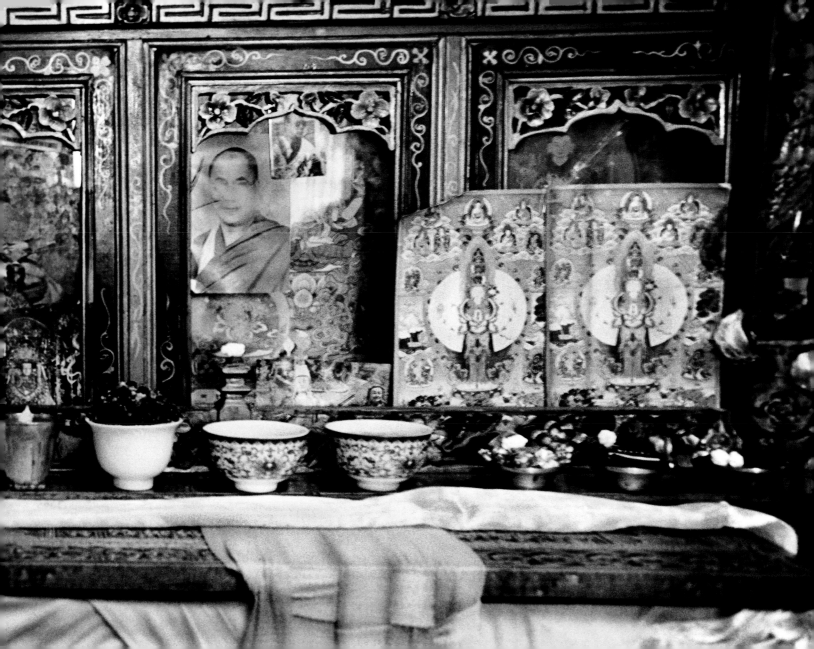

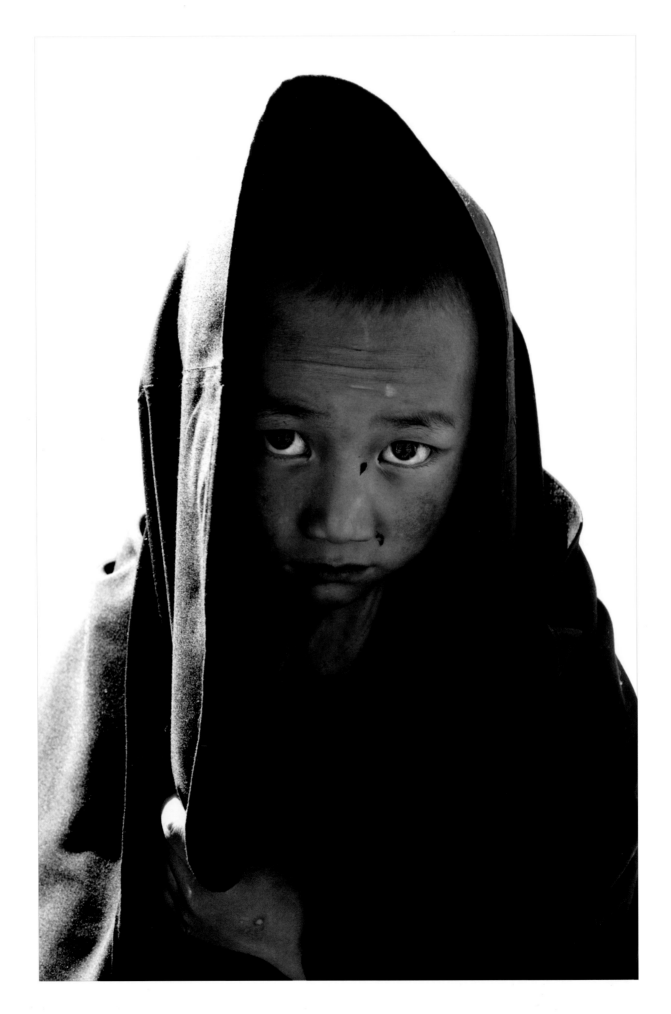

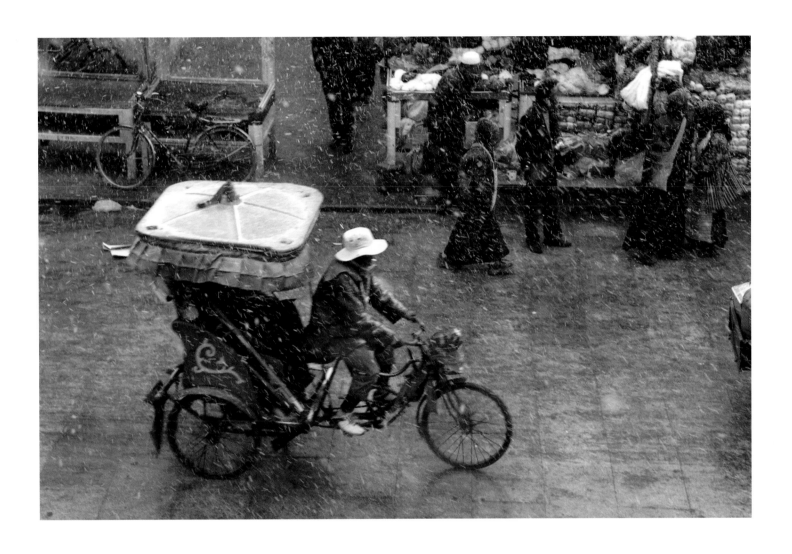

LHASA - KATHMANDU

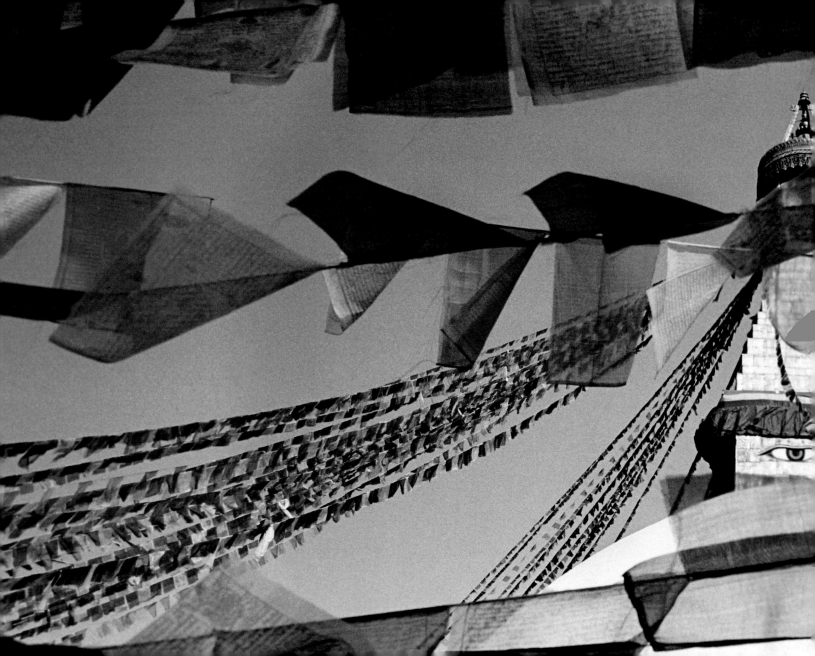

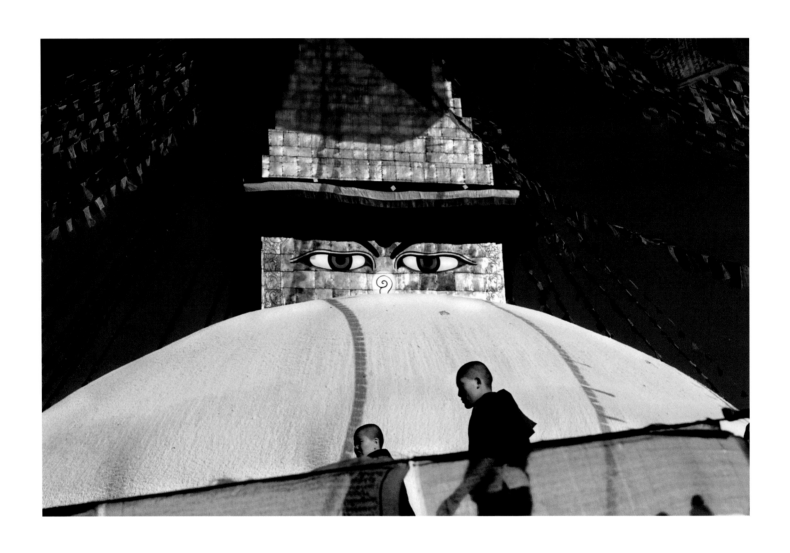

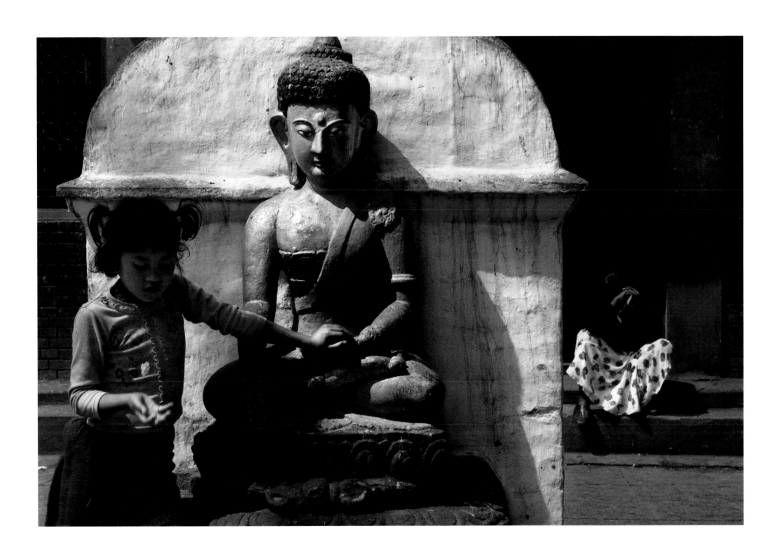

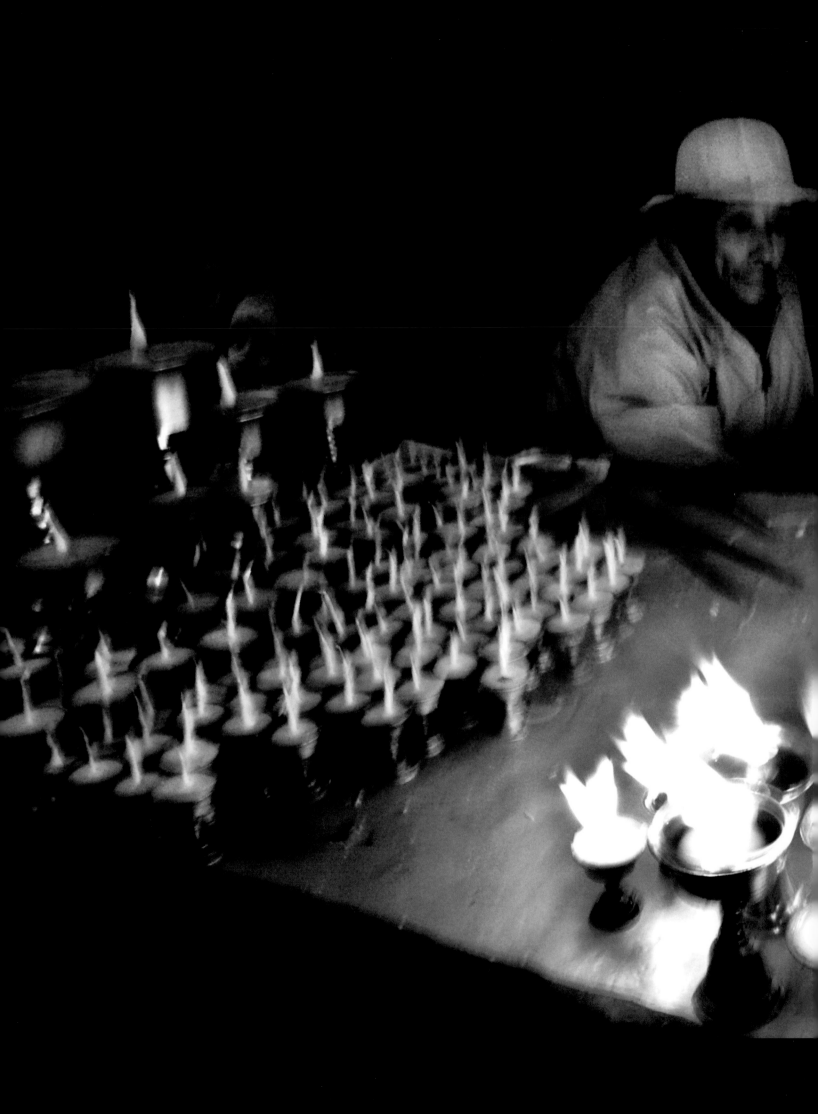

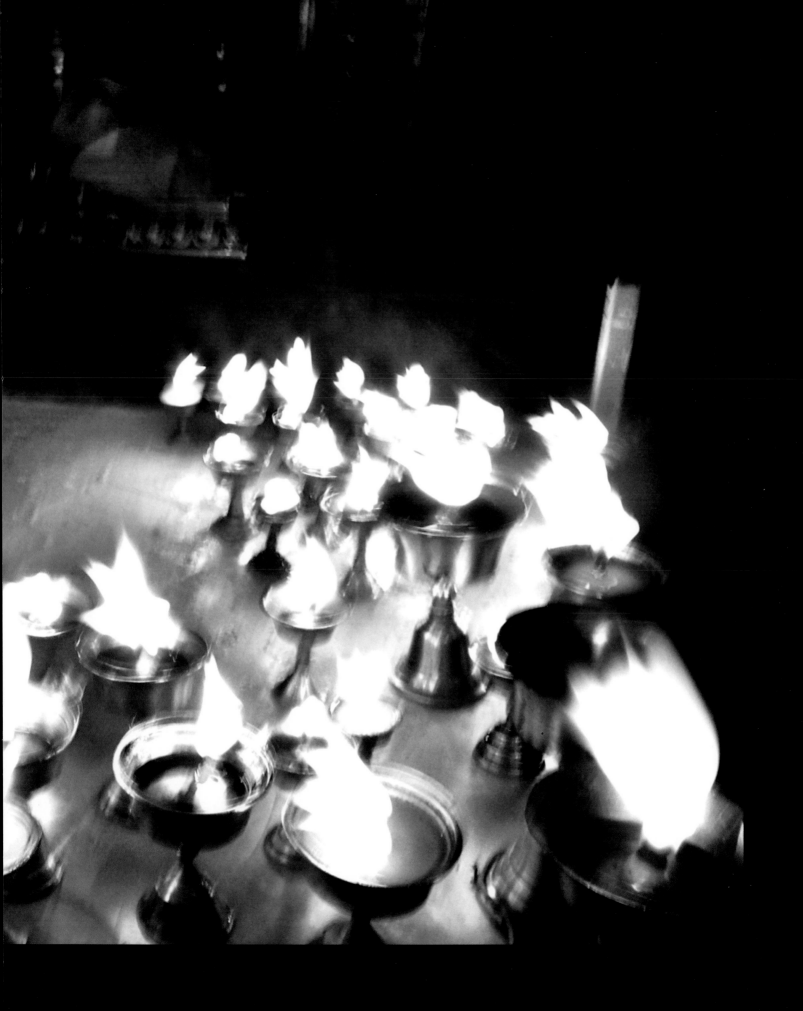

KATHMANDU · DHARAMSALA

THMANDU · DHARAMSALA KATHMANDU · DHARAMSAL

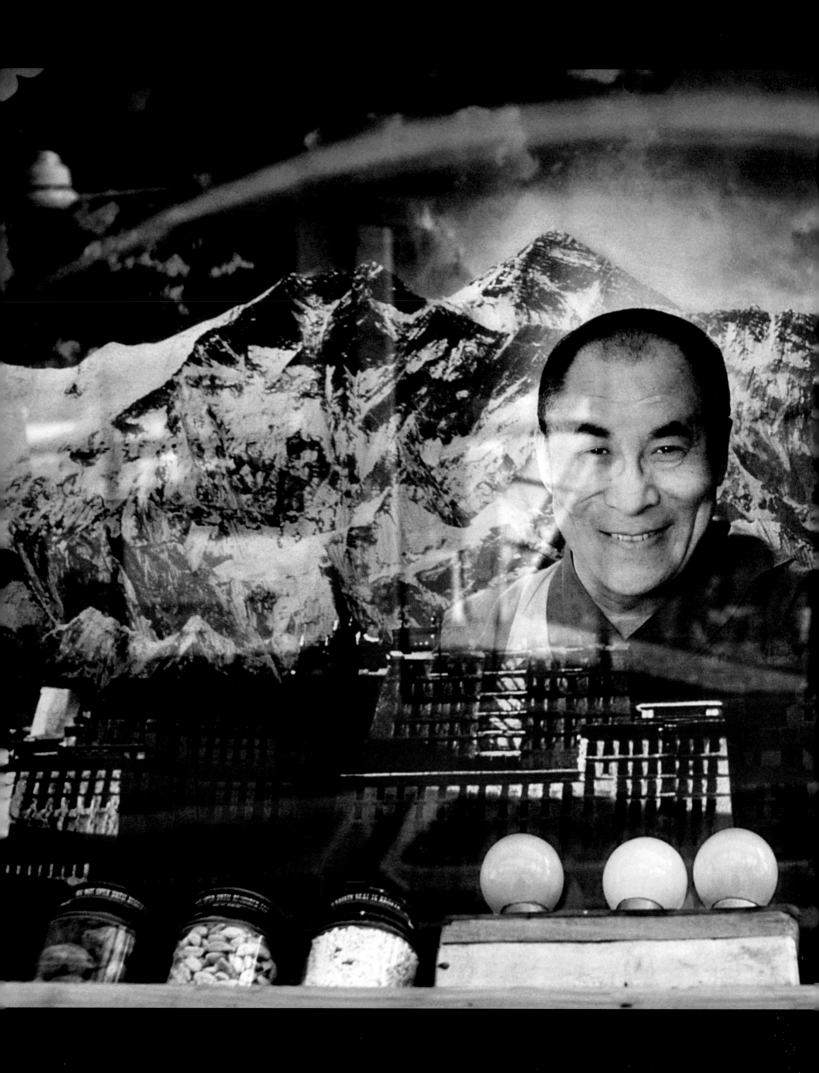

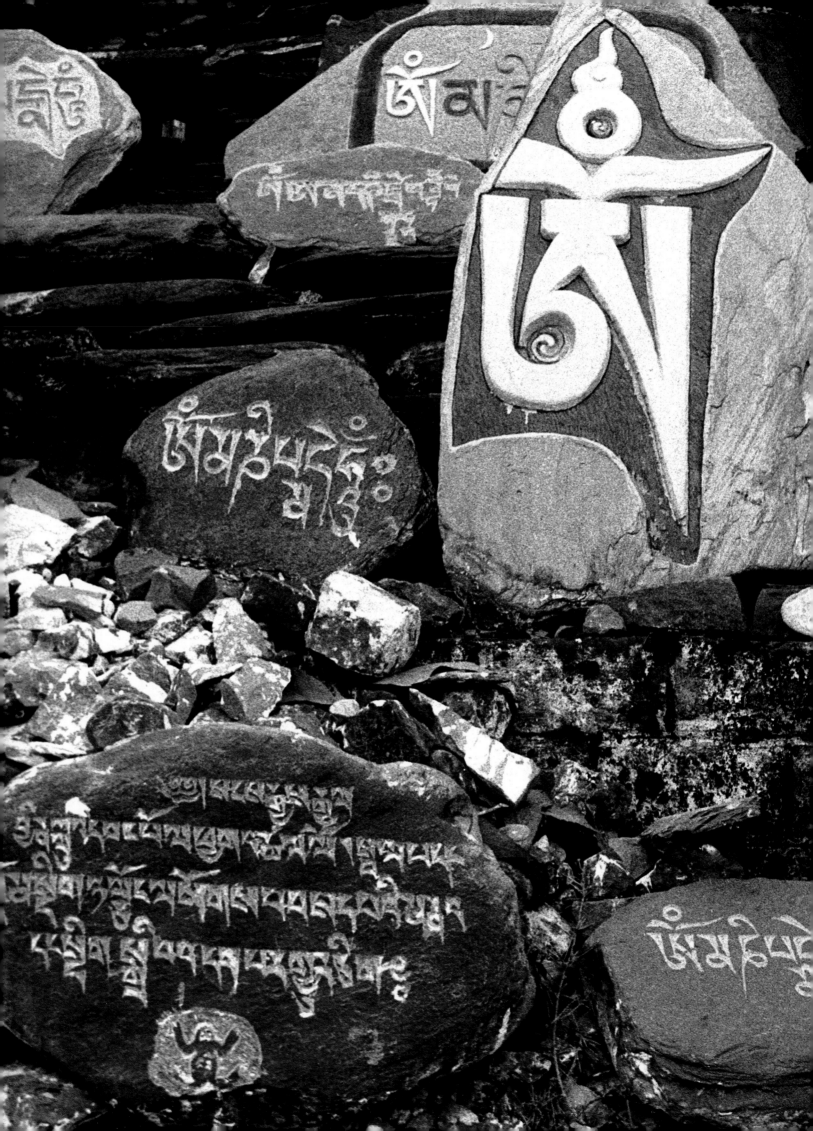

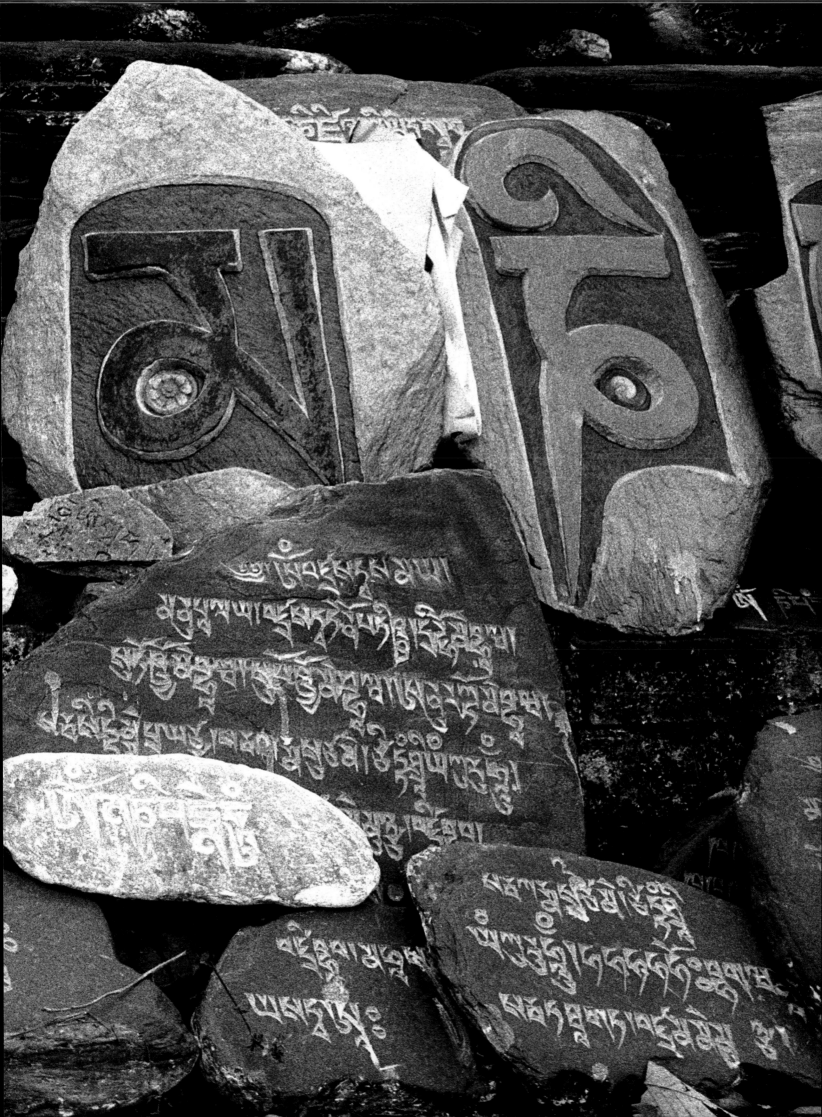

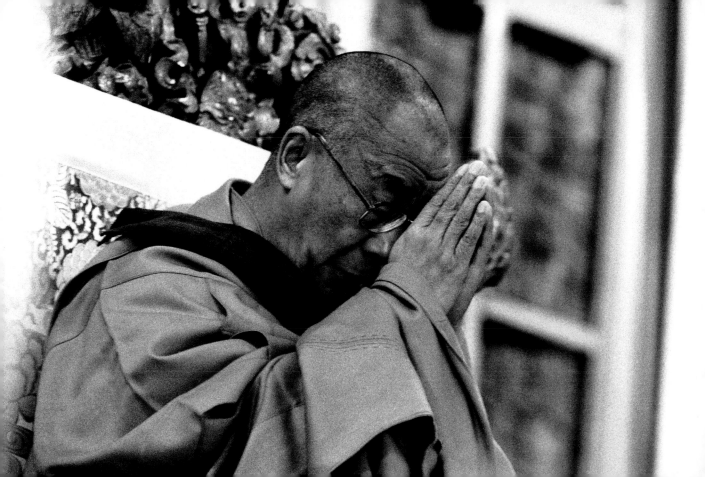

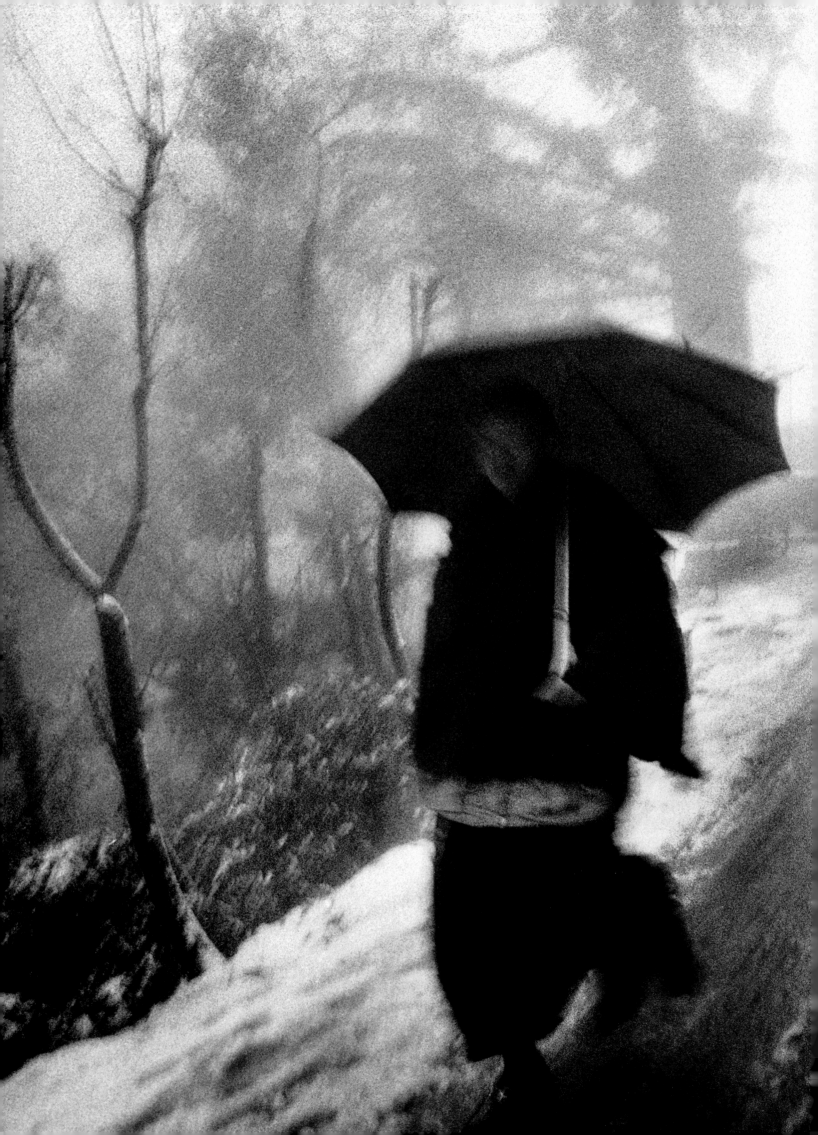

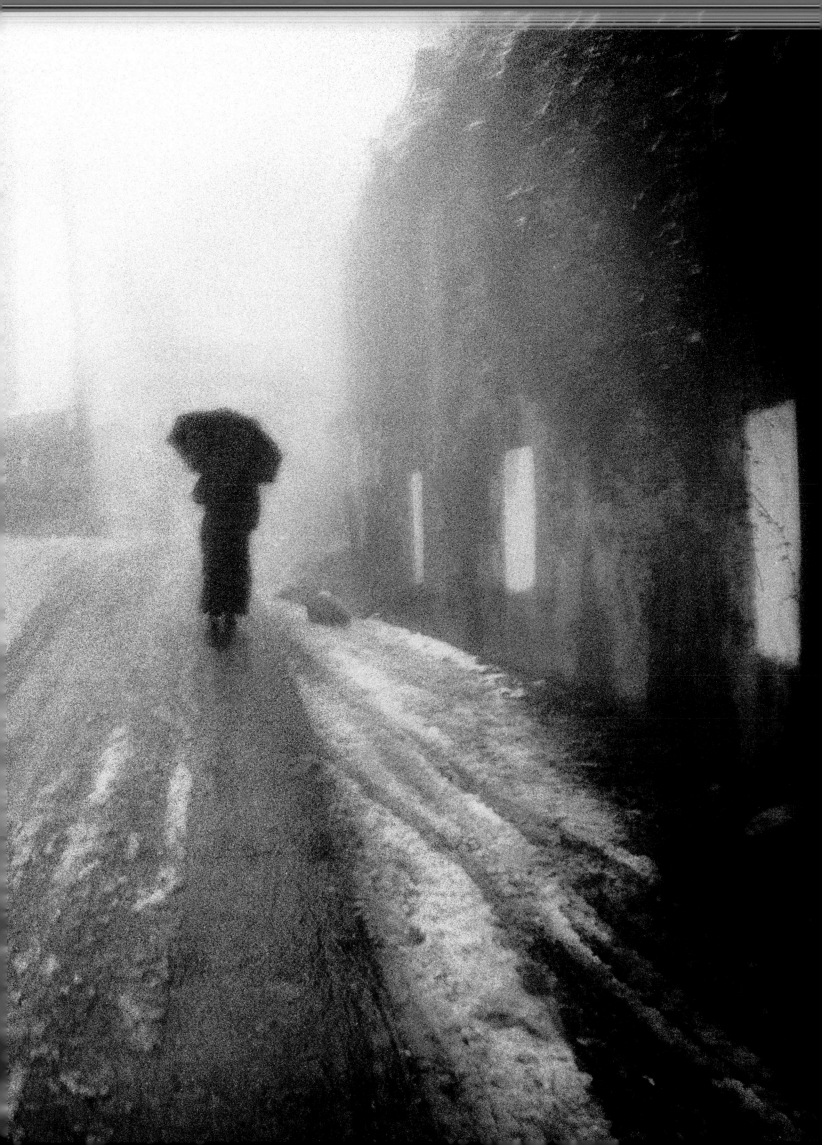

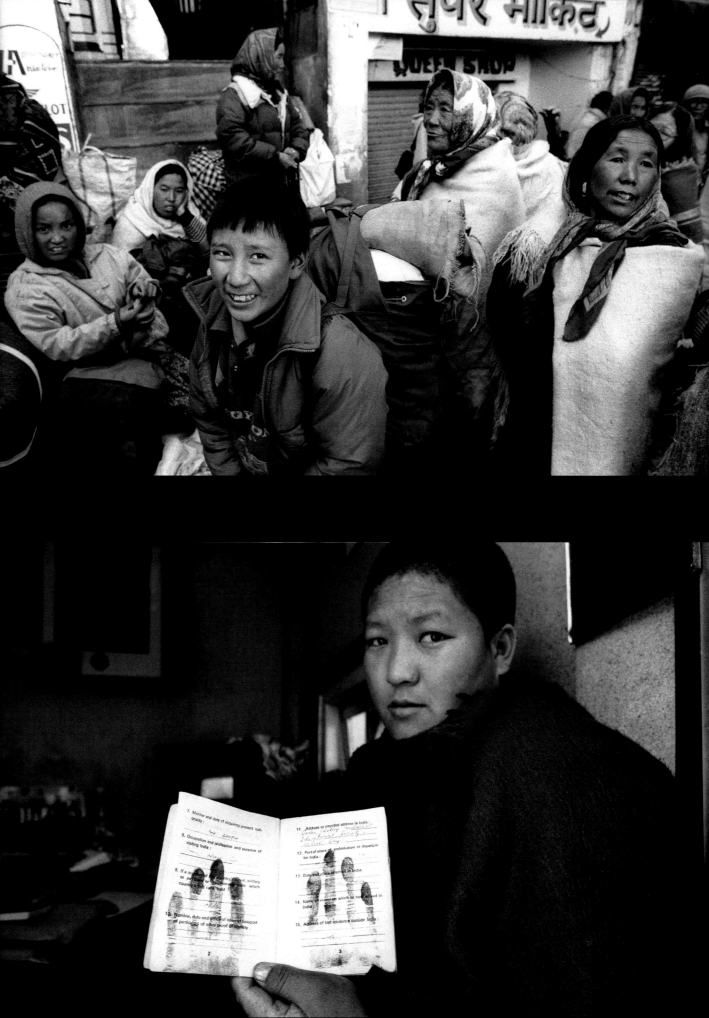

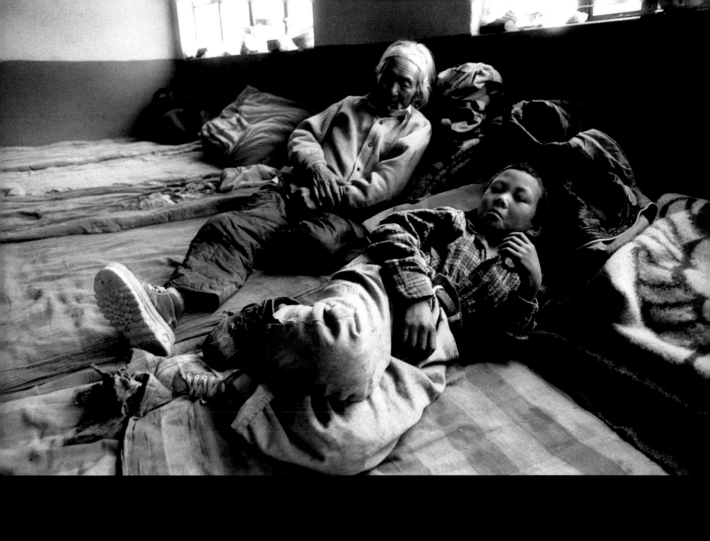
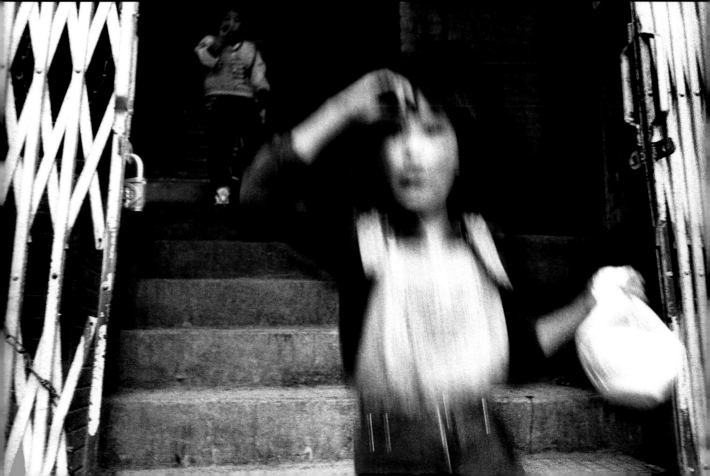

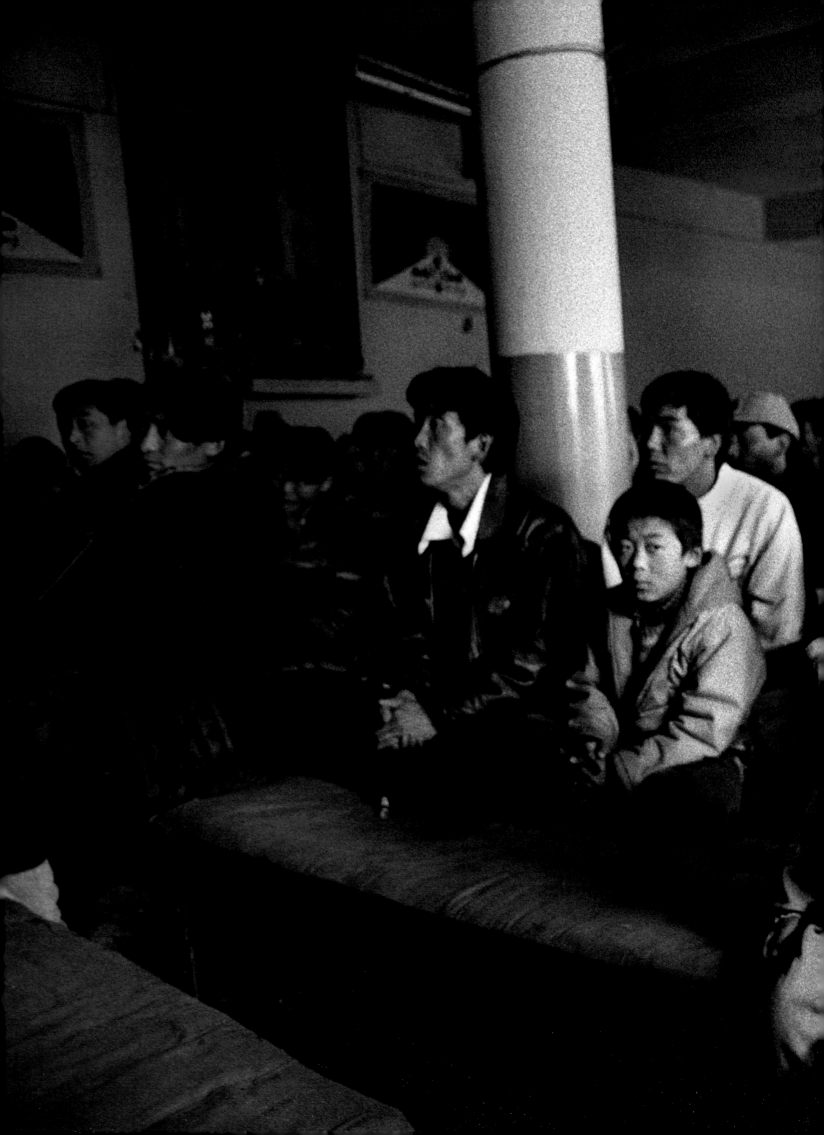

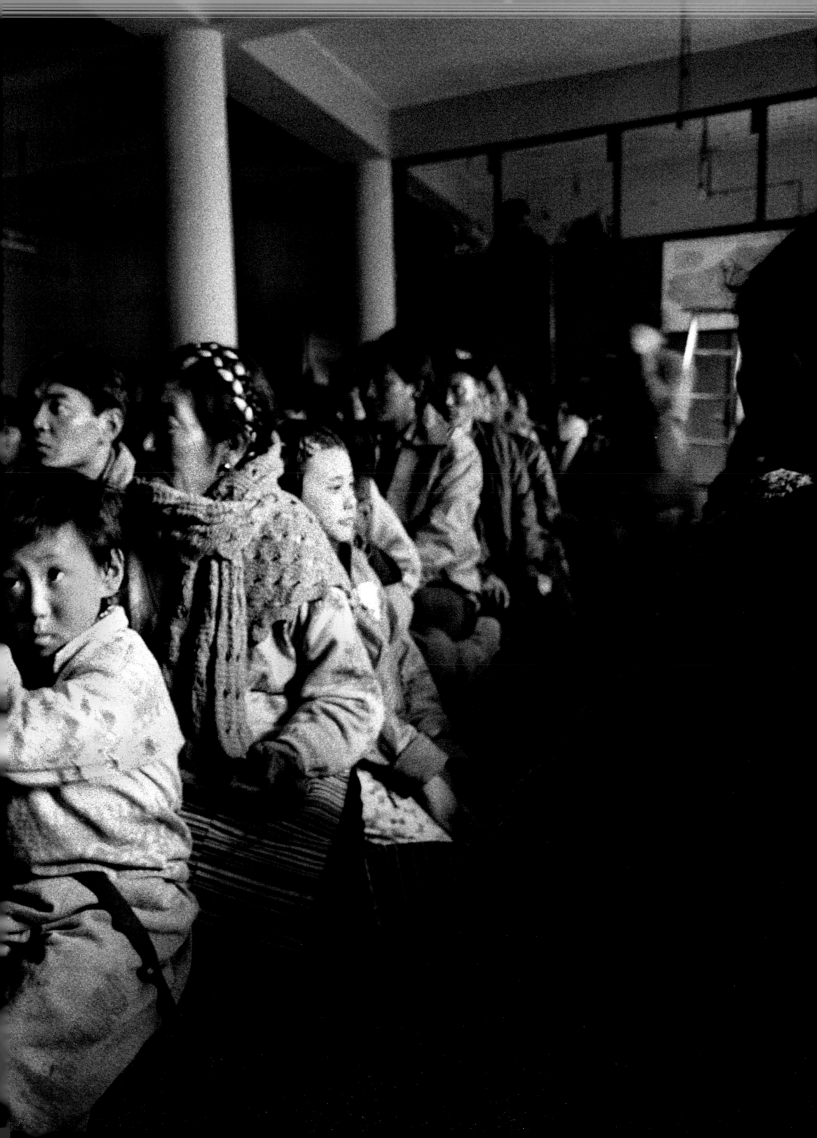

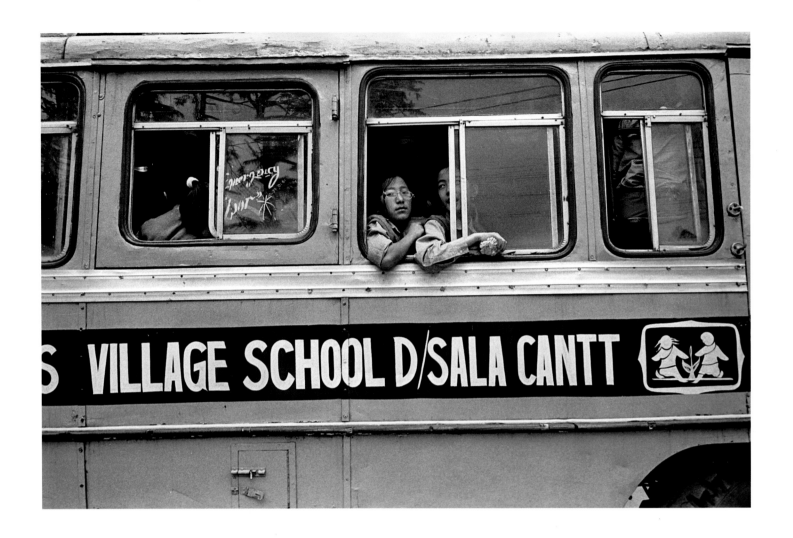

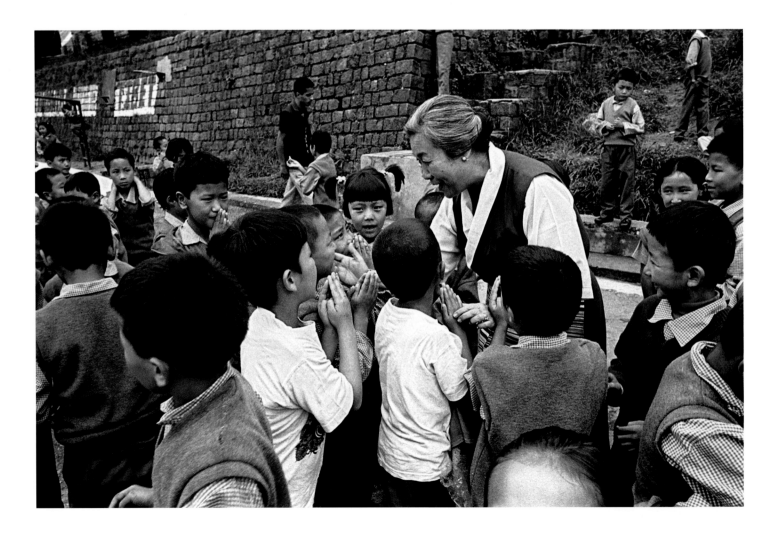

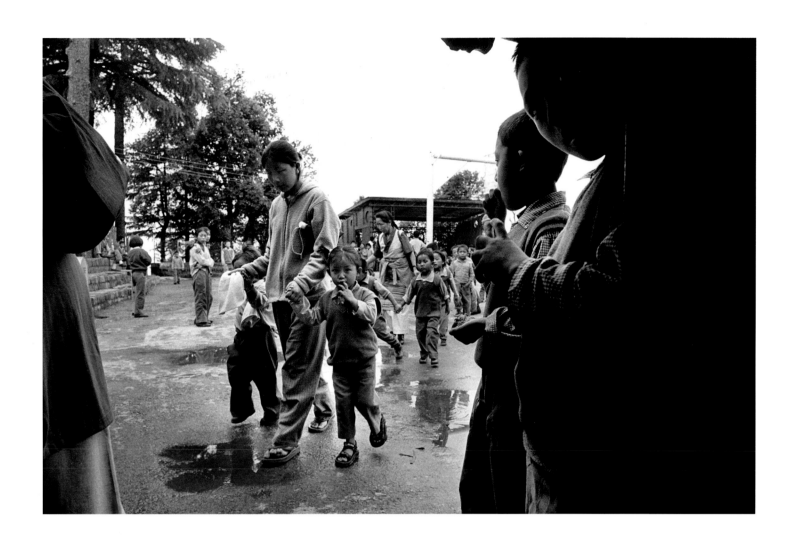

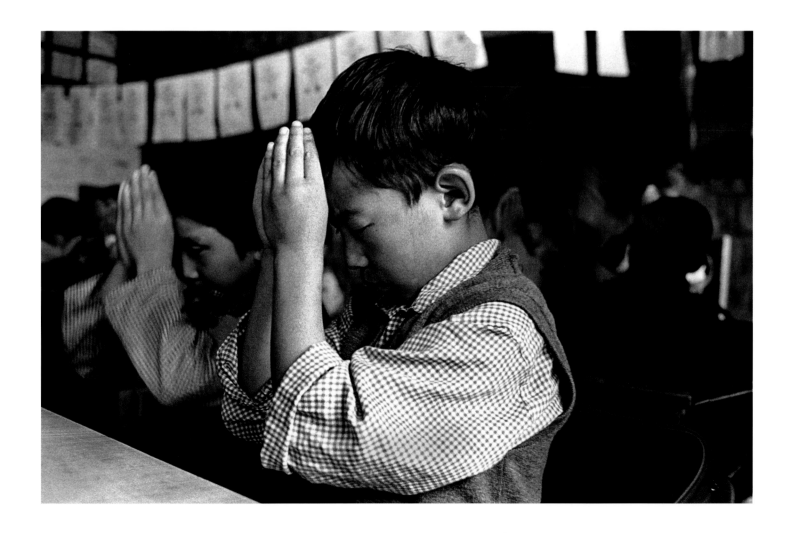

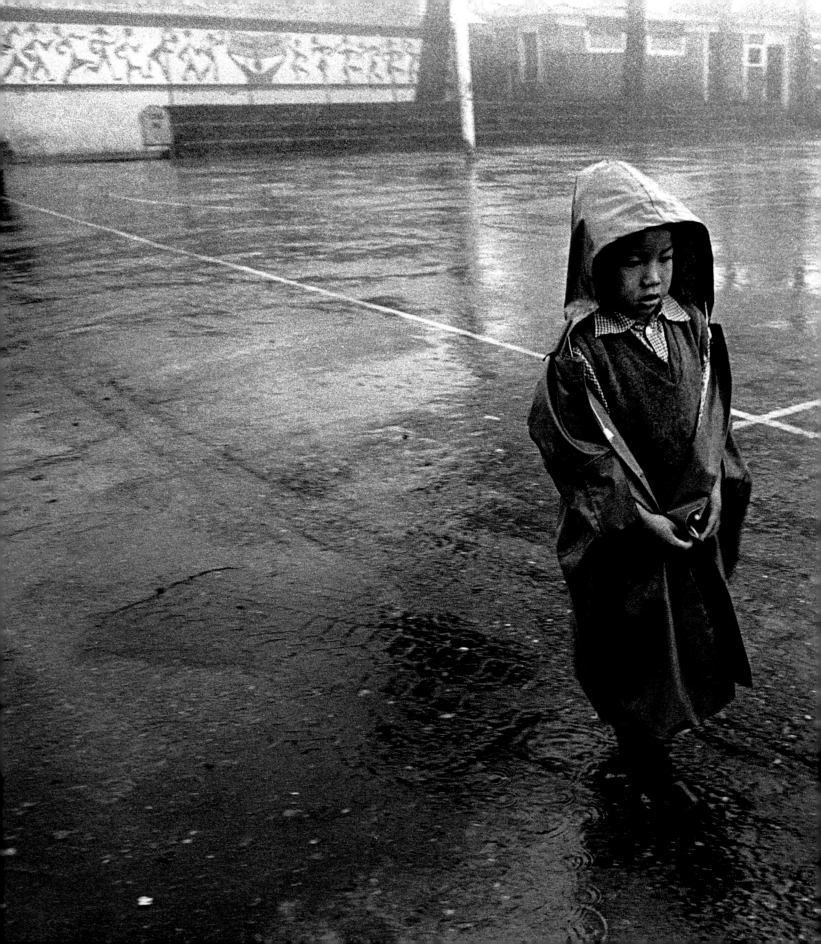

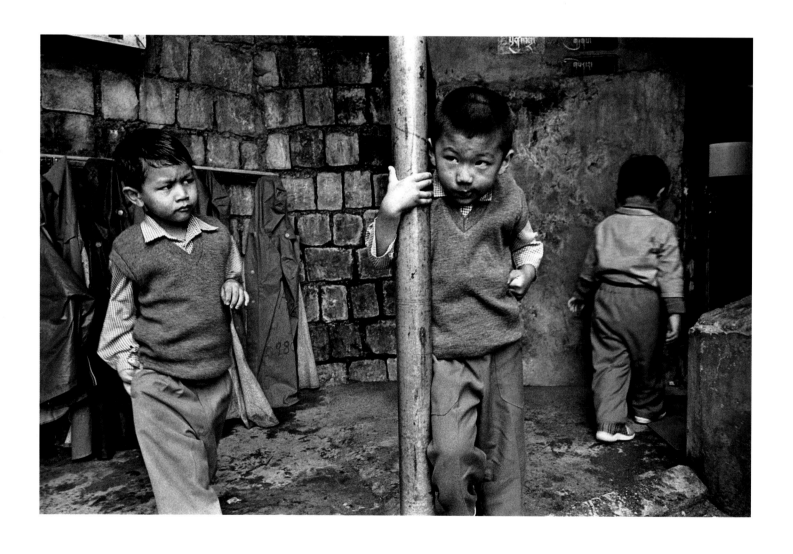

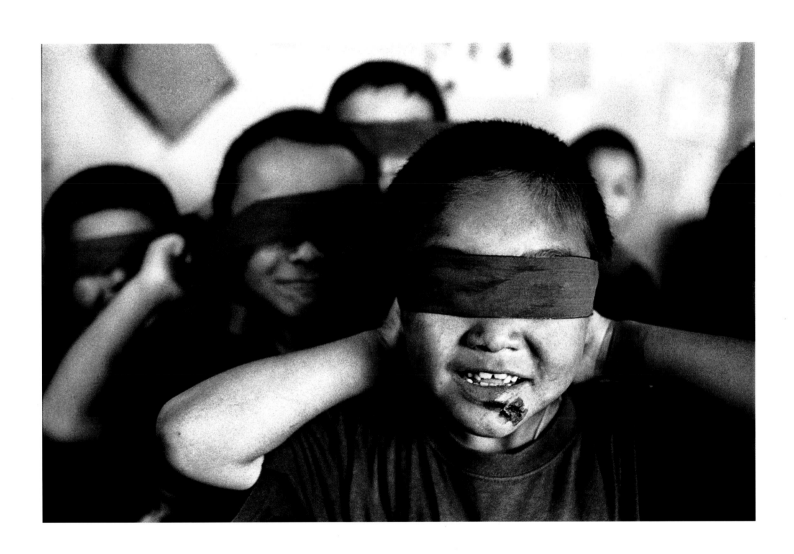

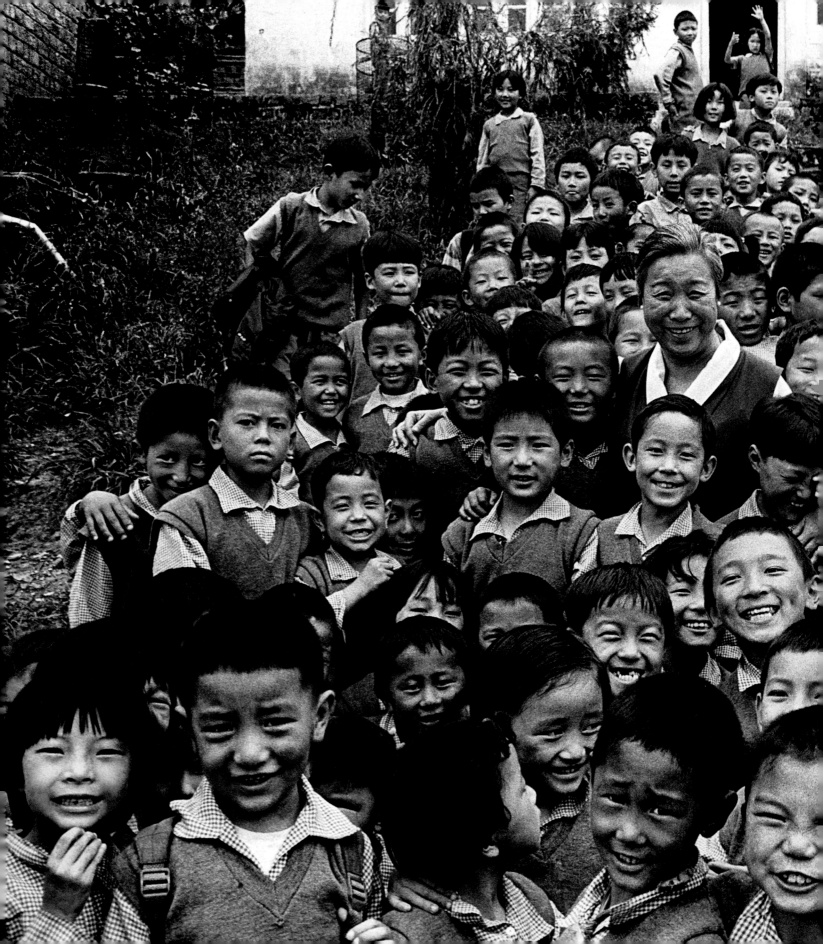

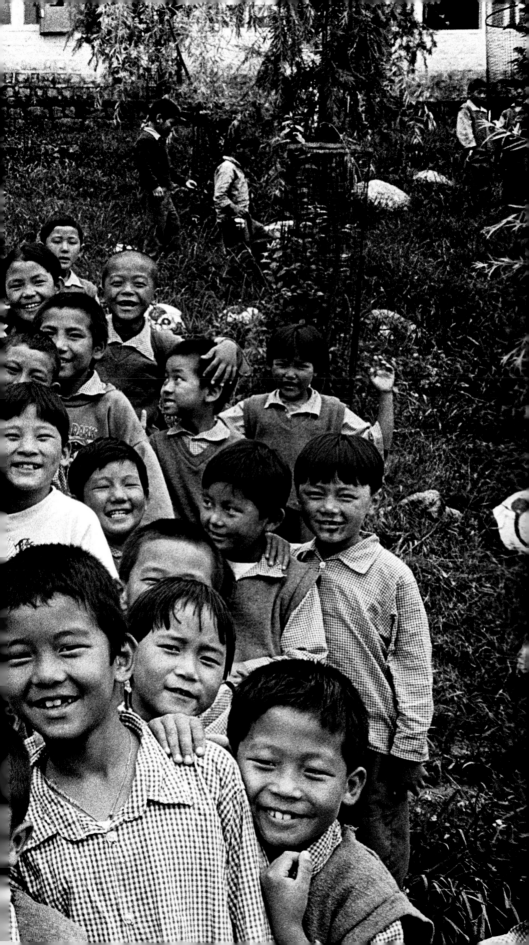

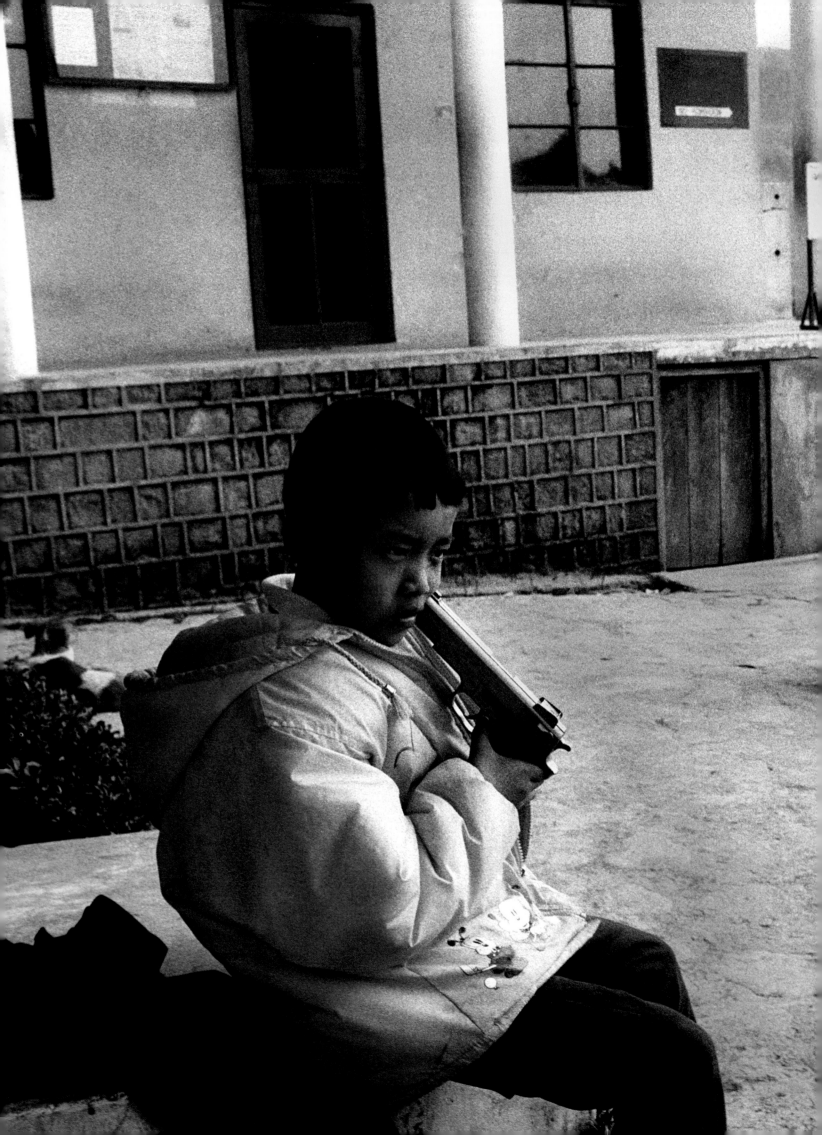

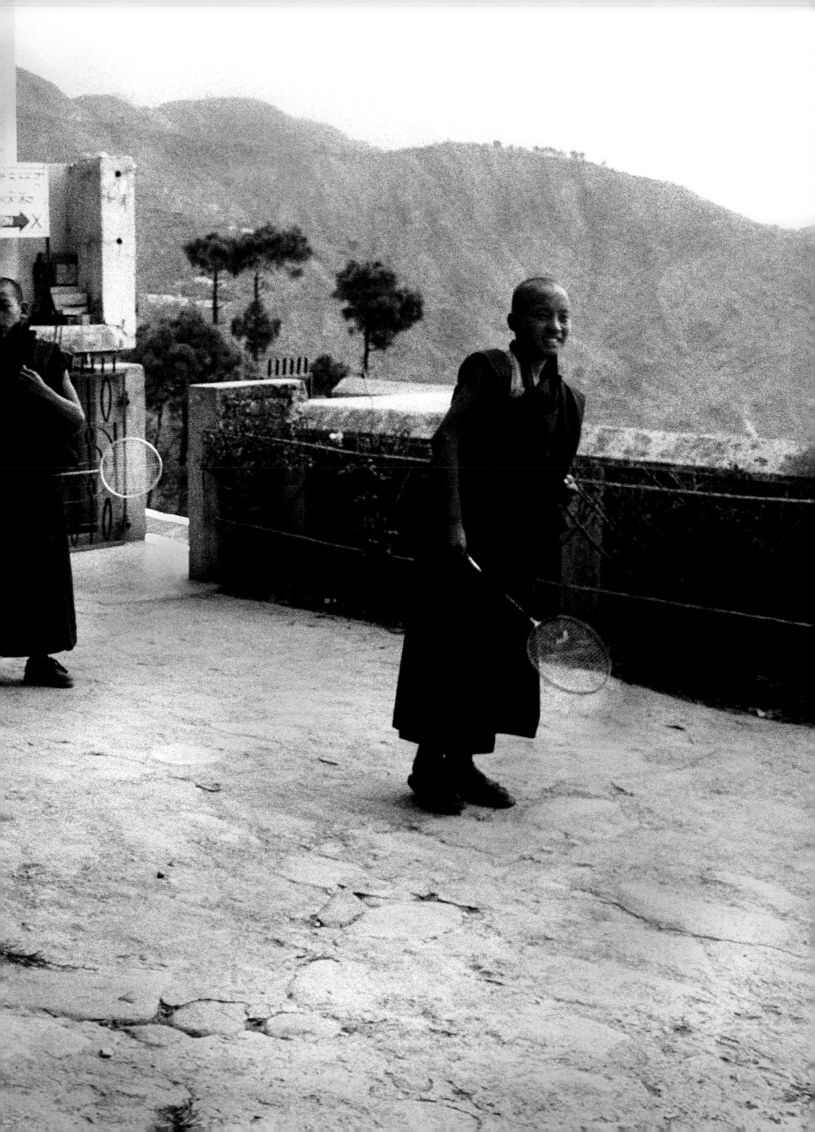

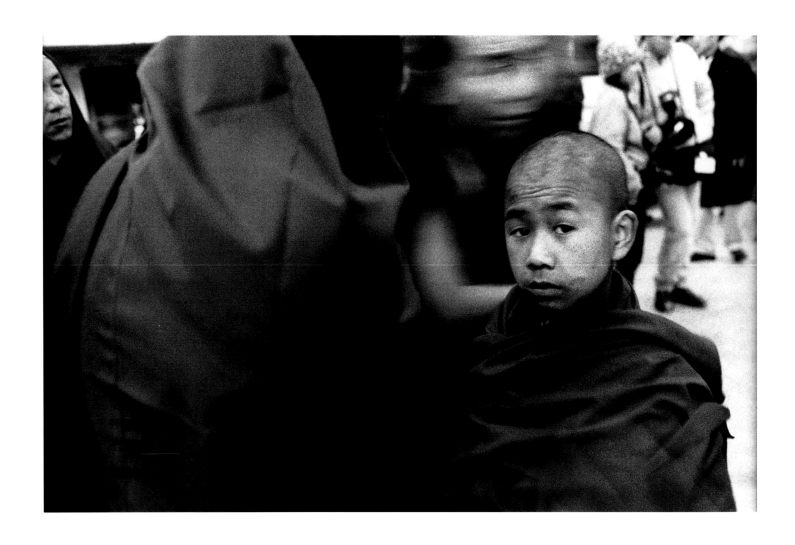

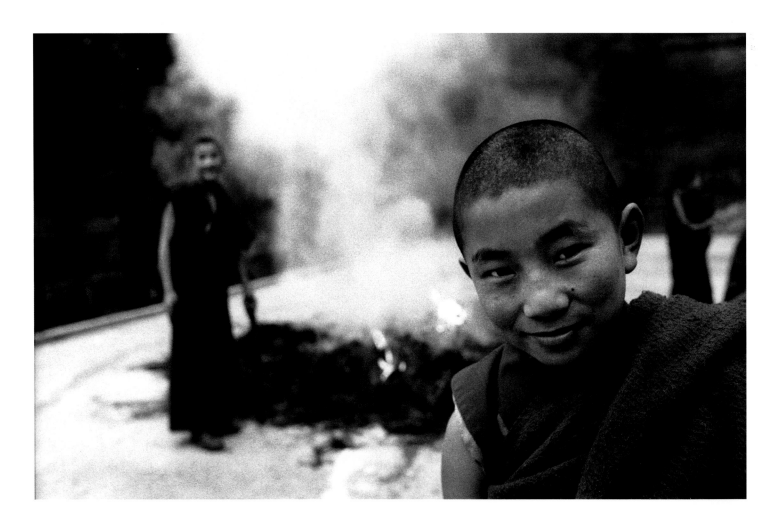

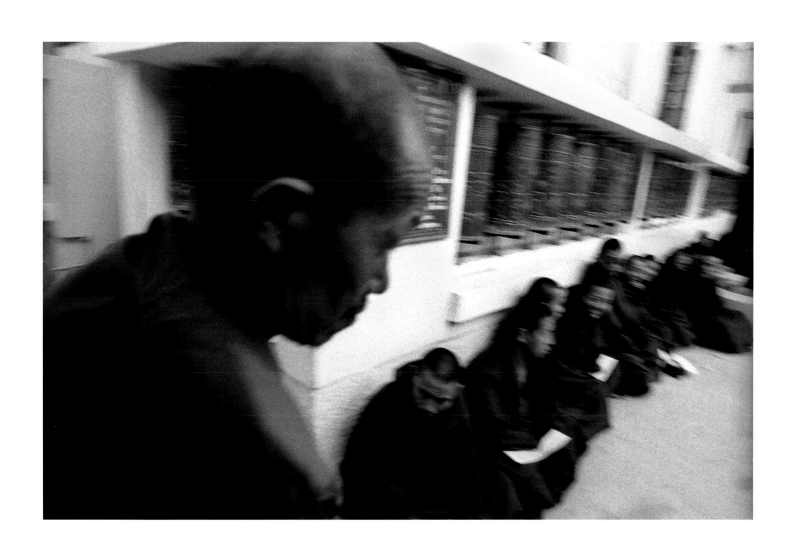

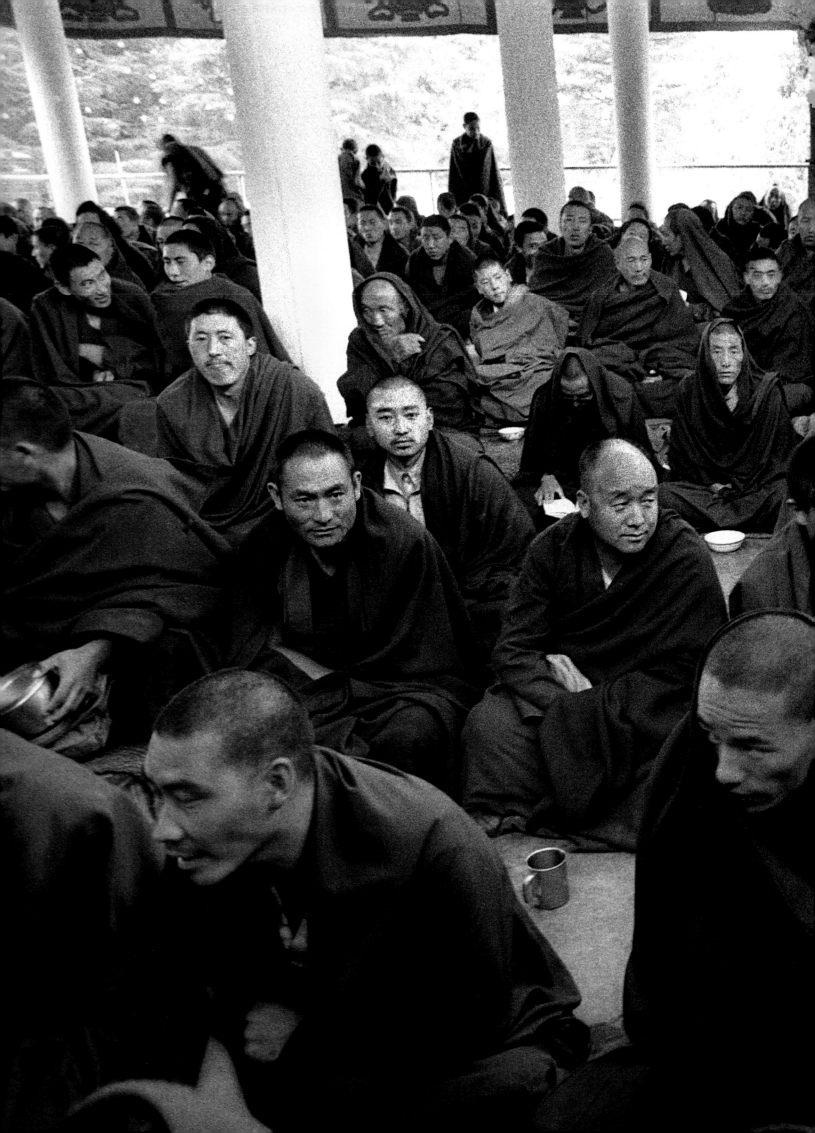

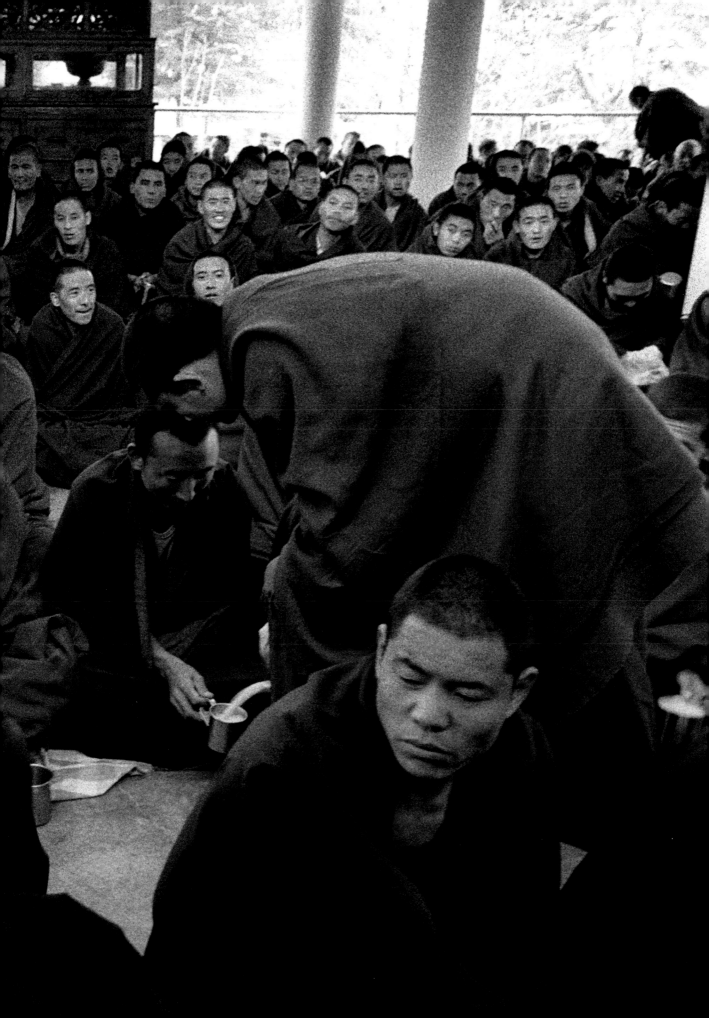

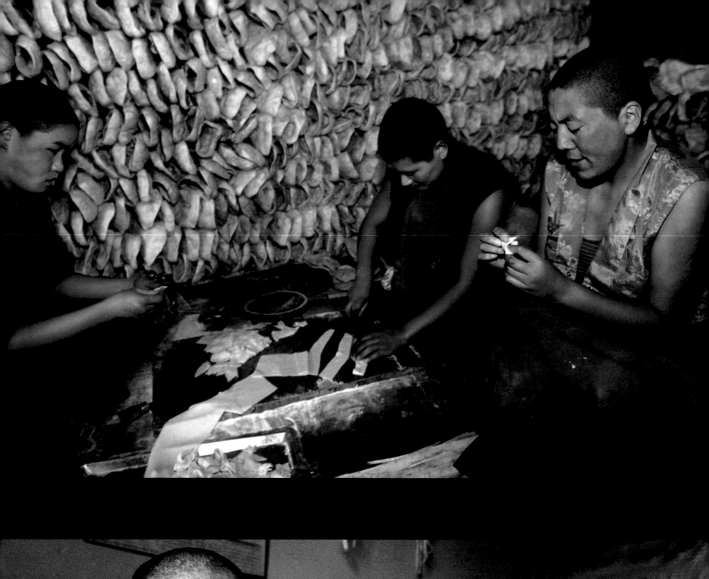
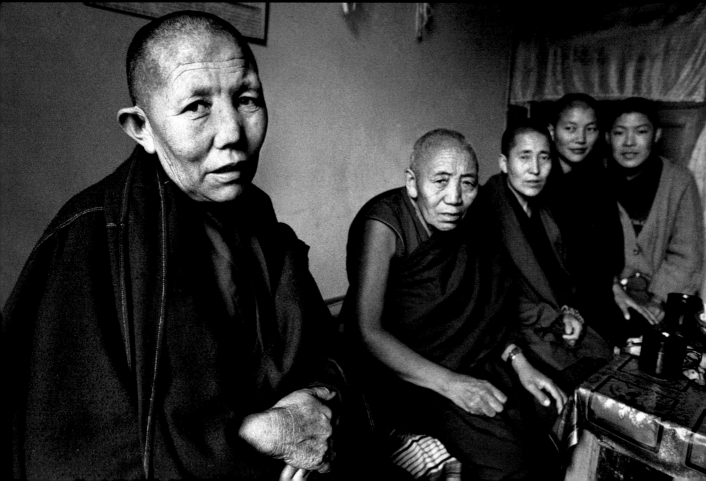

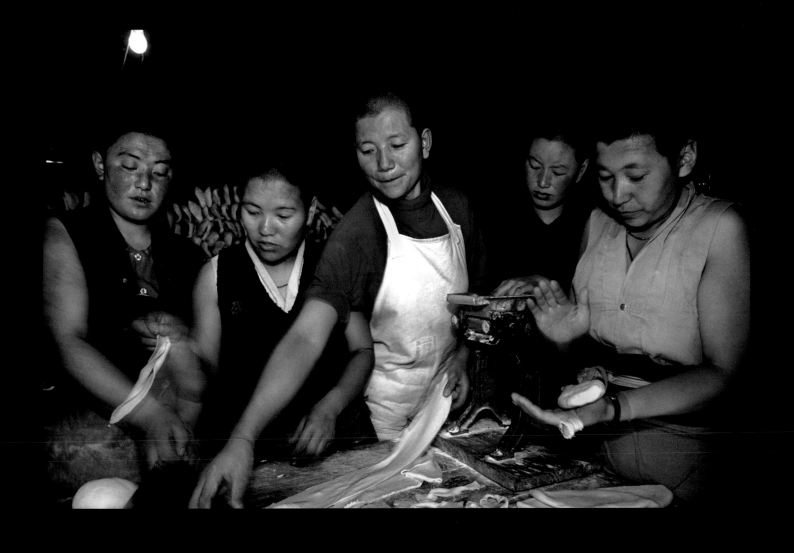

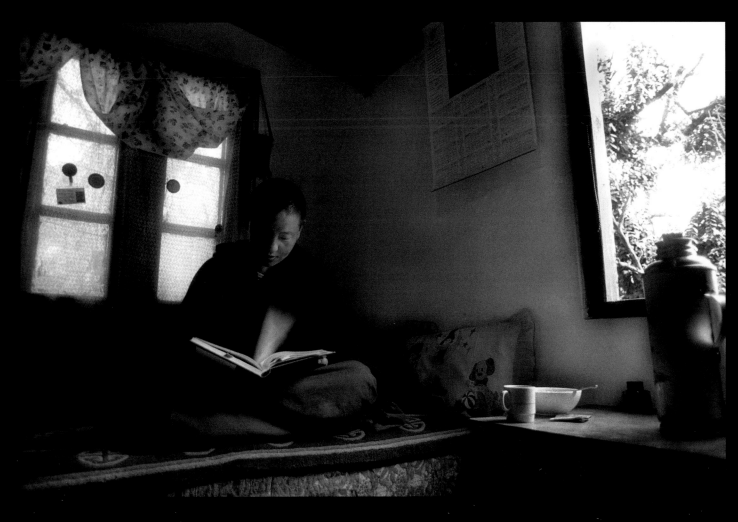

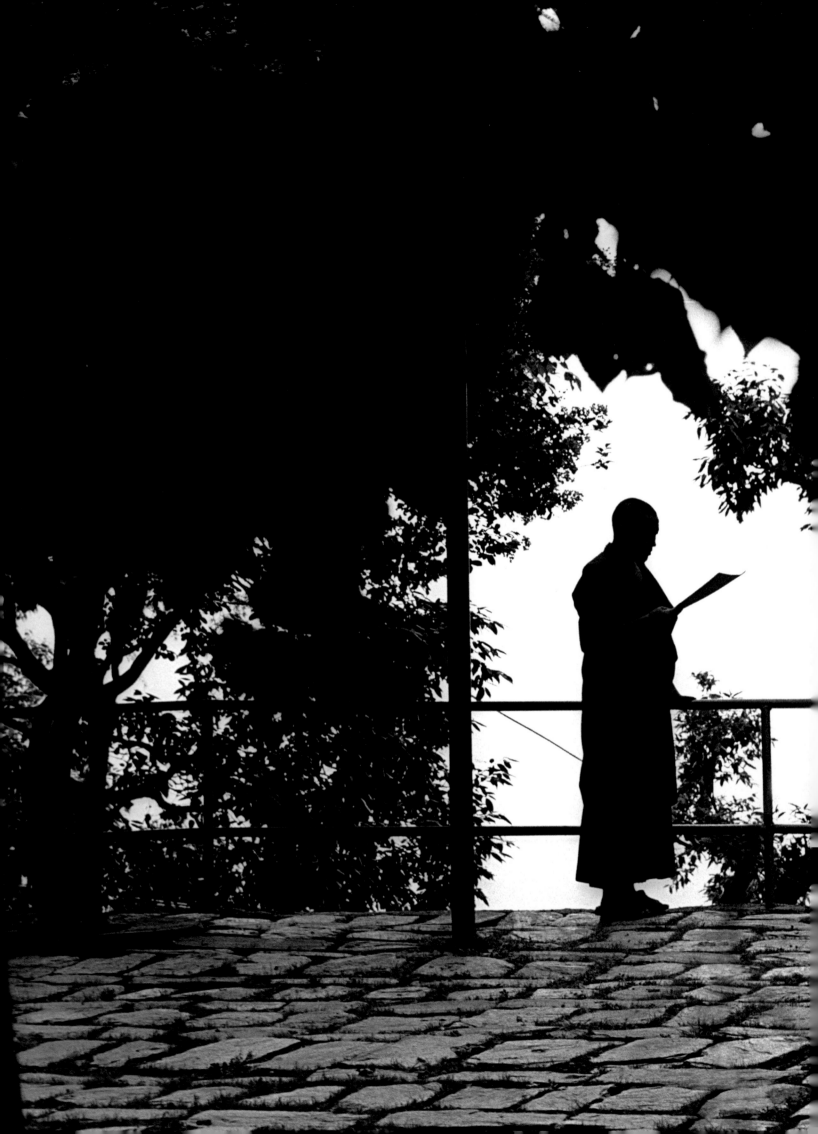

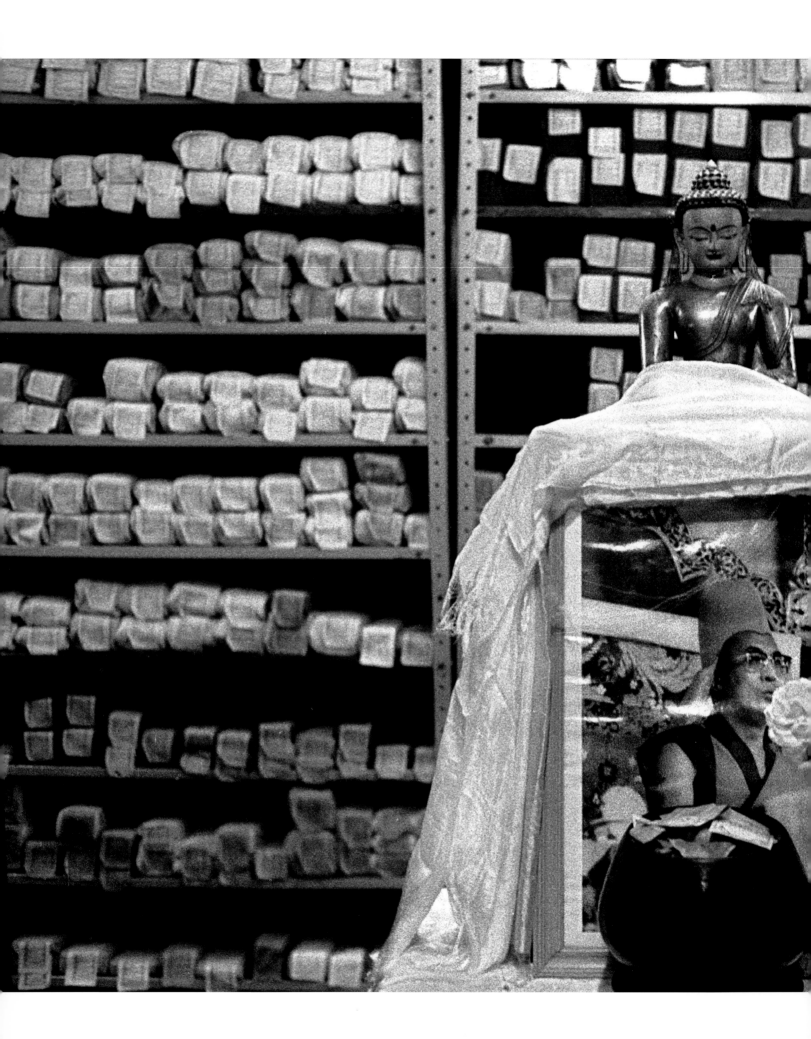

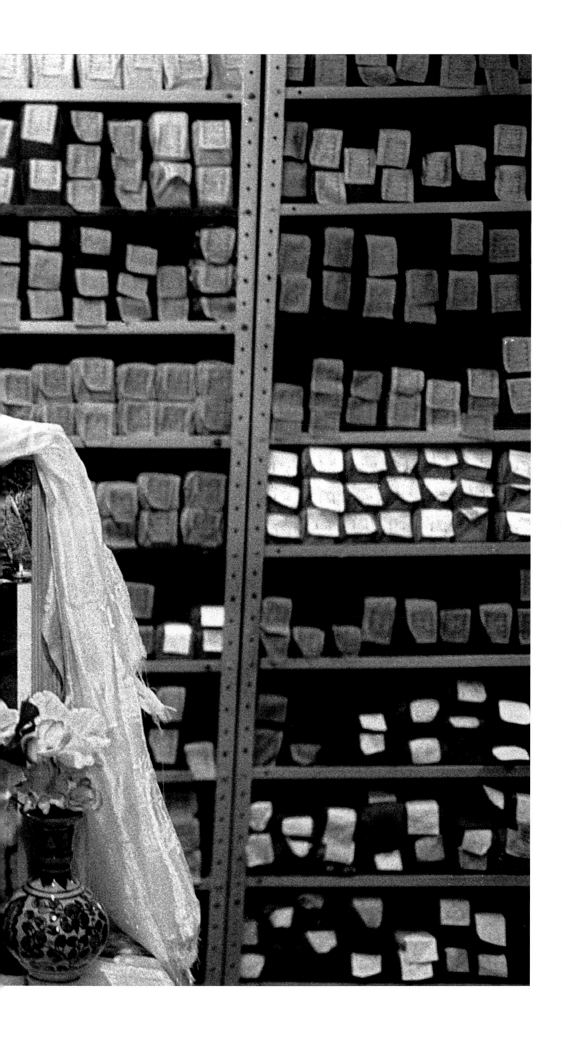

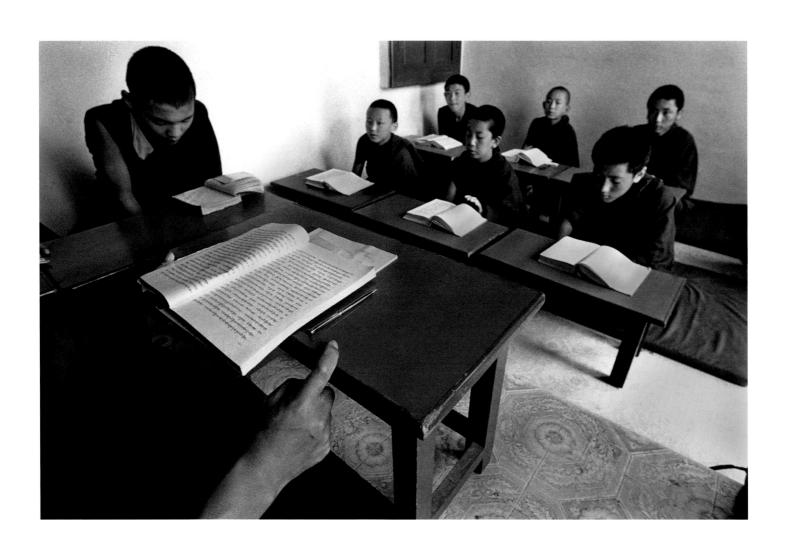

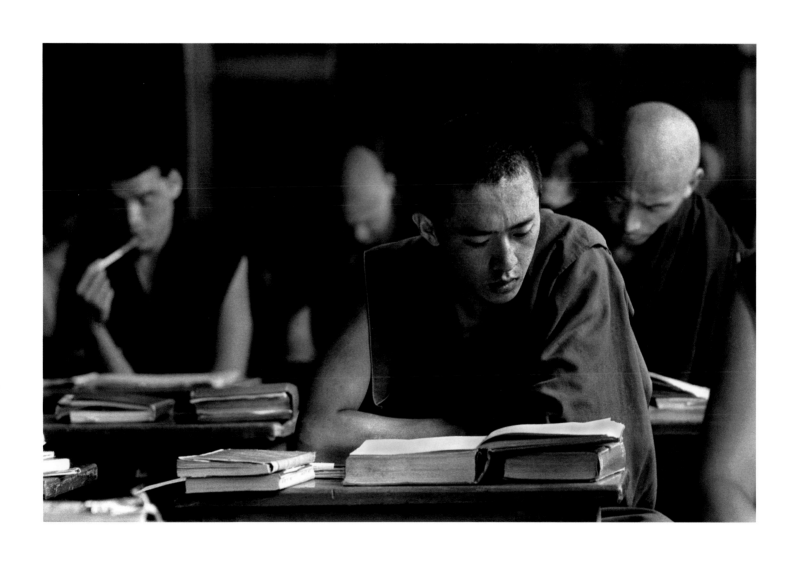

॥ ཉམས་ལེན་བདུན་ལྡན་སྐྱེ་དགུའི་འདུལ་ཁྲིམས་ཆོས་གནས་པ།
MONASTERY & NUNNERY ASSOCIATION
C/o Namgyal Monastery, McLeod Ganj-176219
Dharamsala (H.P.) Distt. Kangra India

Tel : 2492

॥ ཉམས་ལེན་བདུན་ལྡན་སྐྱེ་དགུའི་འདུལ་ཁྲིམས་ཆོས་གནས་པ།
MONASTERY & NUNNERY ASSOCIATION
C/o Namgyal Monastery, McLeod Ganj-176219
Dharamsala (H.P.) Distt. Kangra India

Ref. No. *Dated*

Ref. No. *Dated*

འདོད་པ་བརྒྱབ་ཁས་པ་བཞག་པ།

༄༅། །ཁམས་ཆེན་ཆོས་ཉིད་བཀྲ་ཤིས་པ་ཡང་ཆོས་ཉིད་བཀྲ་ཤིས་འཛིན་གྱིས་ཆོས་པ་ཁམས་ཆེན་ཁྱབ་པ་ཡང་ཆེན་ཆོས་ཉིད་བཀྲ་ཤིས་པ་ཡང་ཆོས་ཉིད་བཀྲ་ཤིས་པ།

[The remainder of the page consists of continuous Tibetan (Uchen script) body text which is too faint and low-resolution to transcribe reliably.]

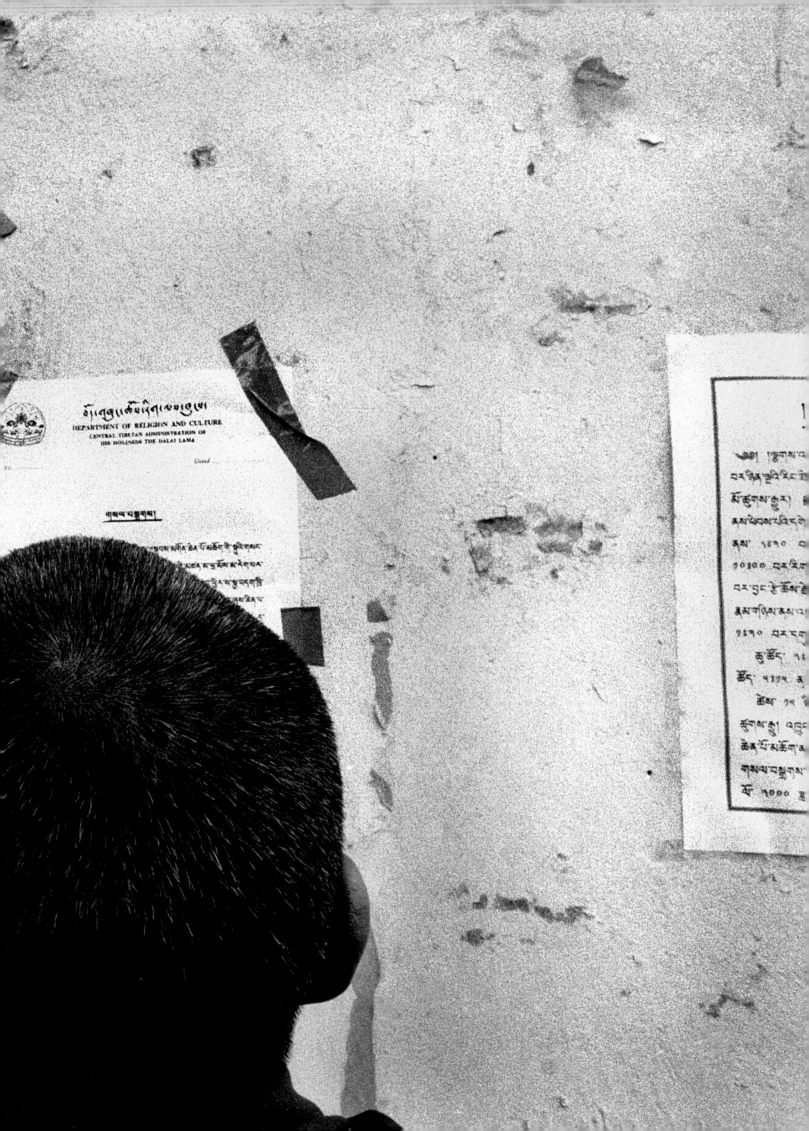

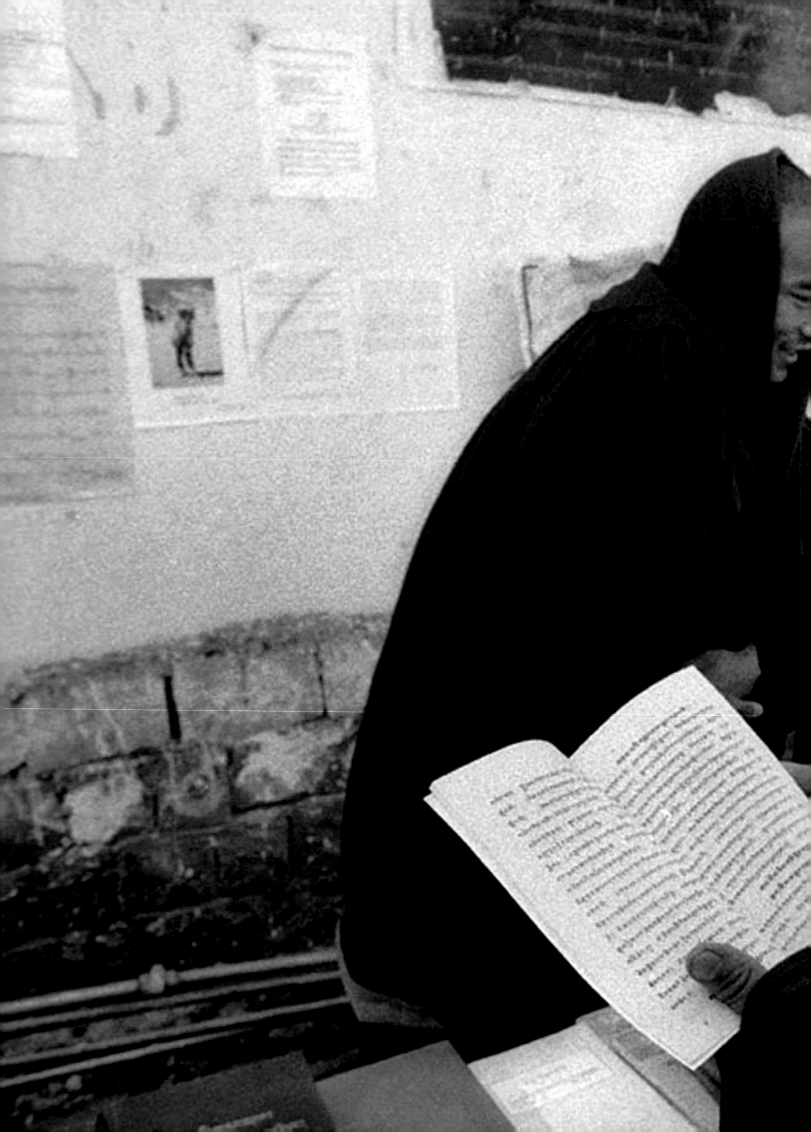

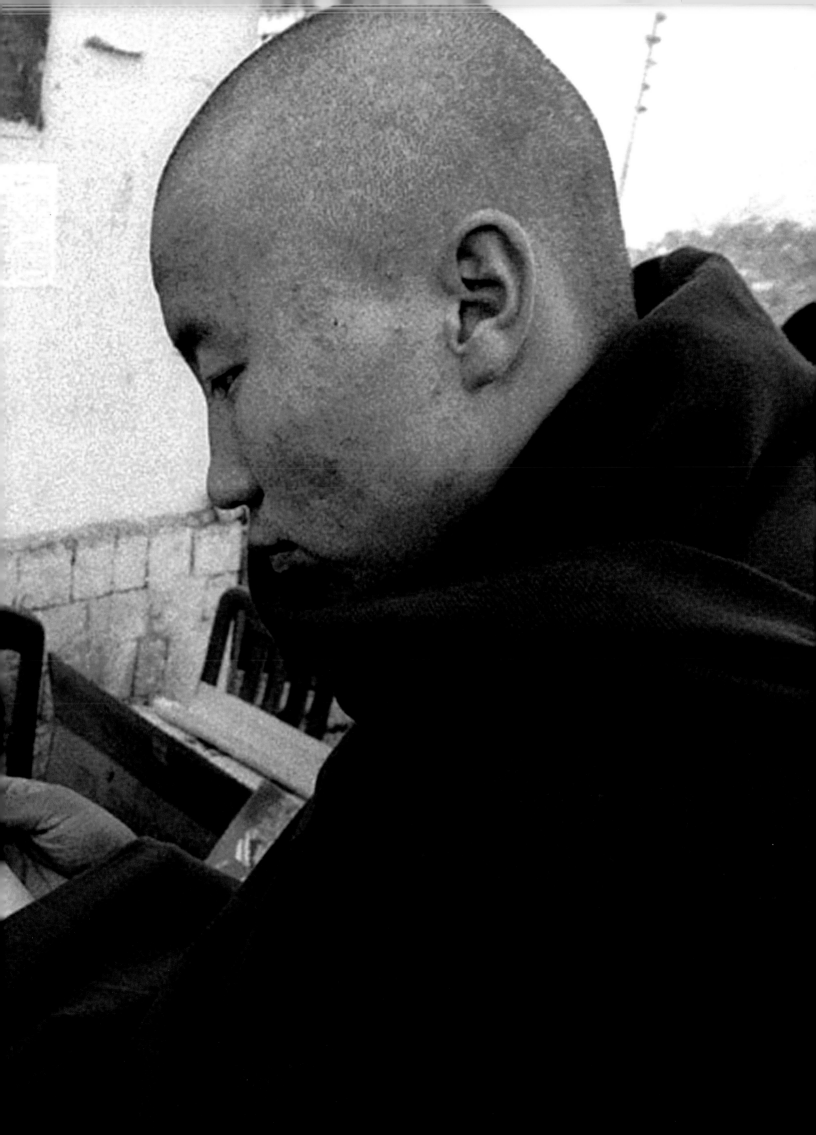

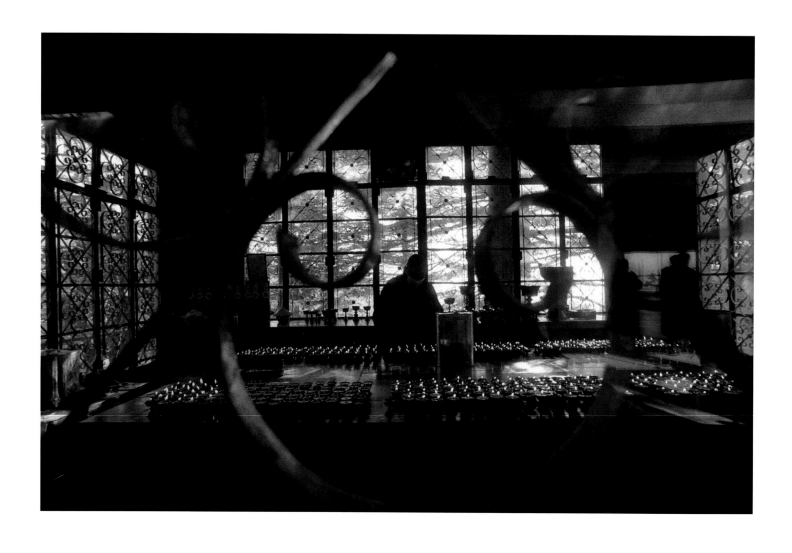

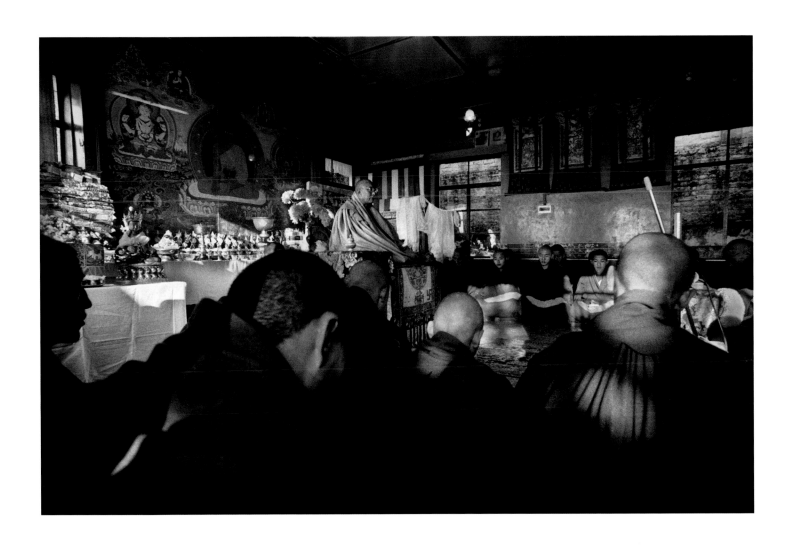

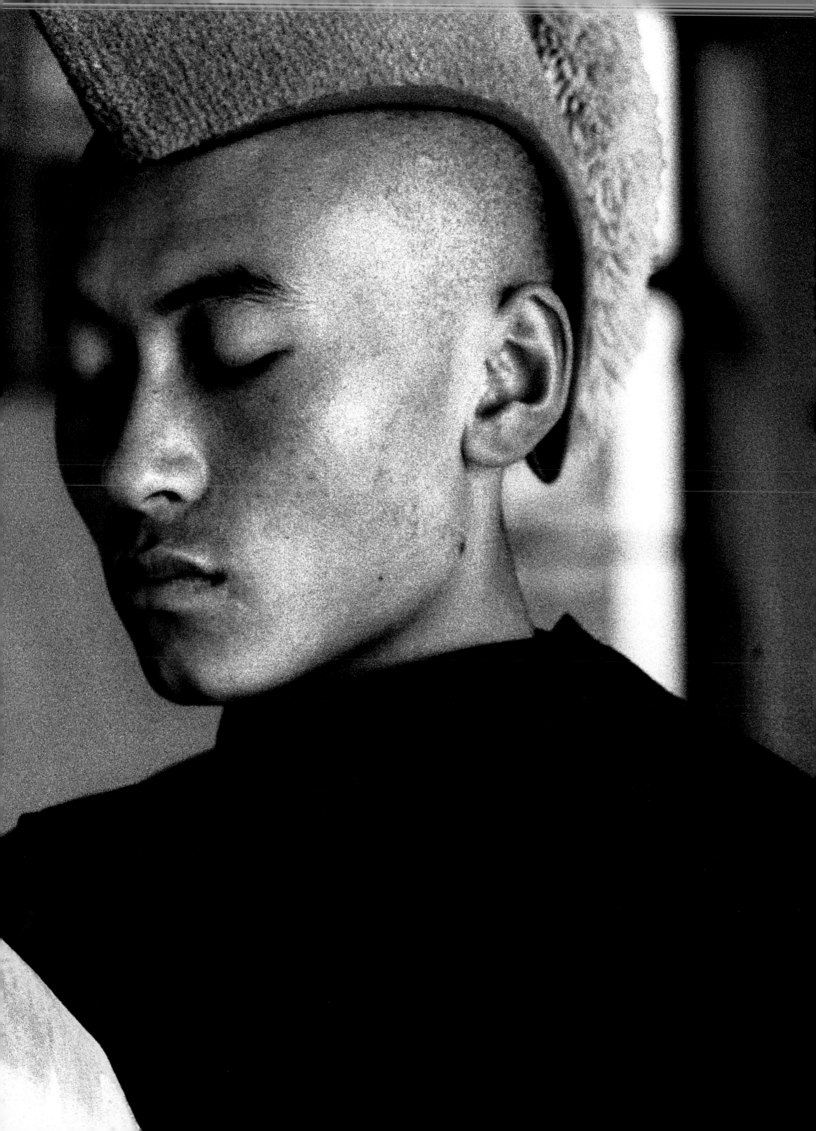

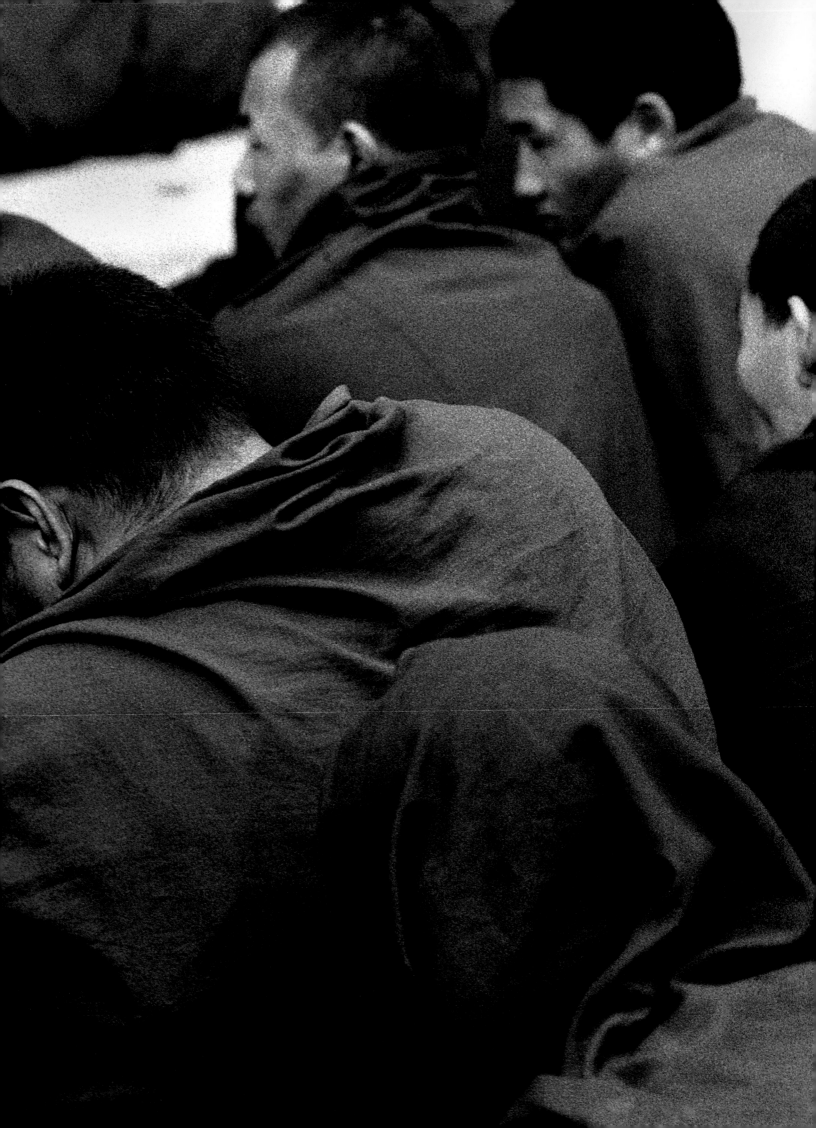

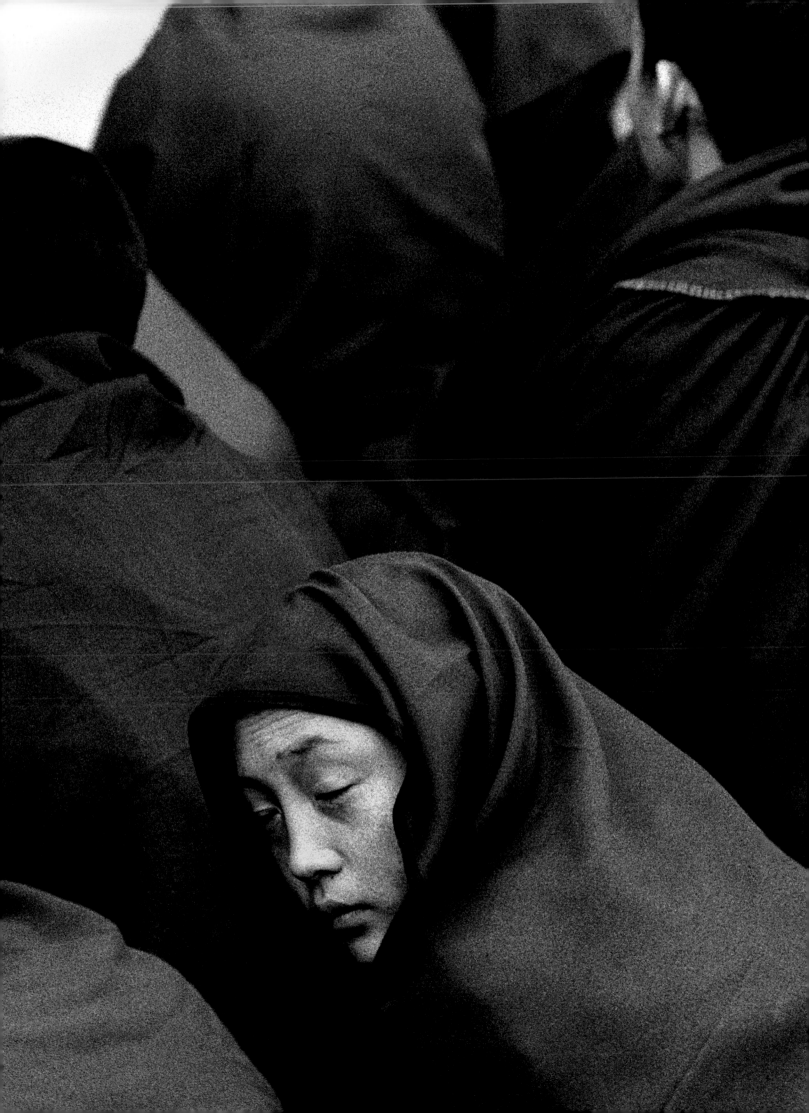

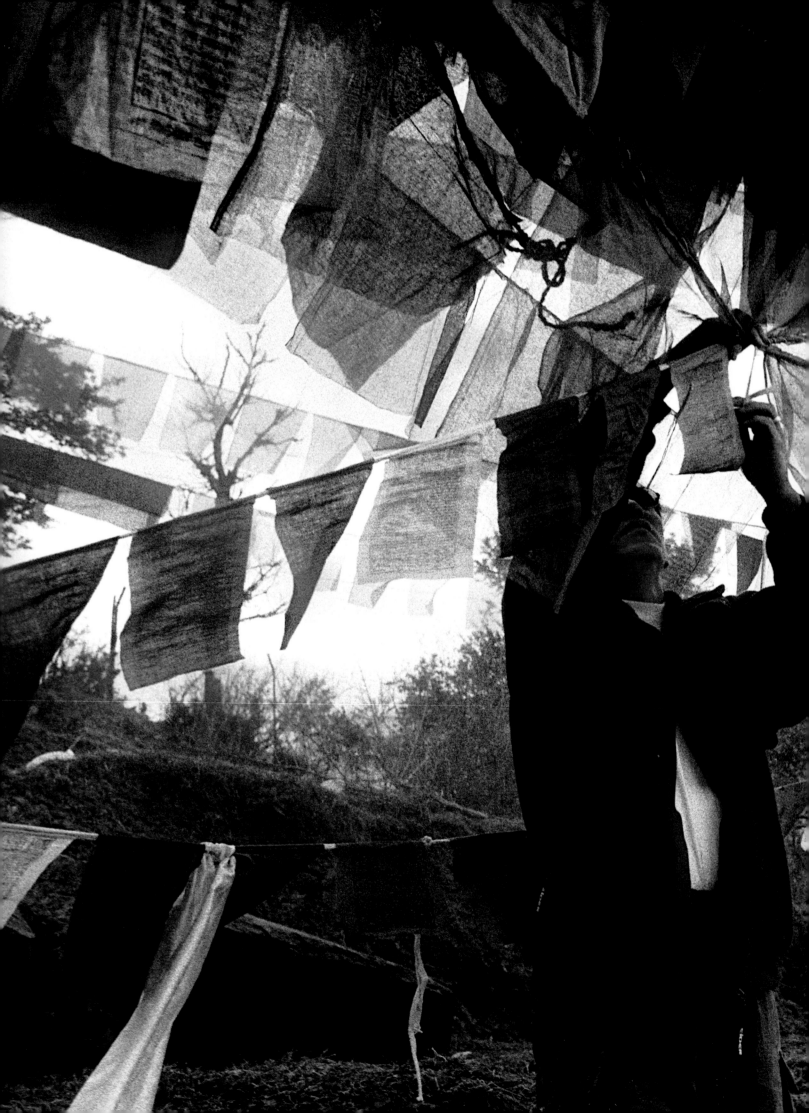

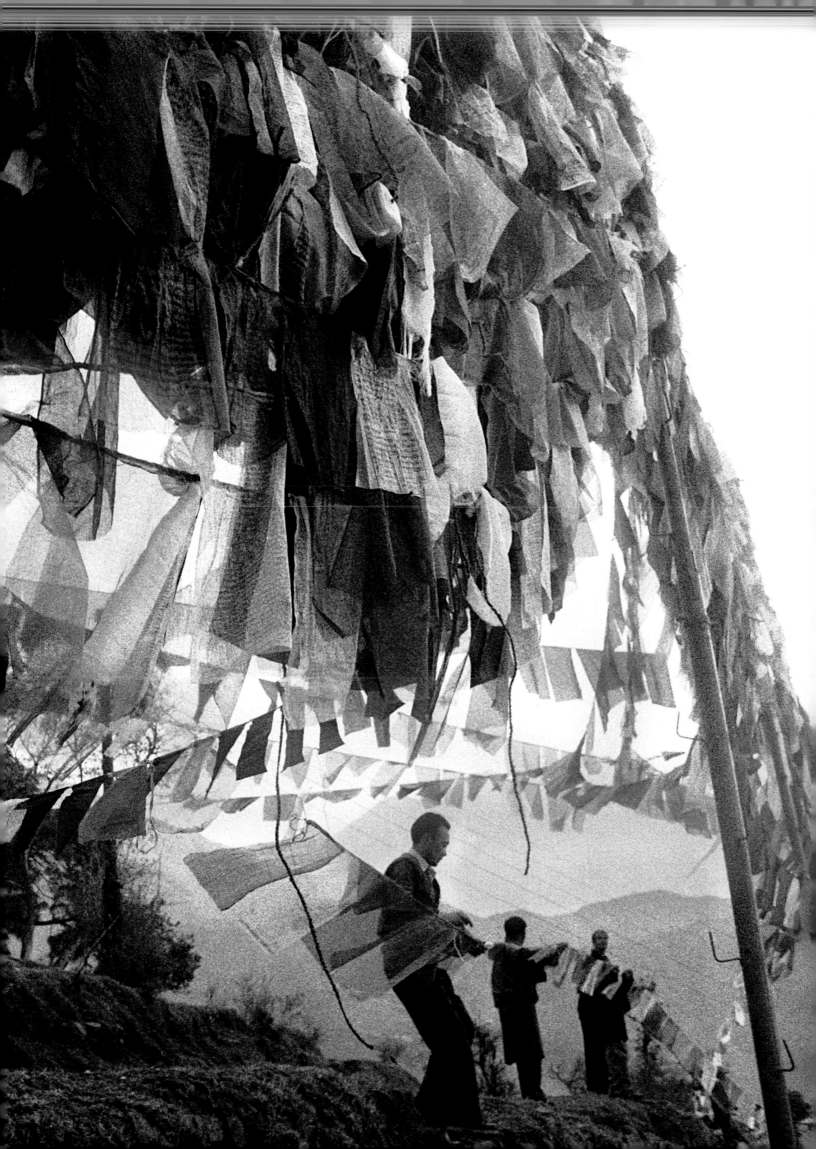

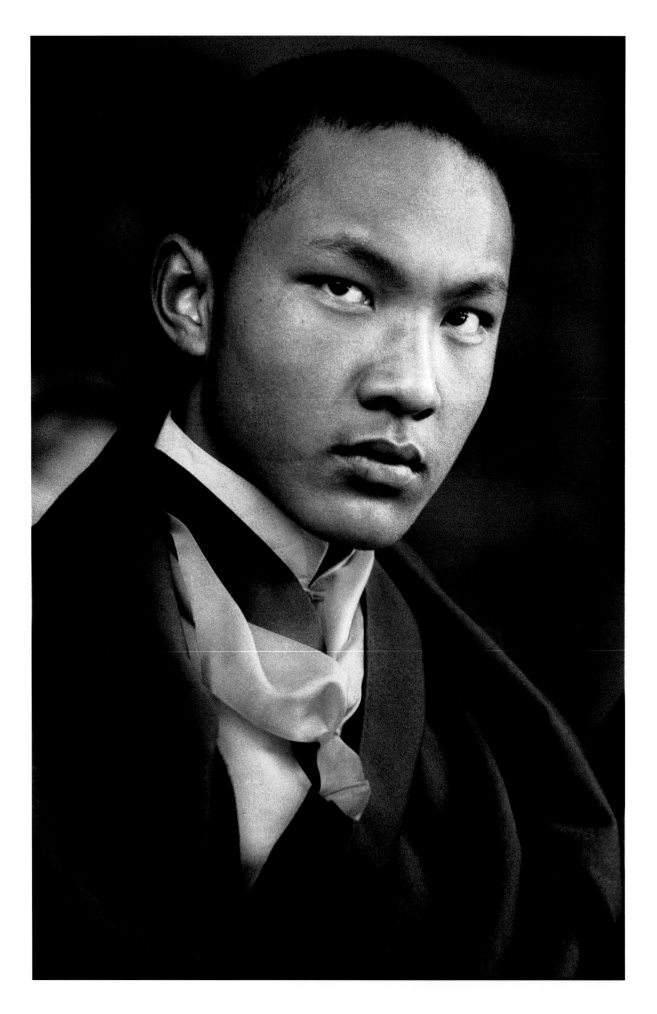

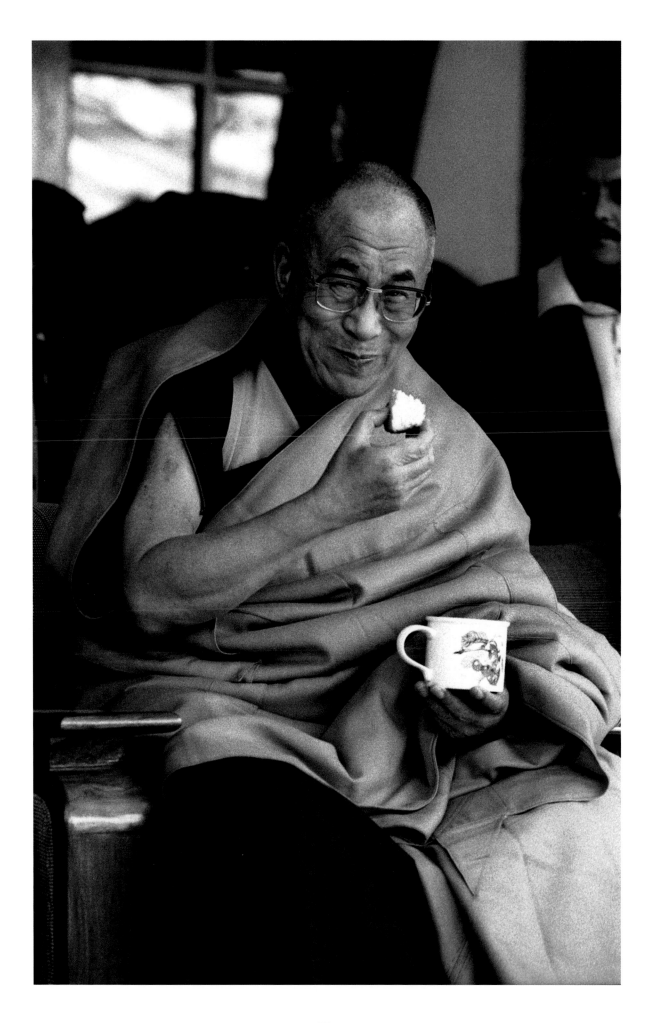

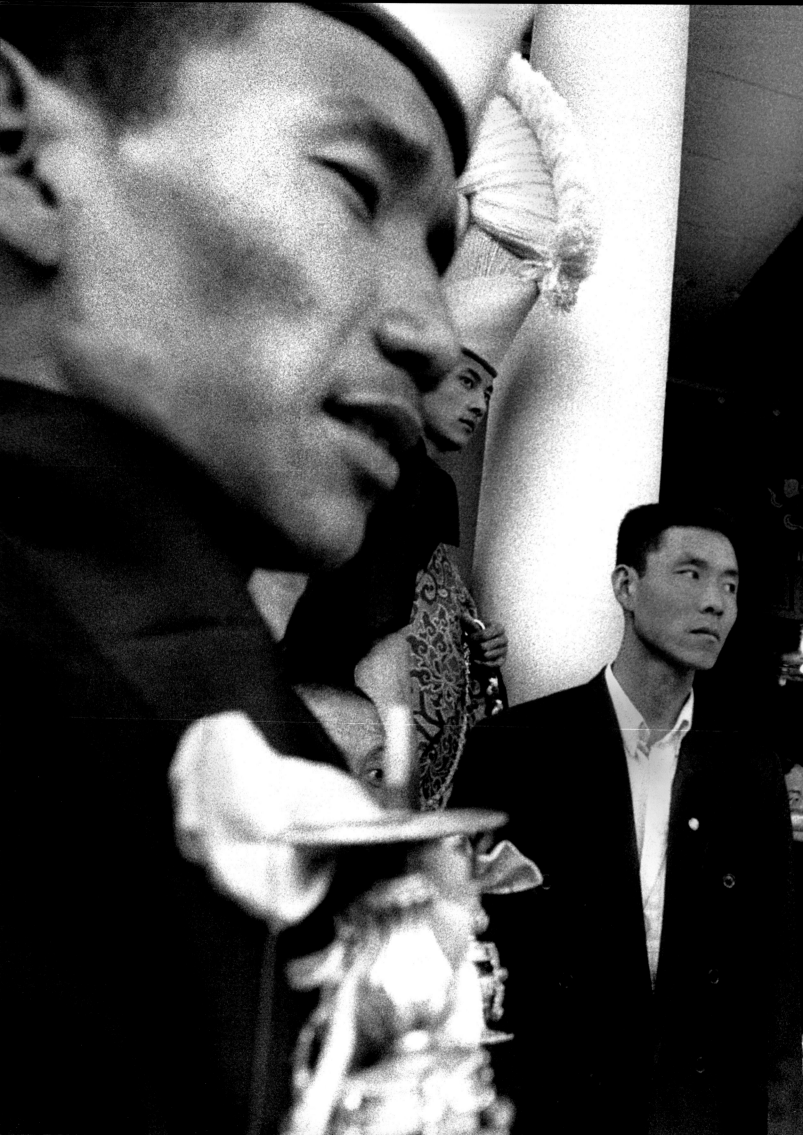

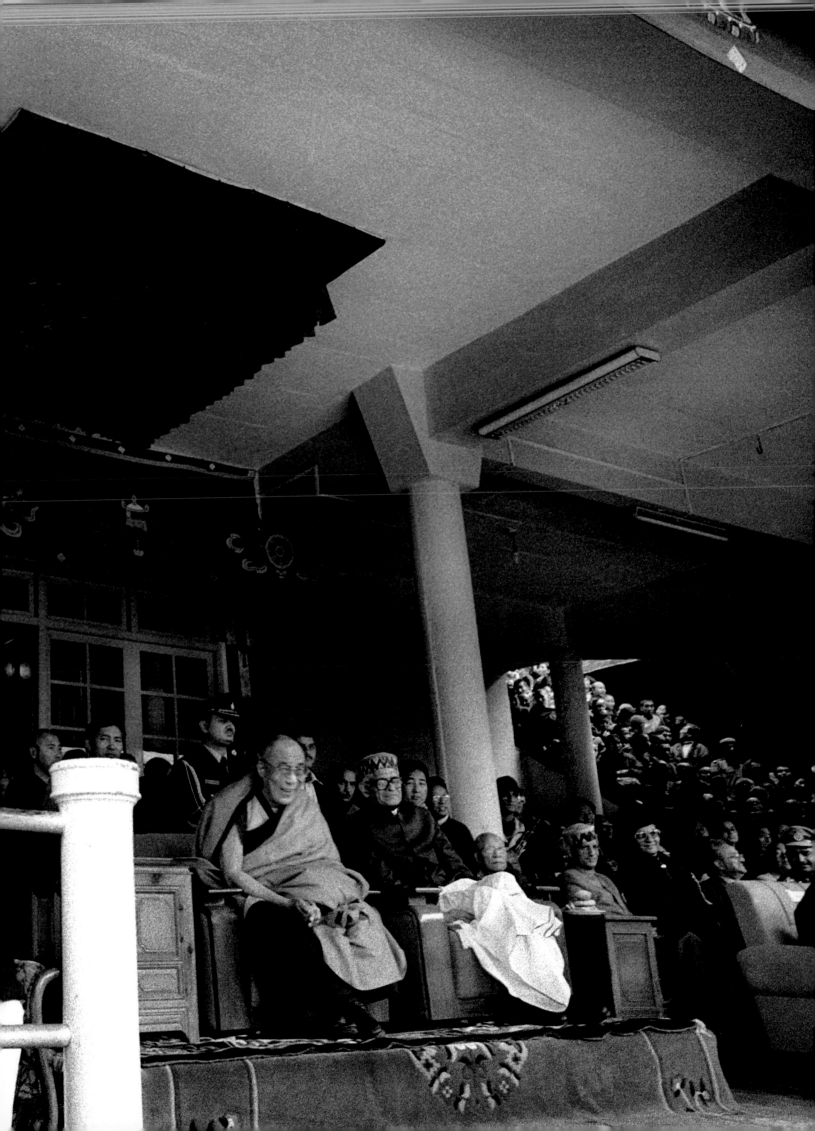

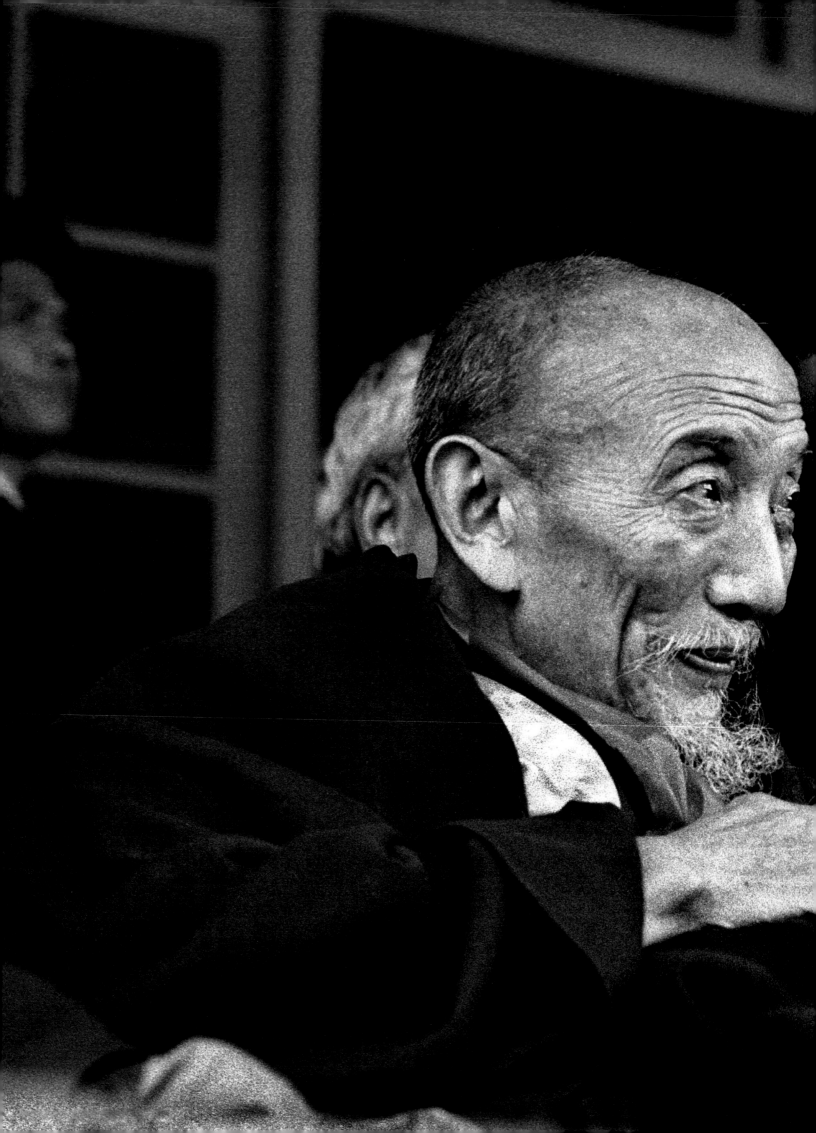

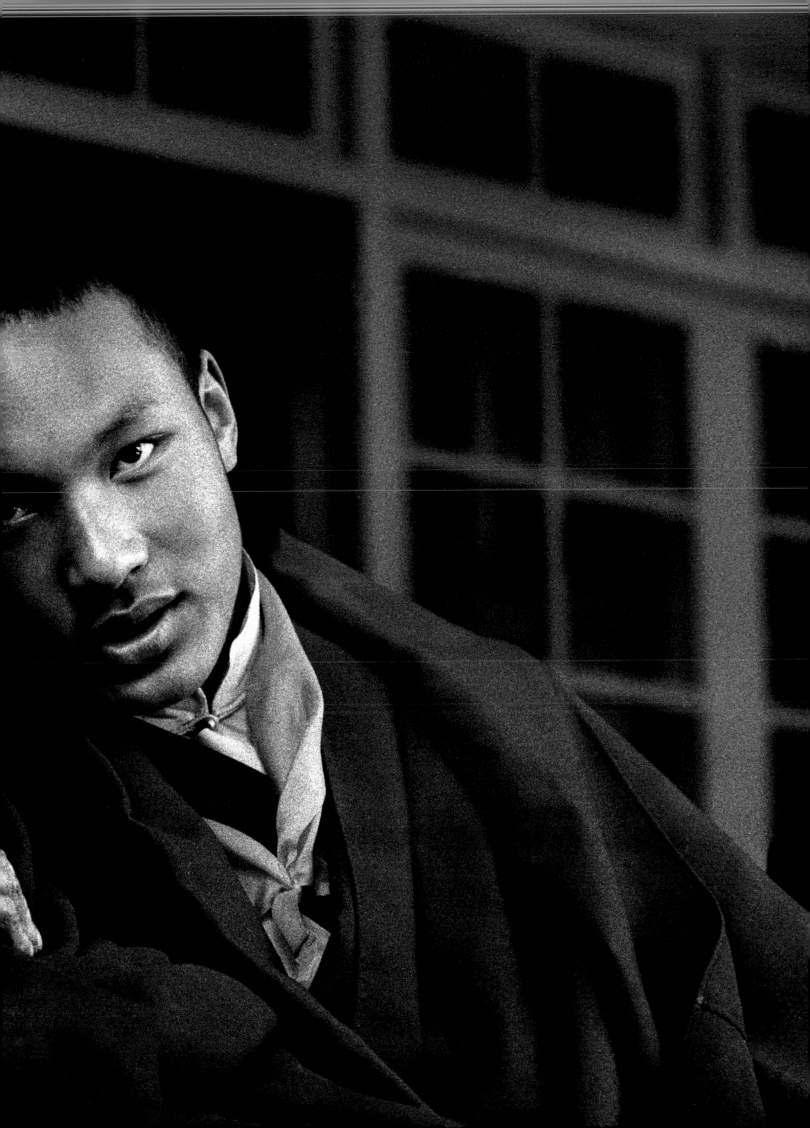

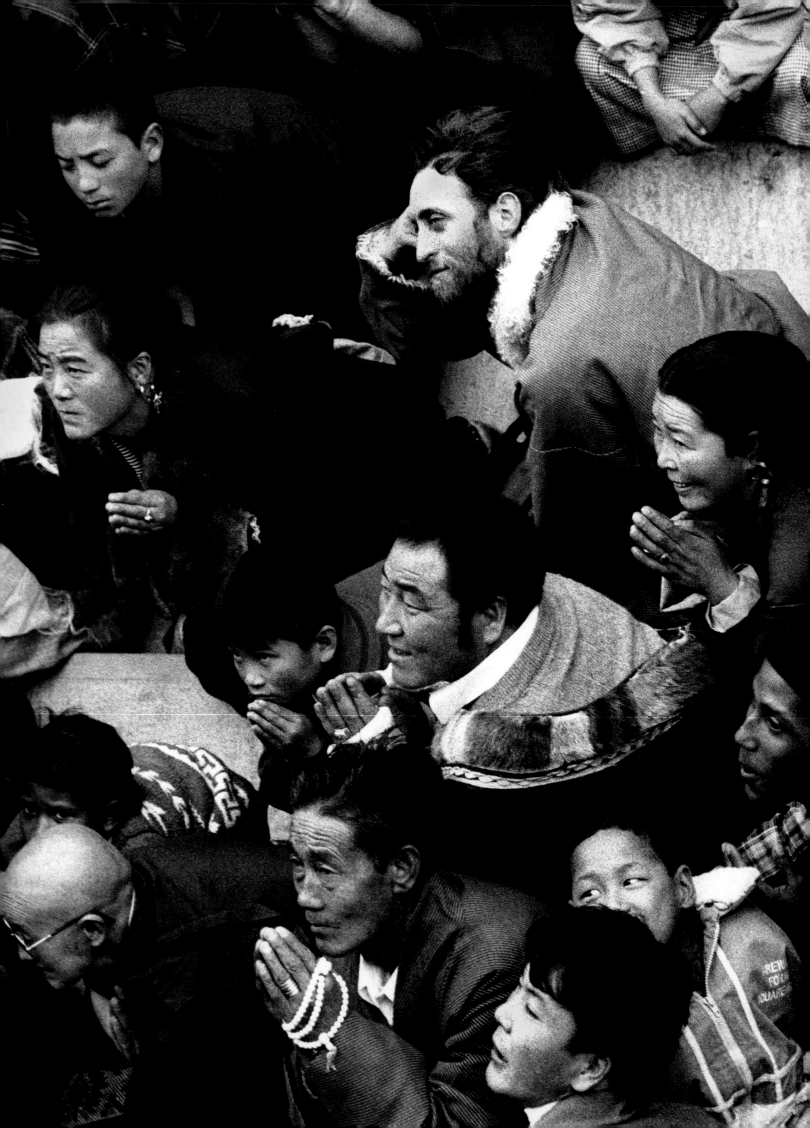

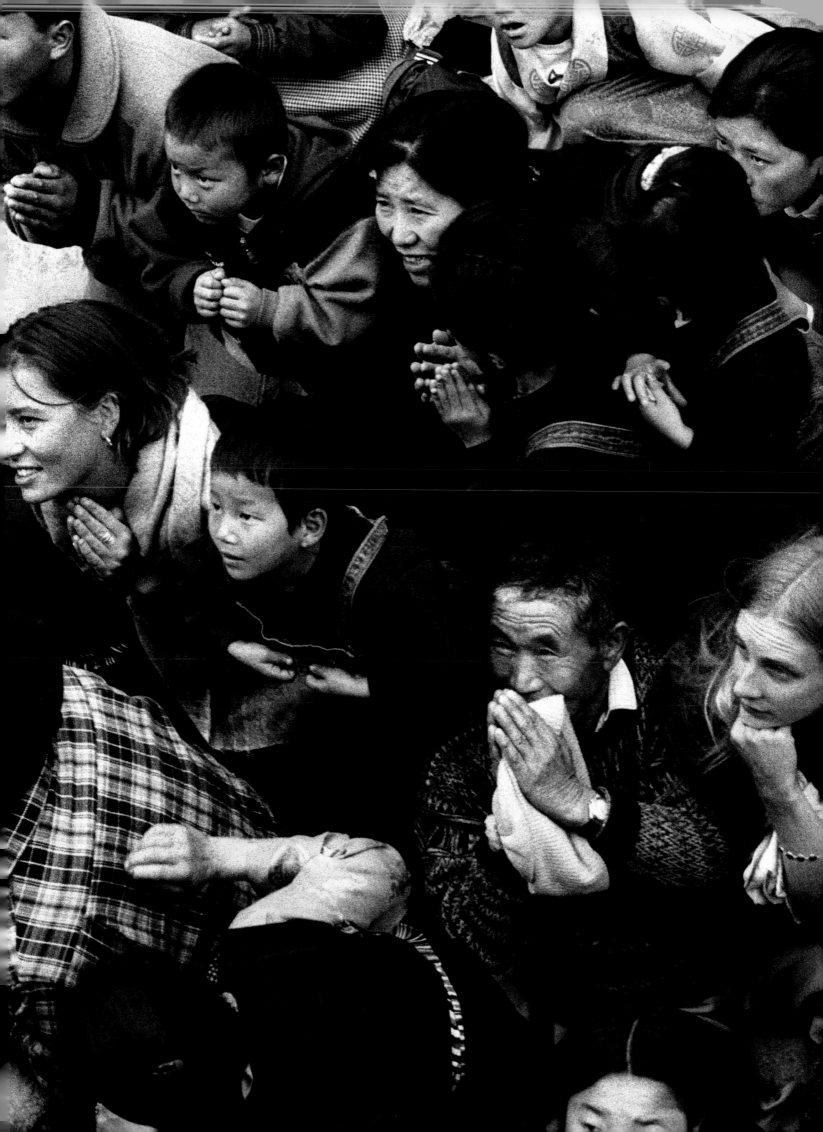

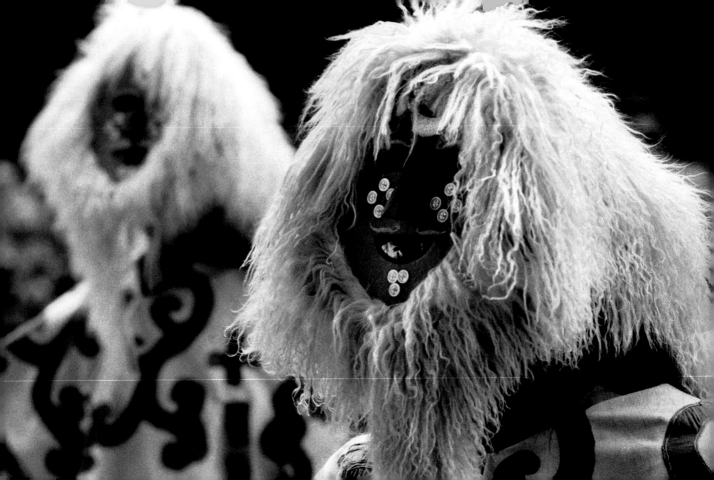

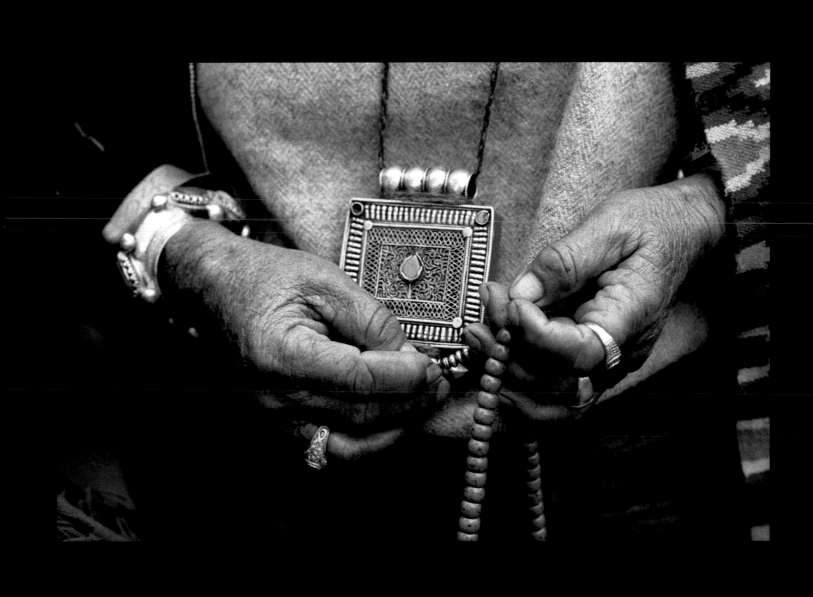

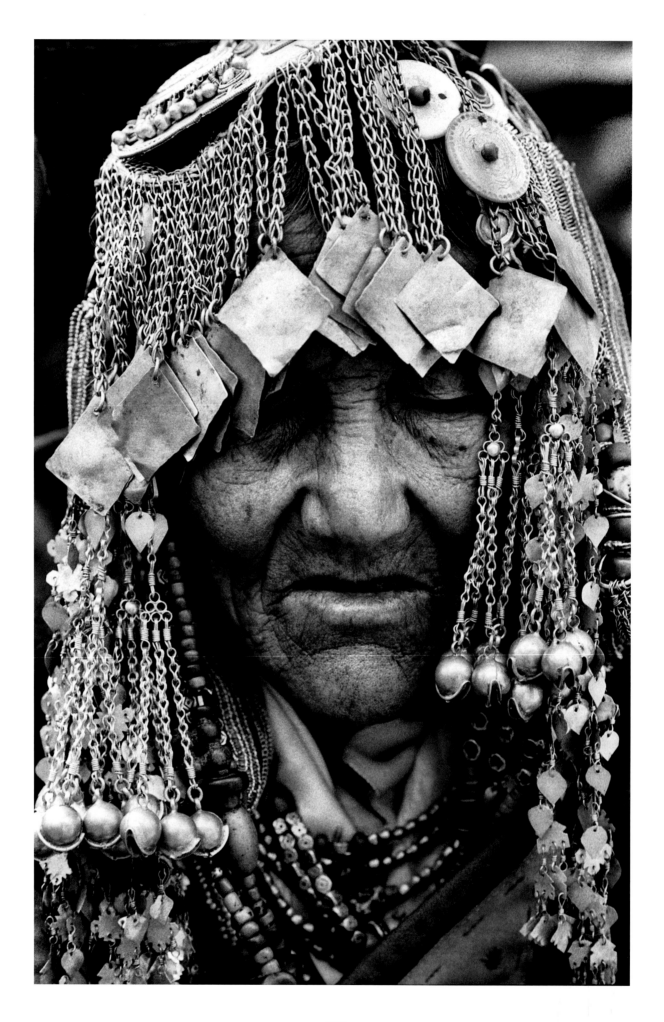

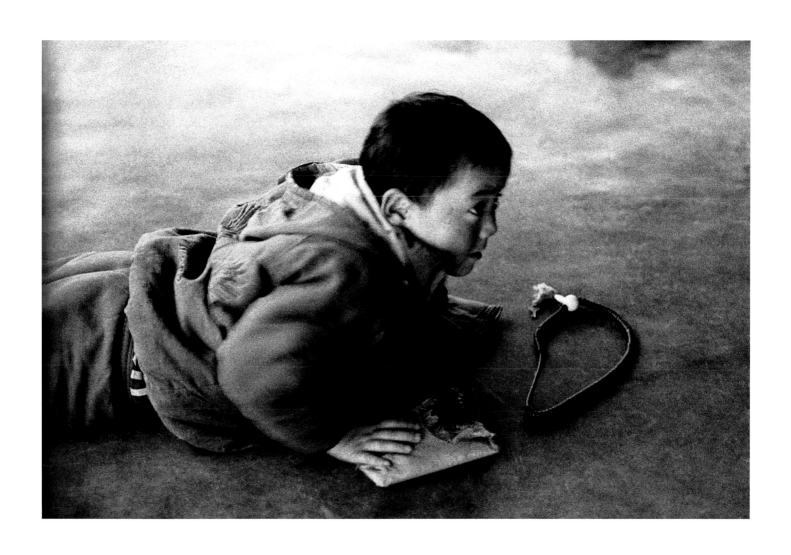

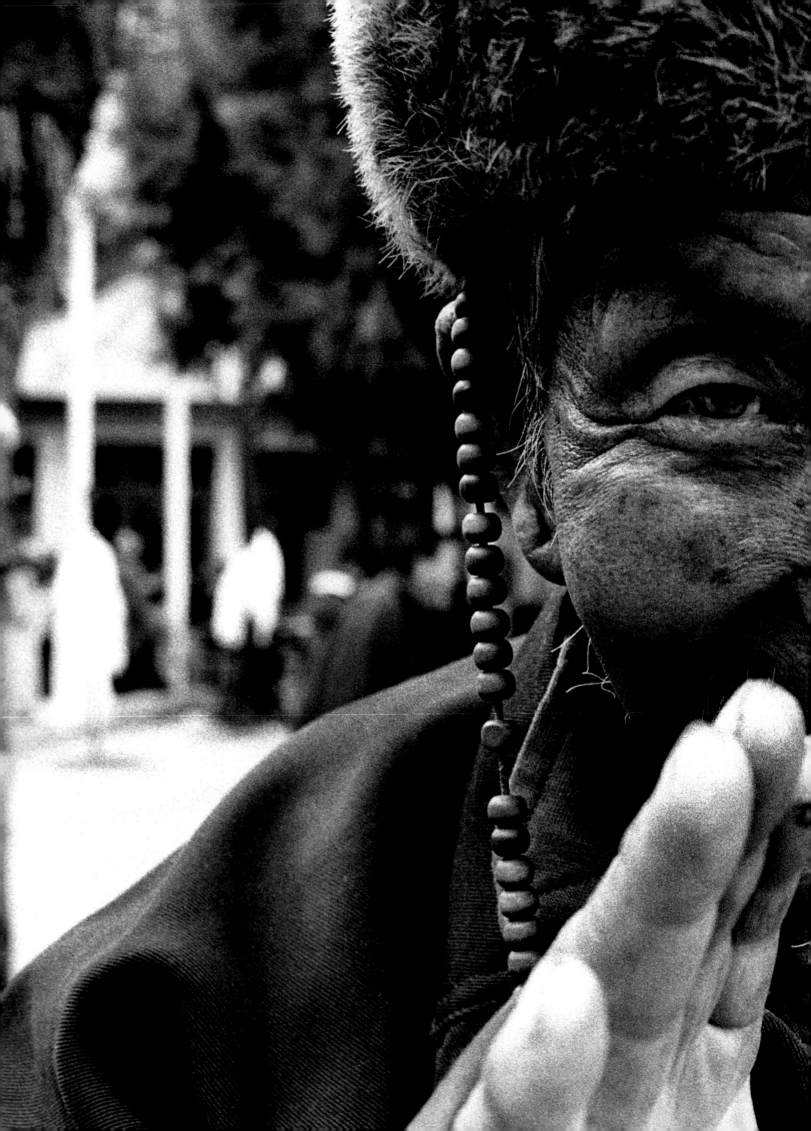

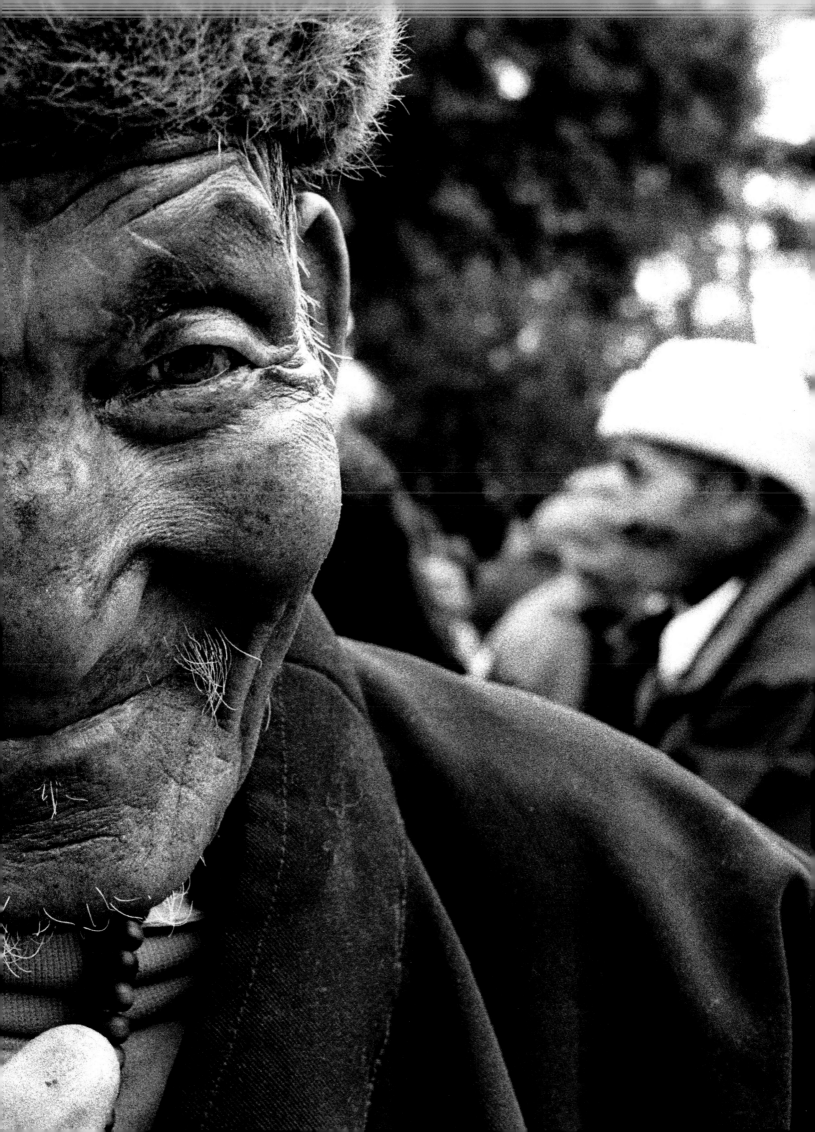

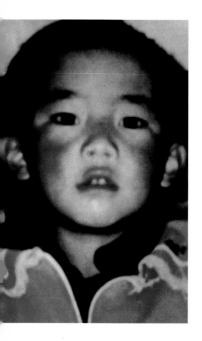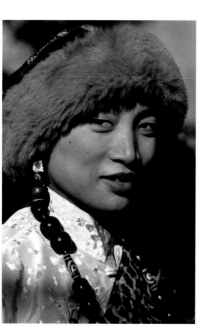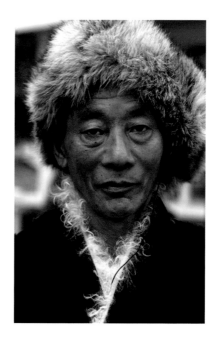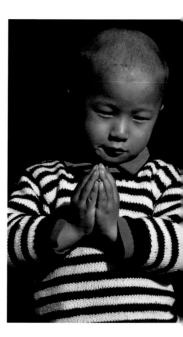

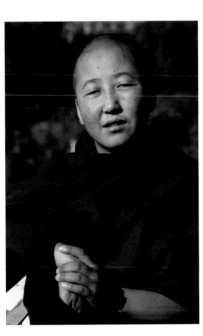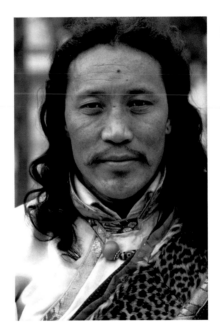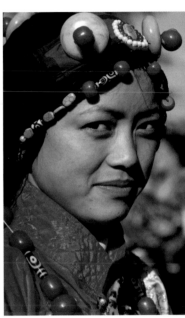

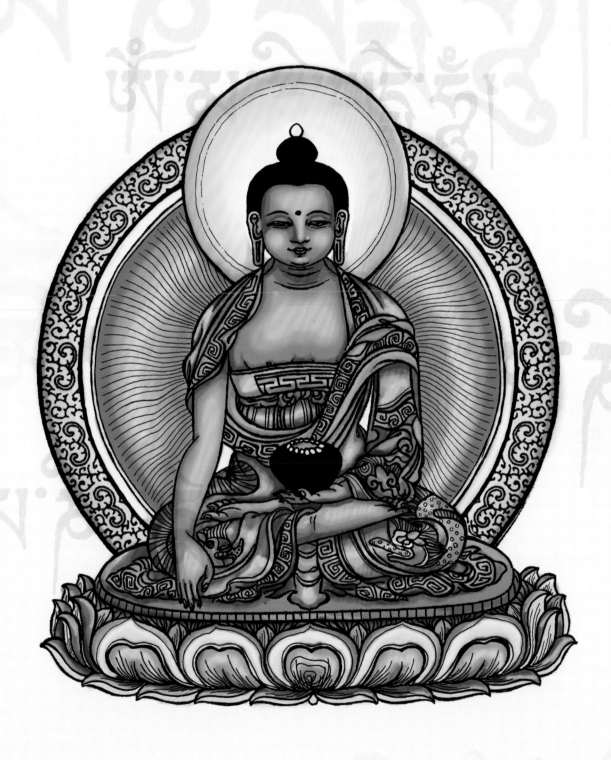

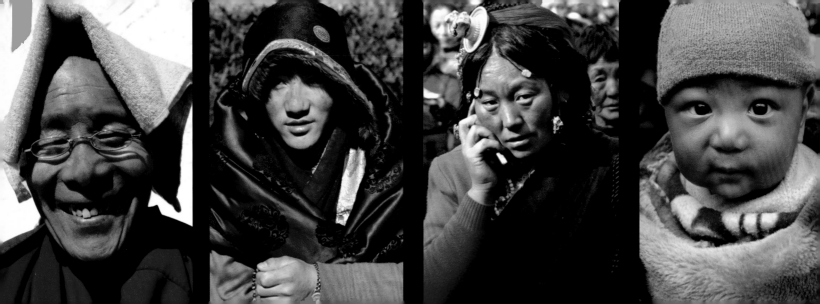

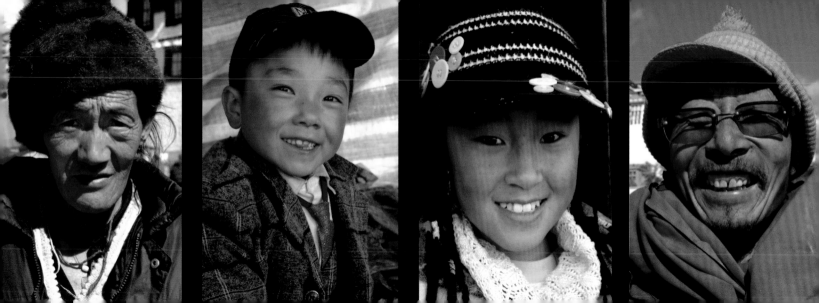

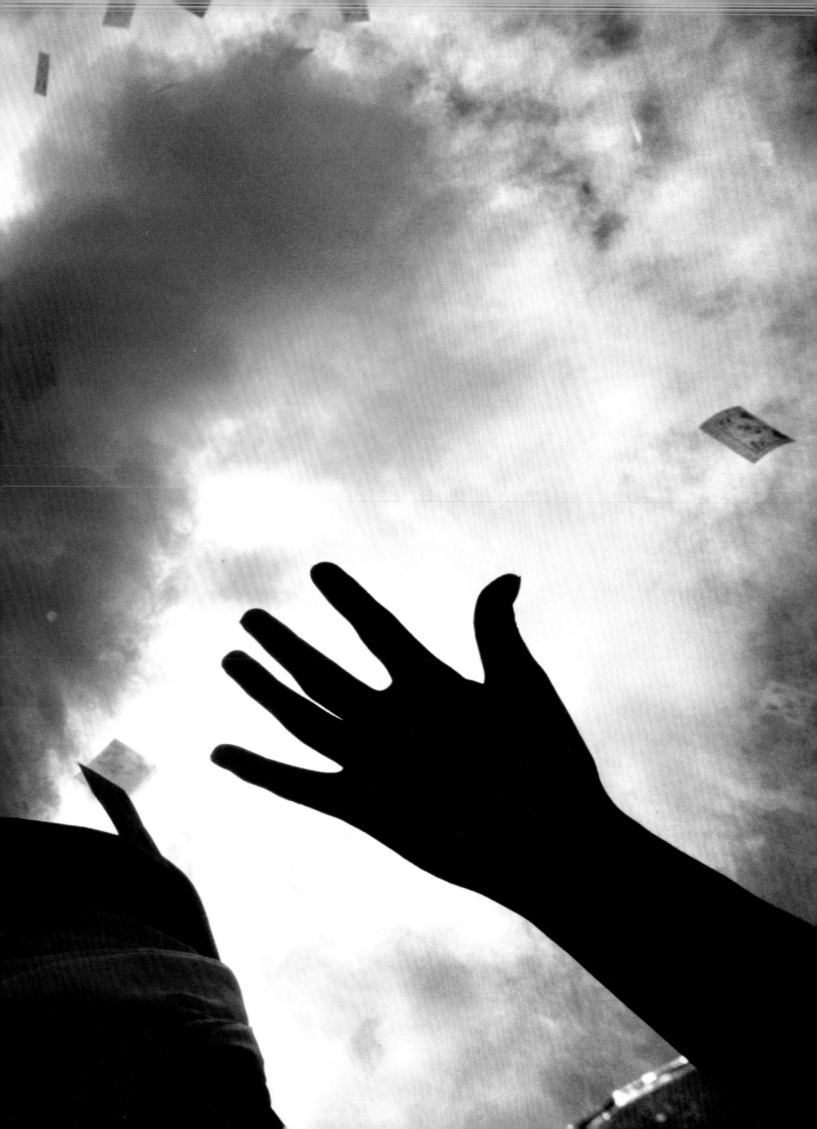

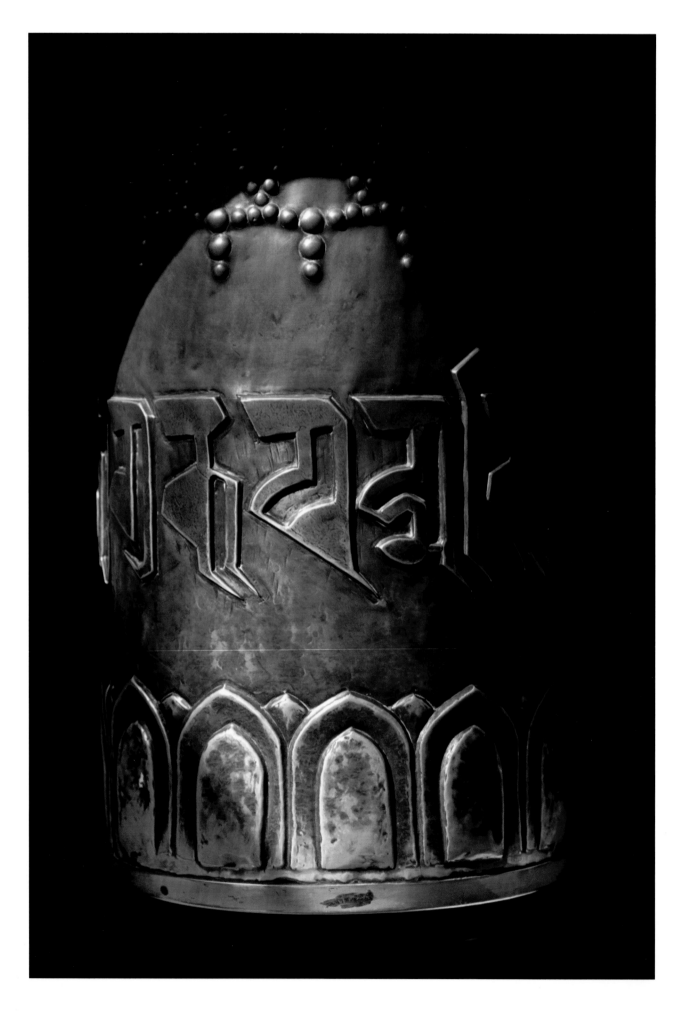

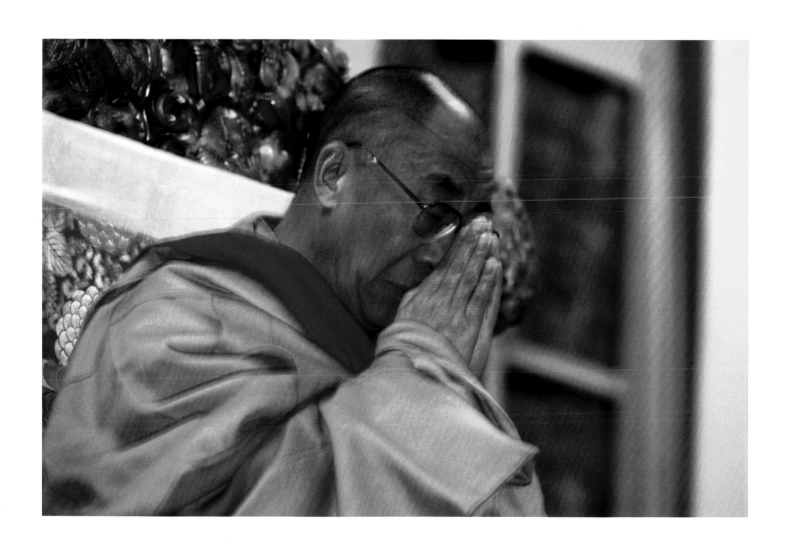

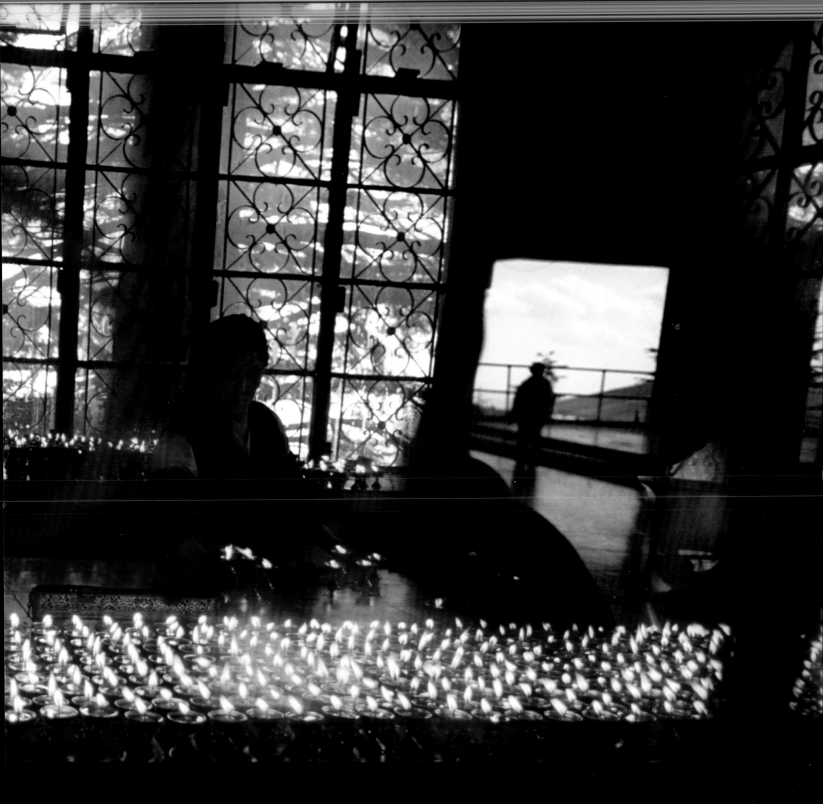

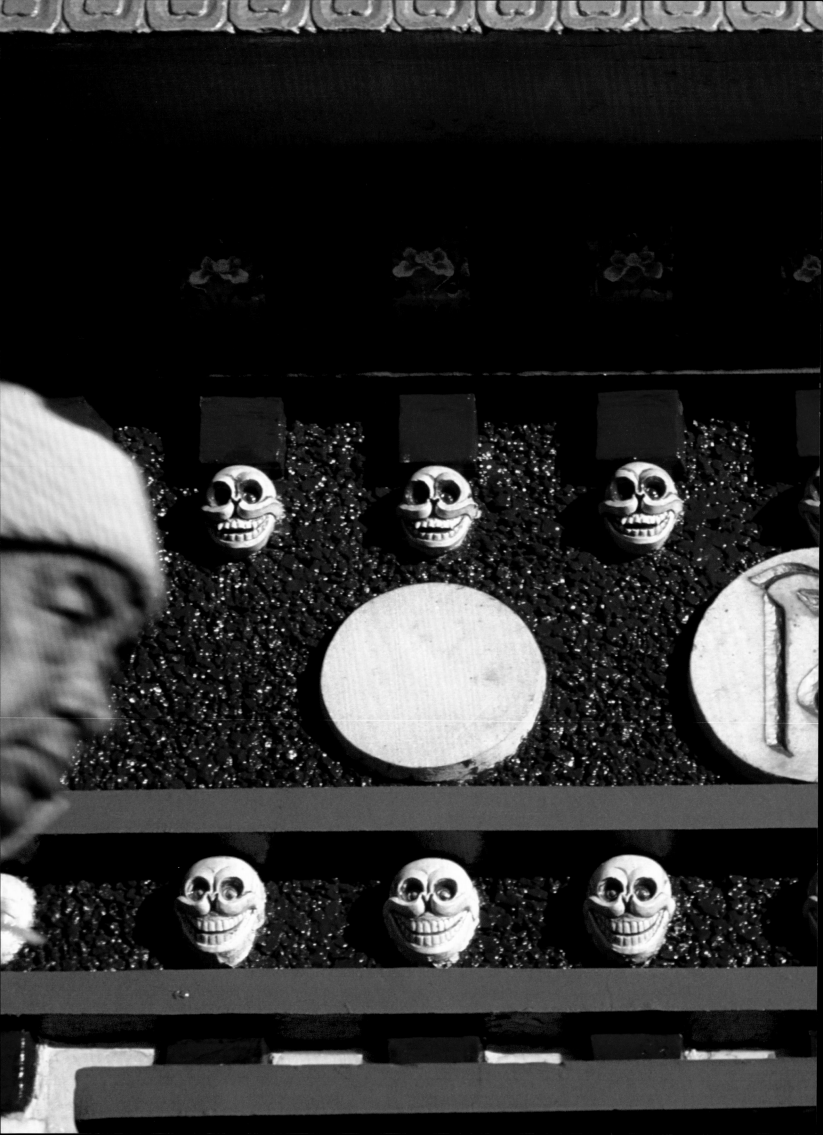

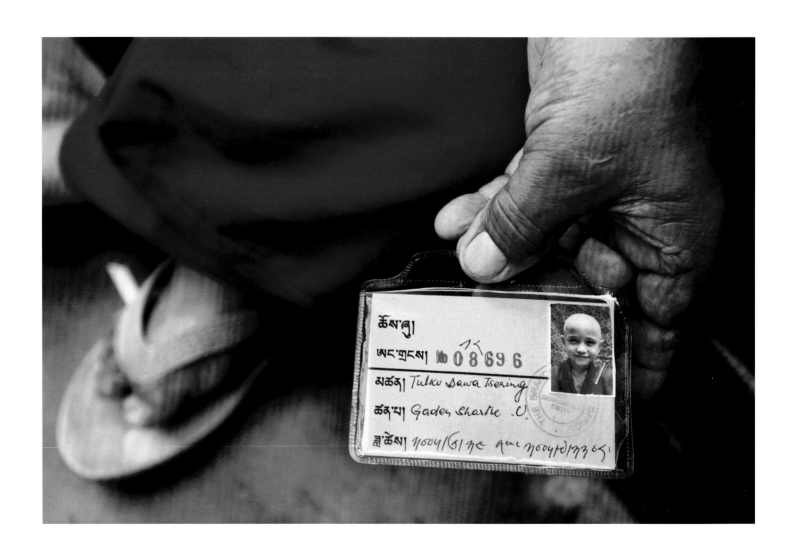

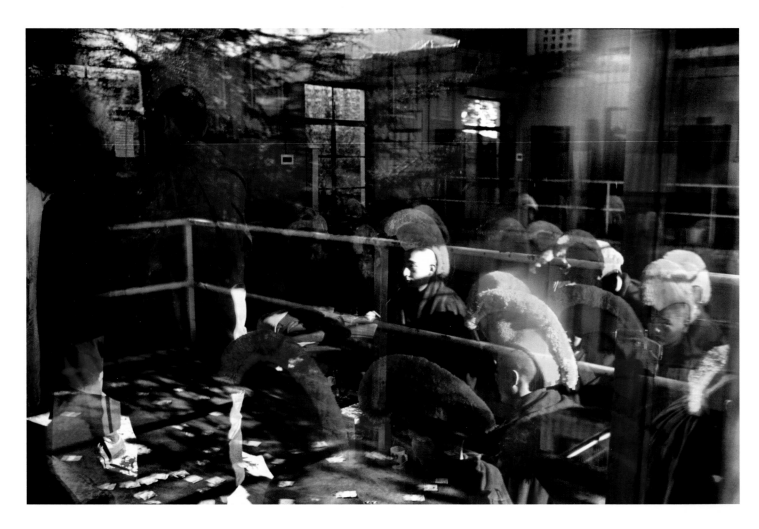

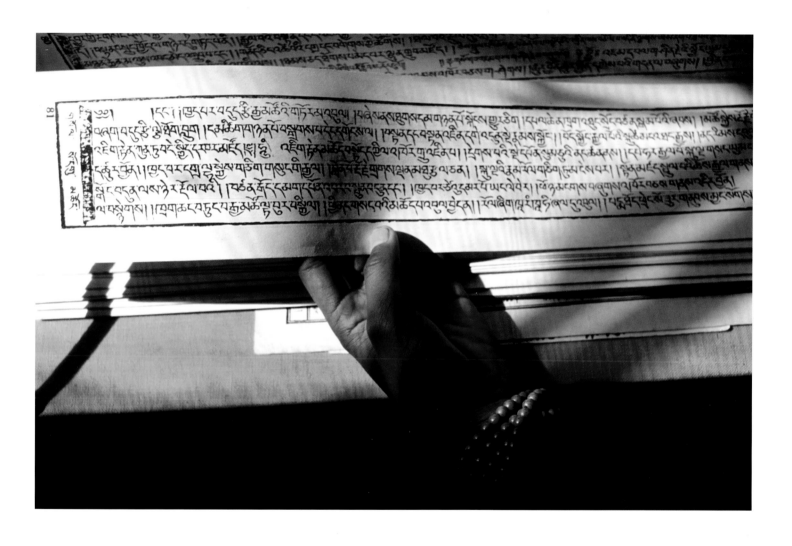

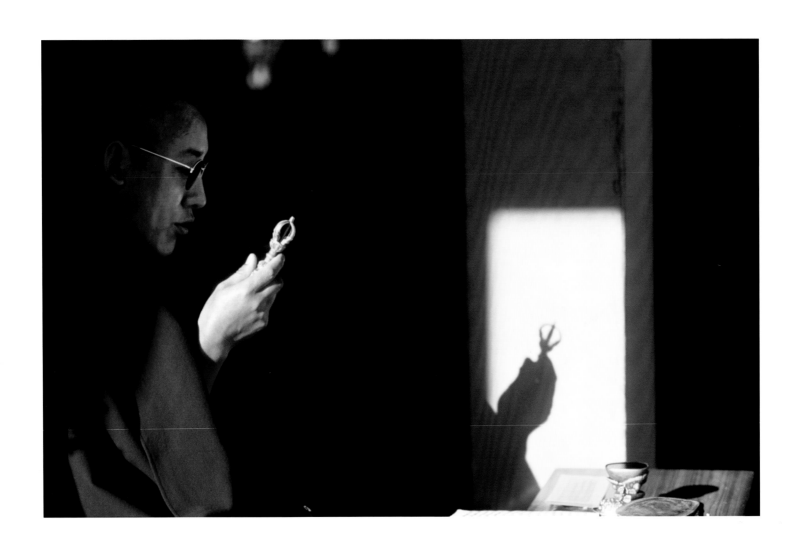

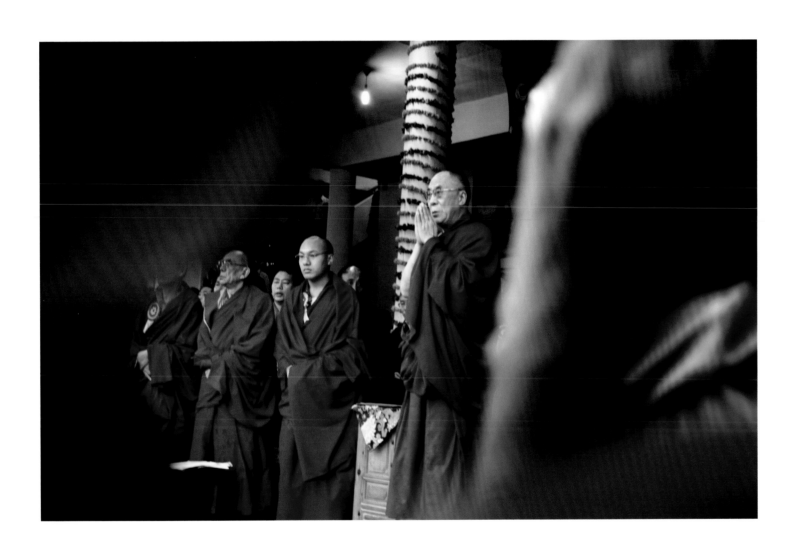

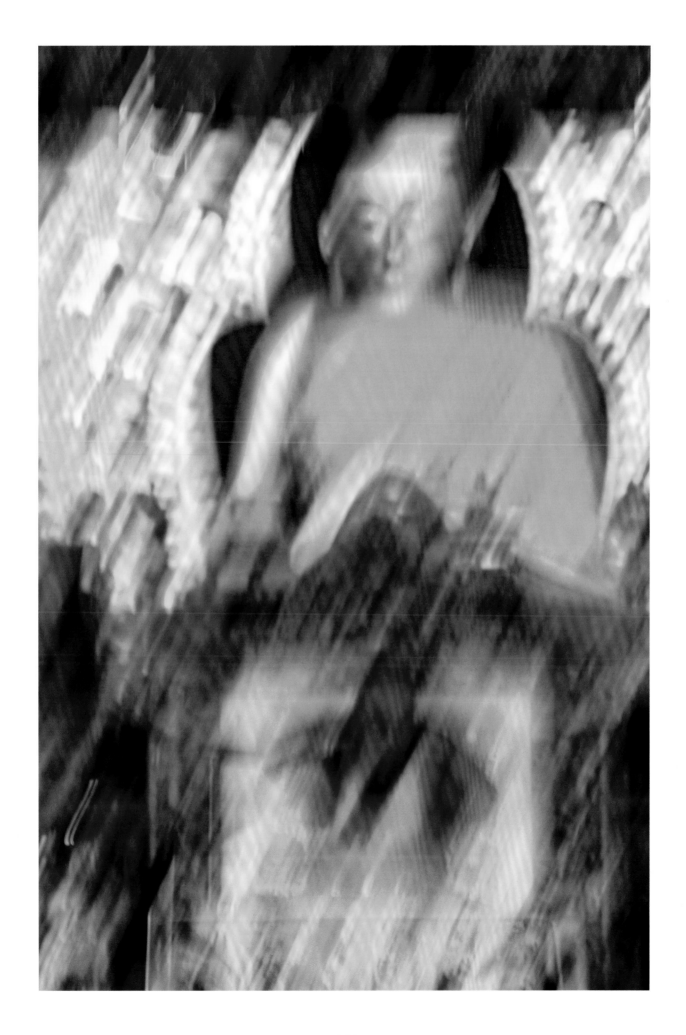

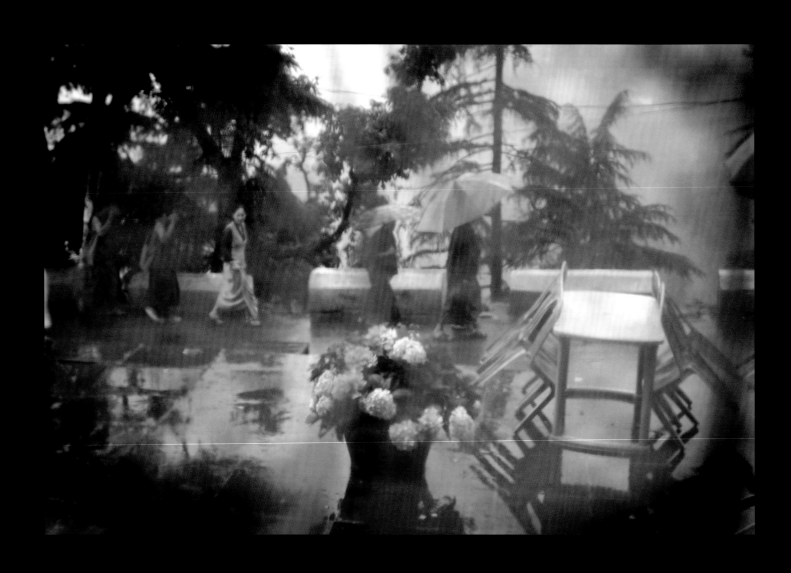

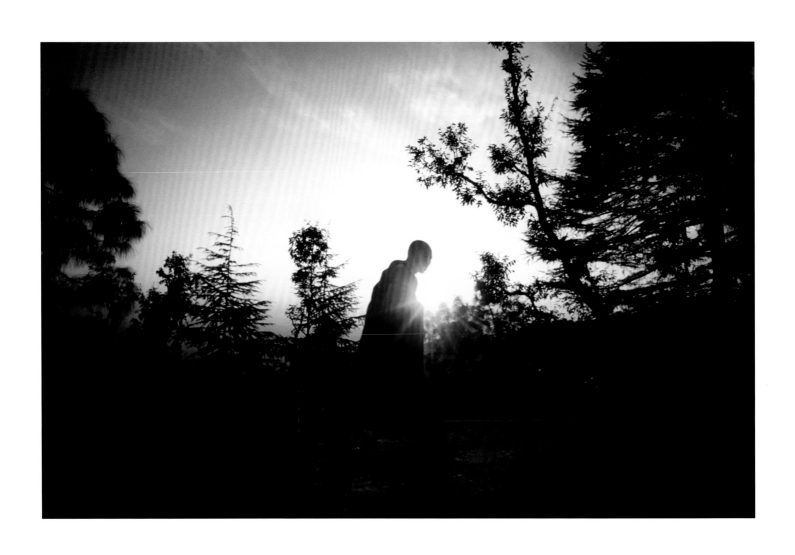

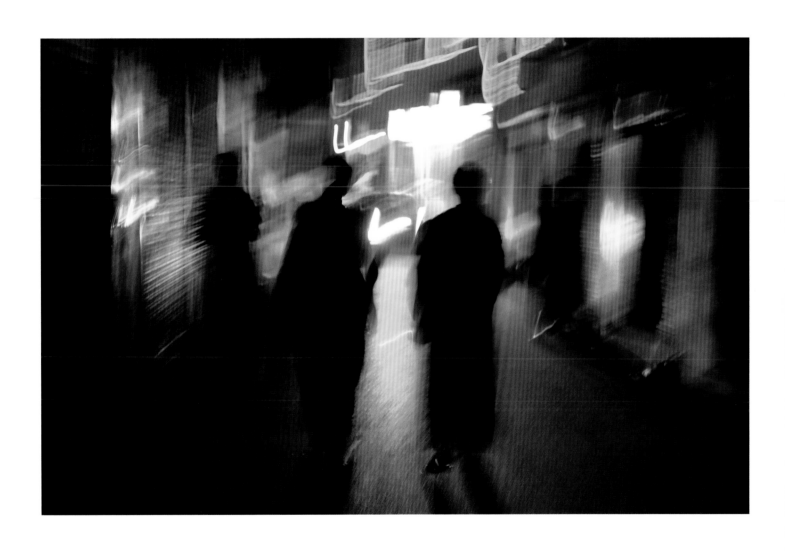

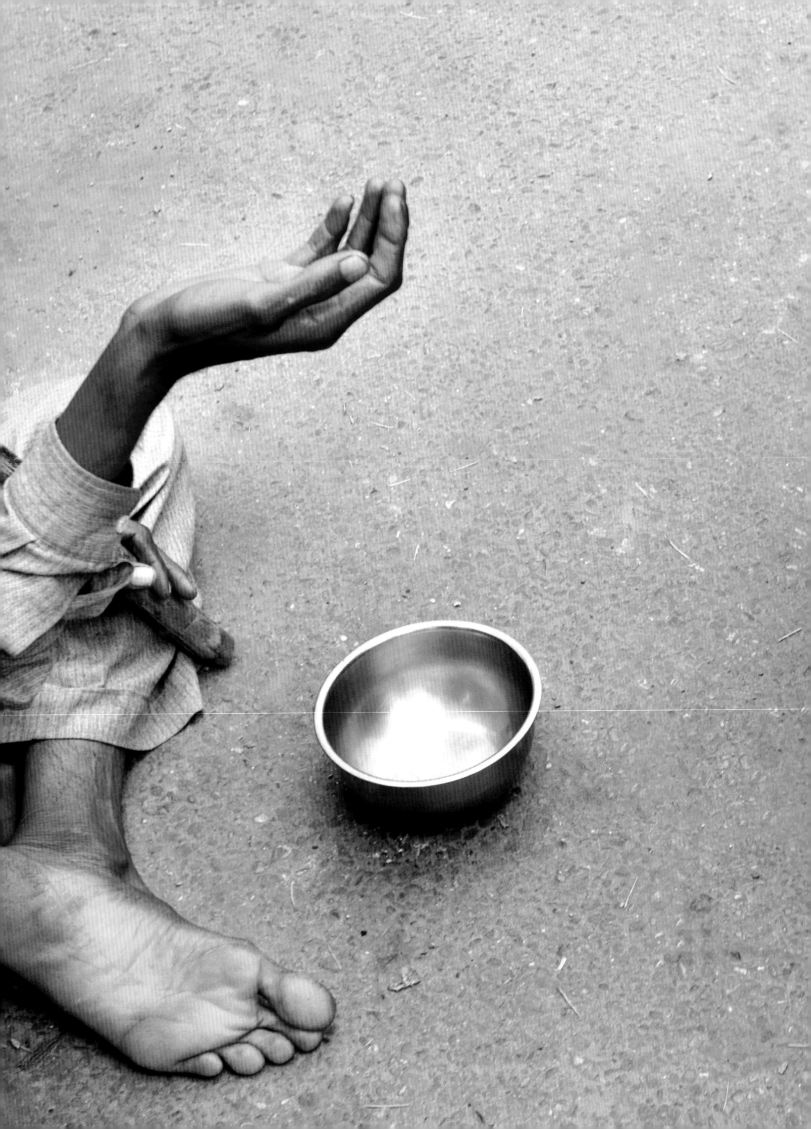

LHASA · CHINA

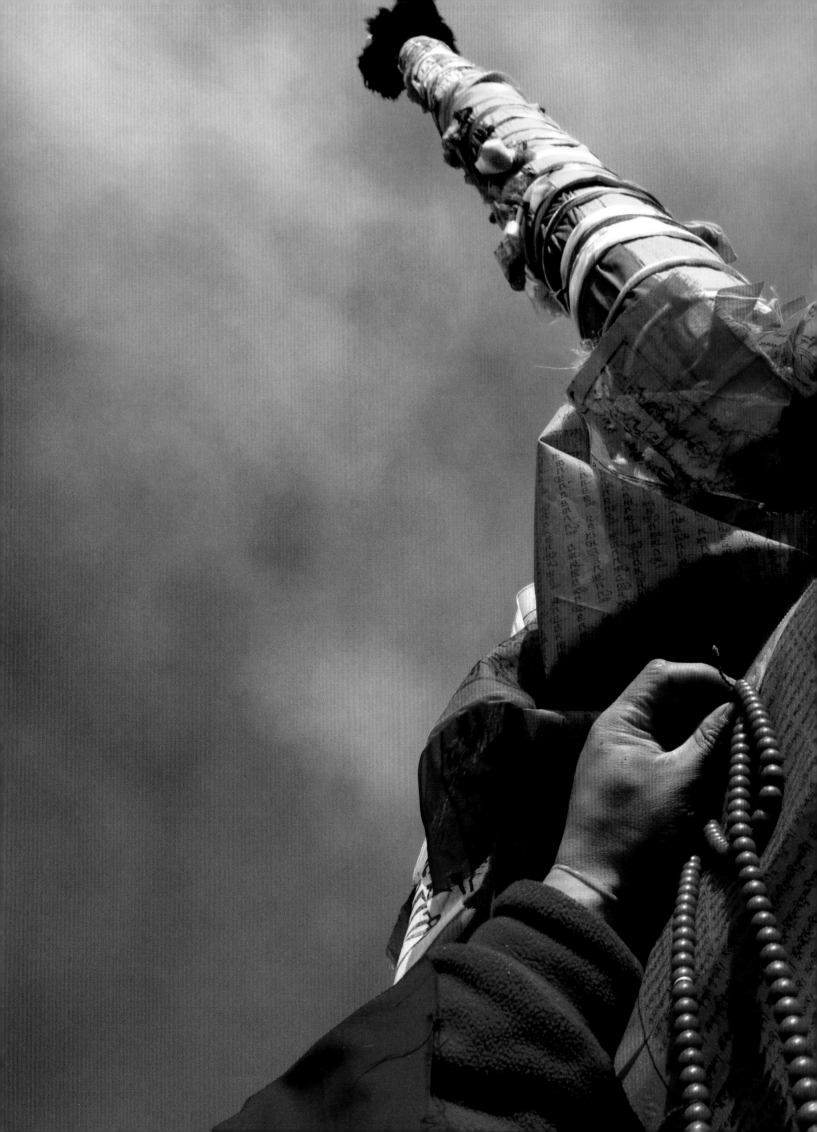

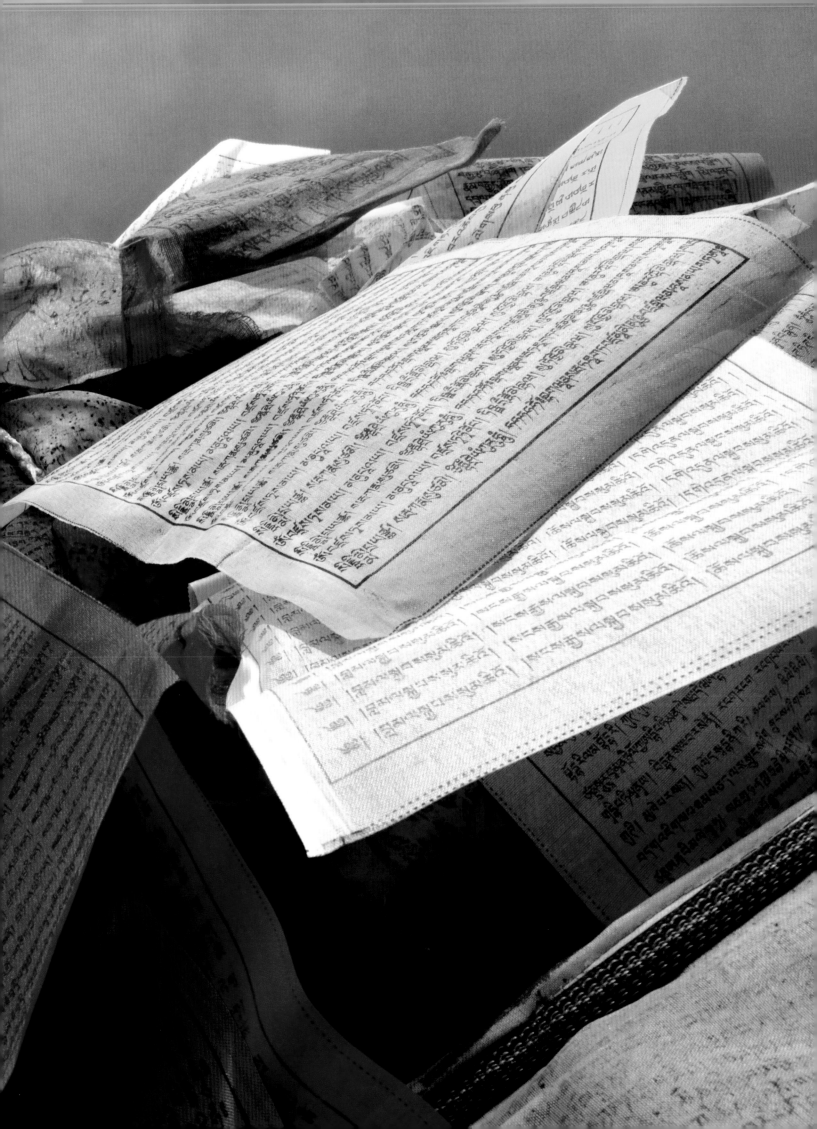

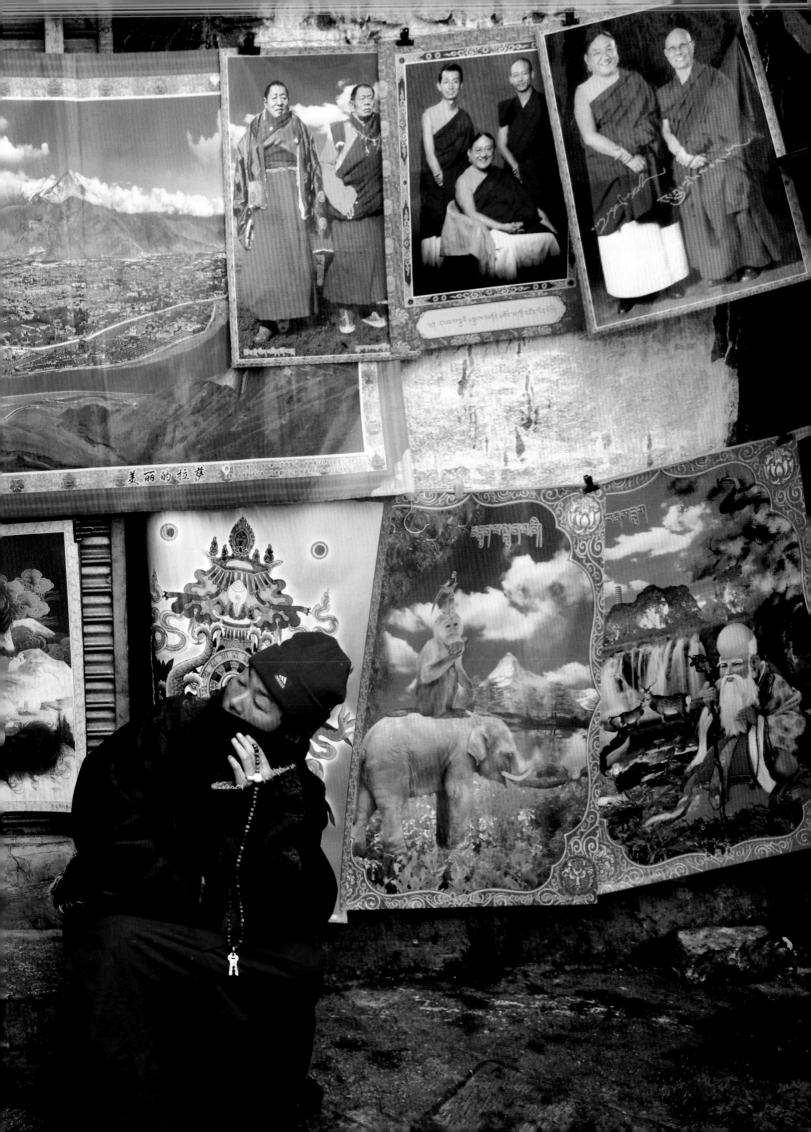

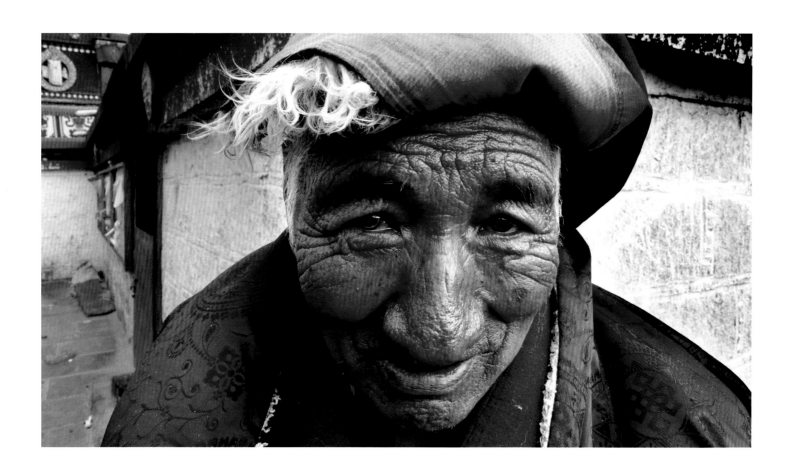

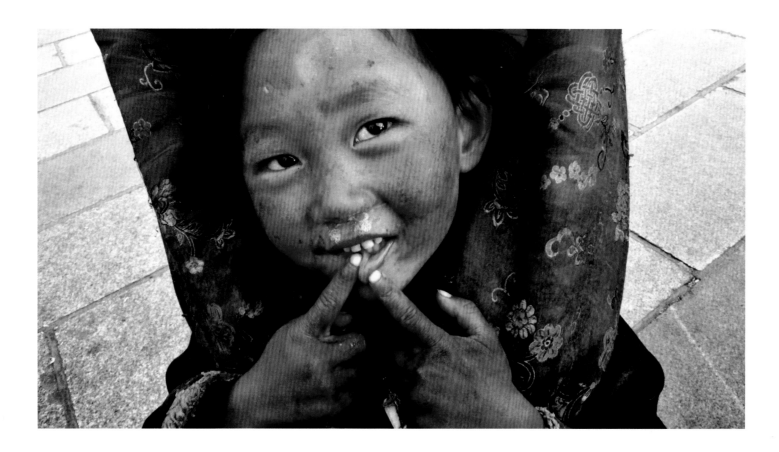

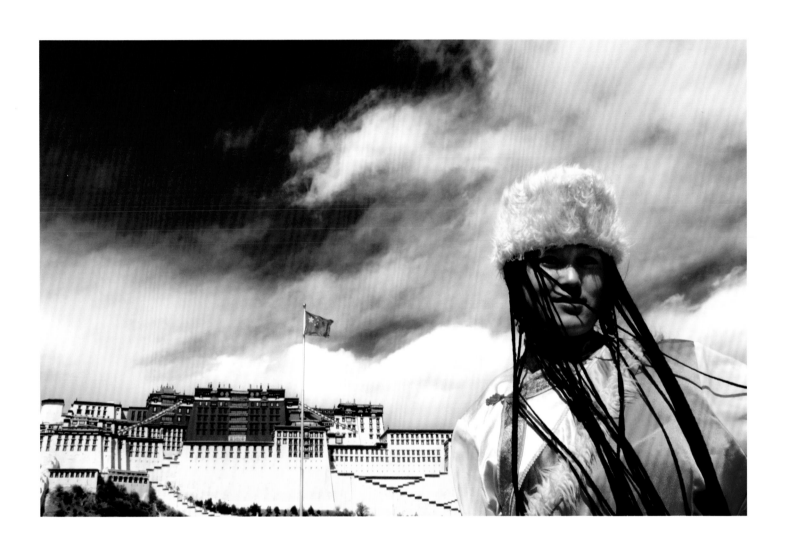

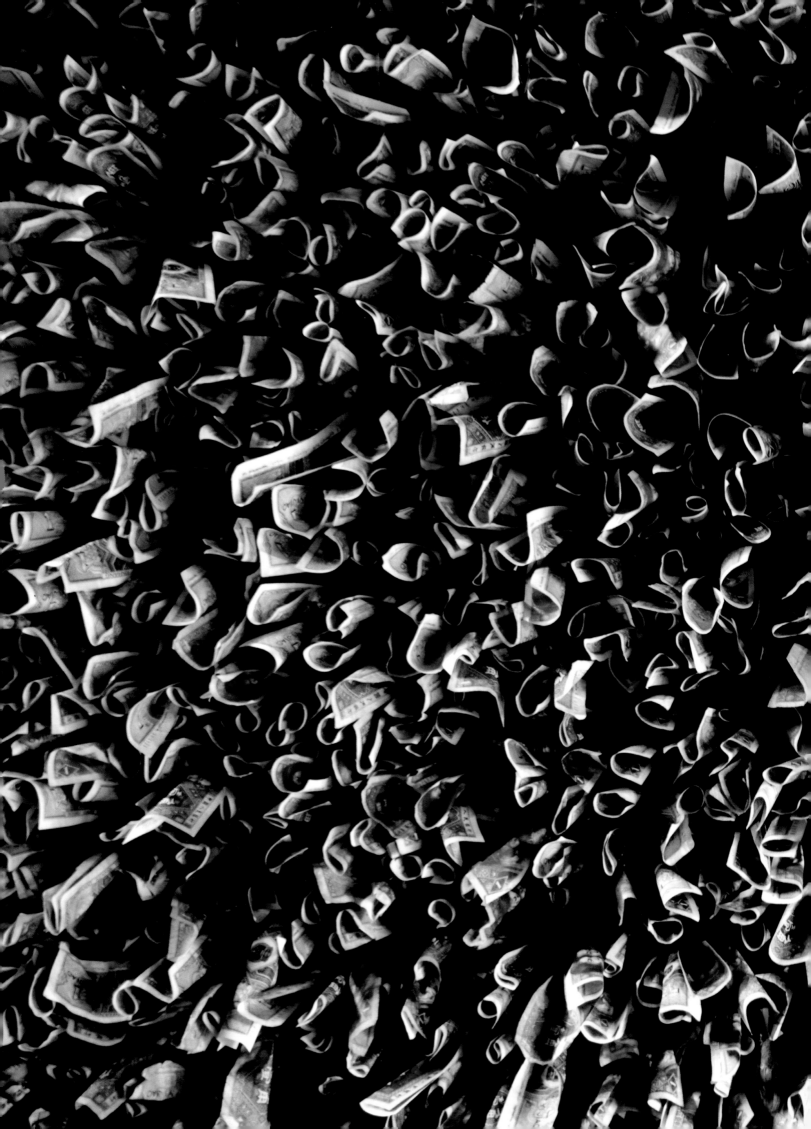

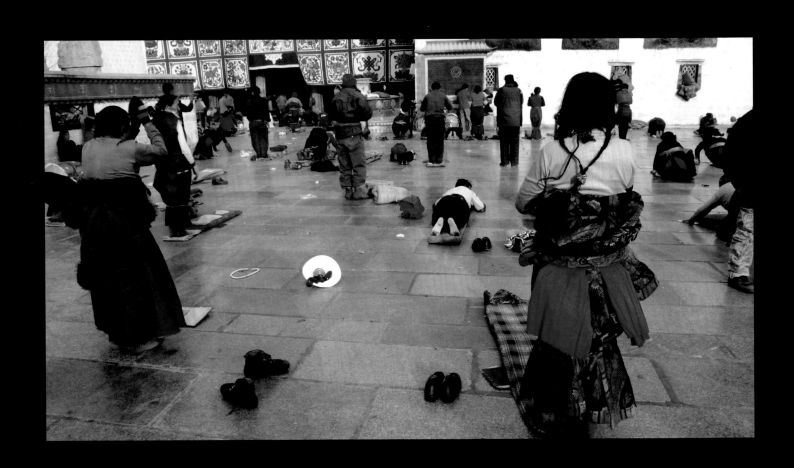

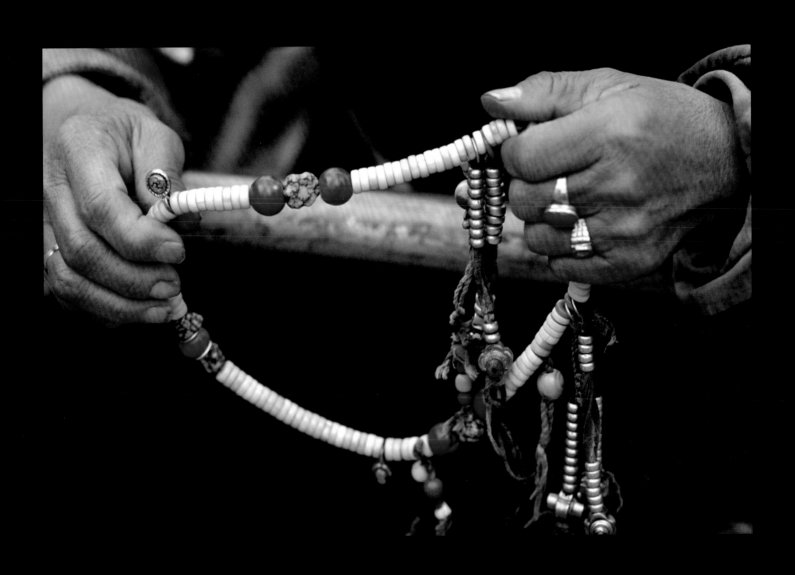

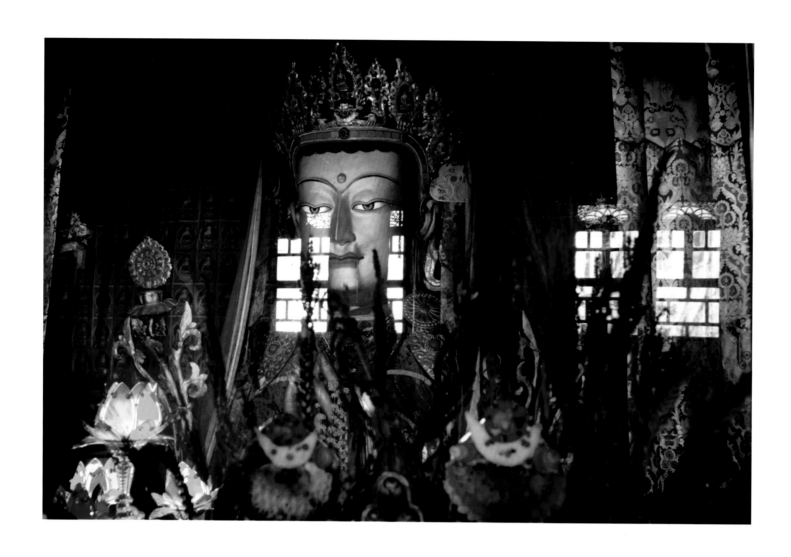

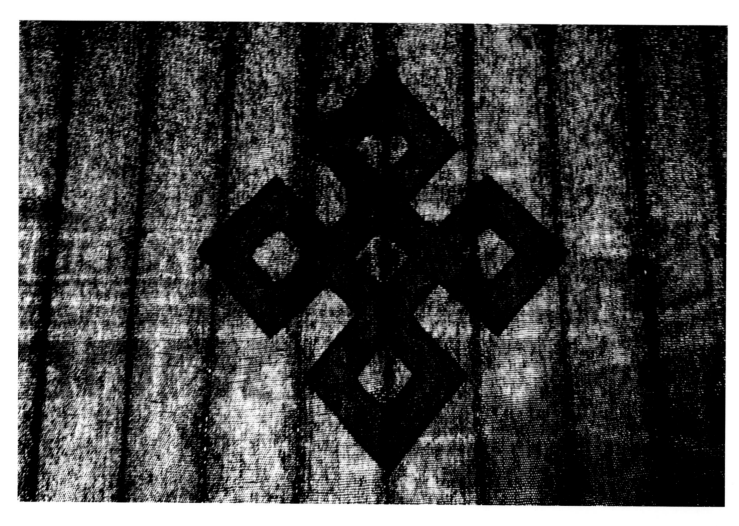

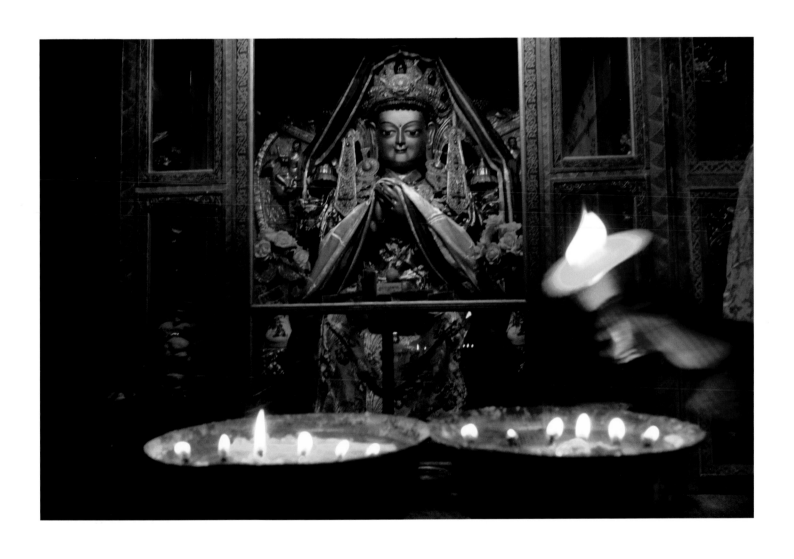

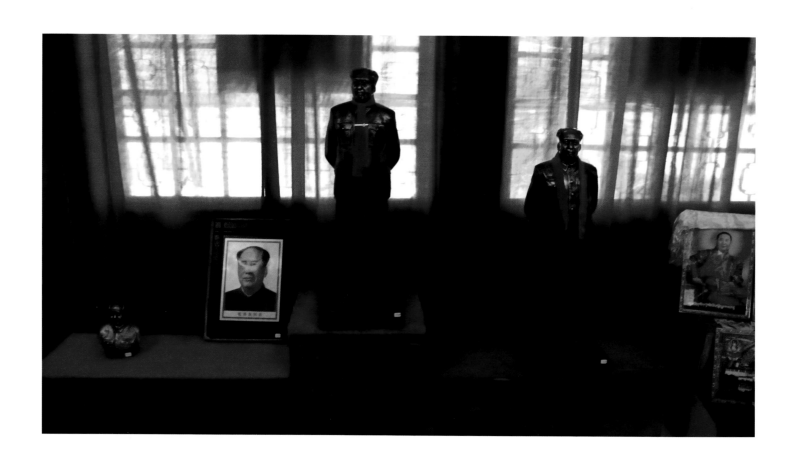

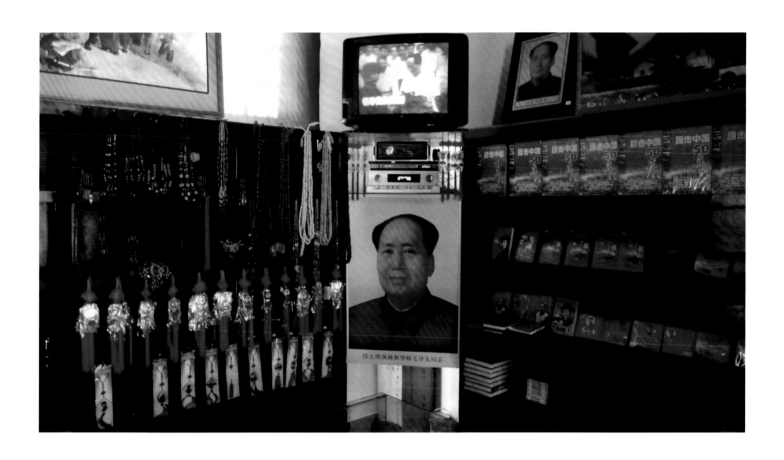

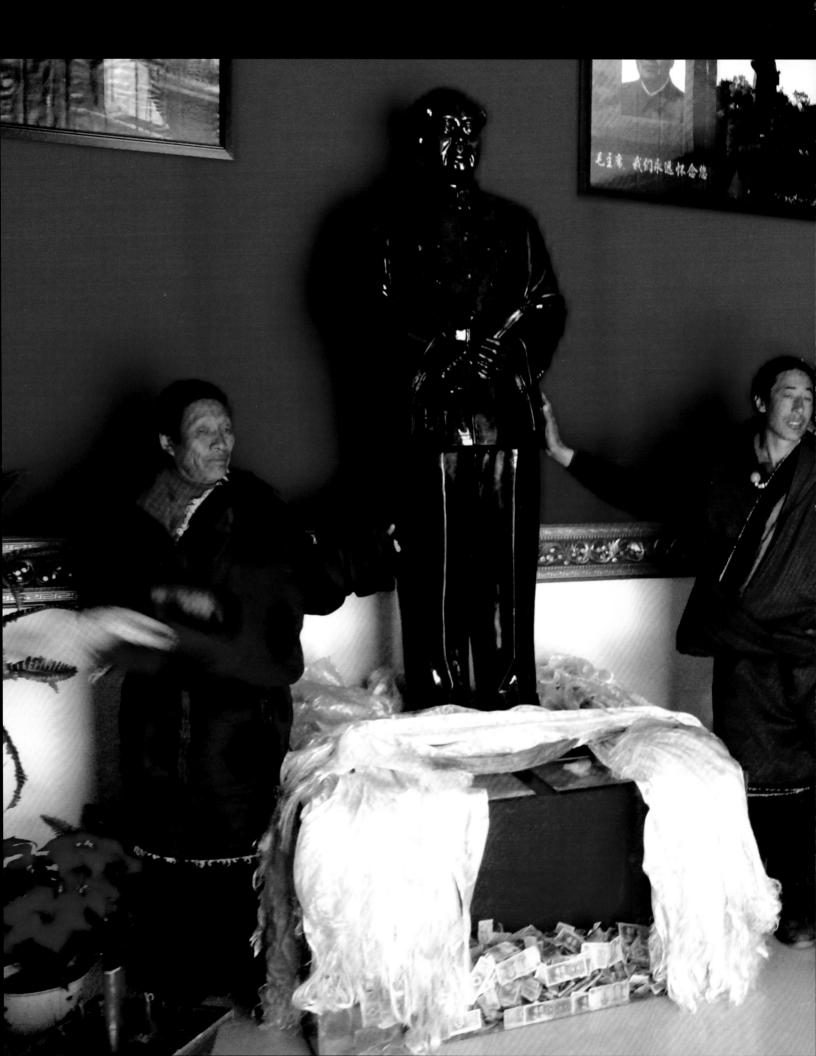

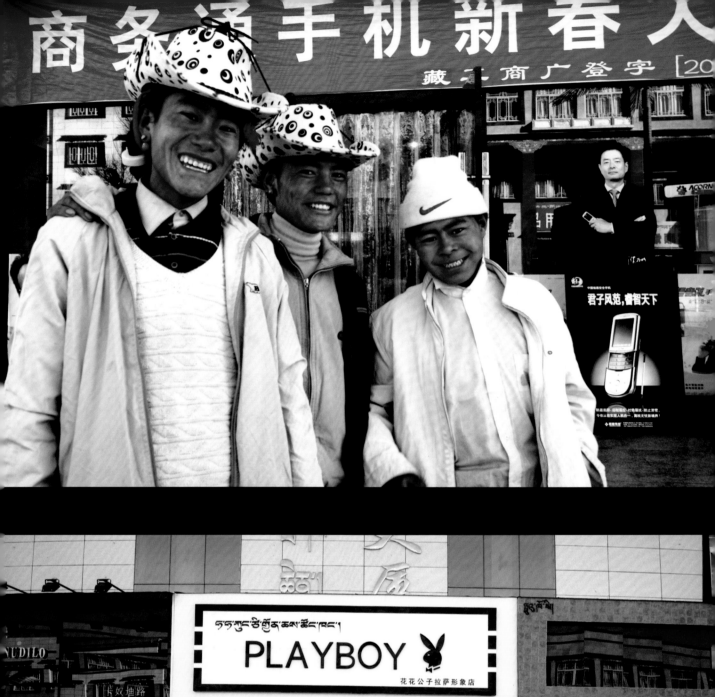
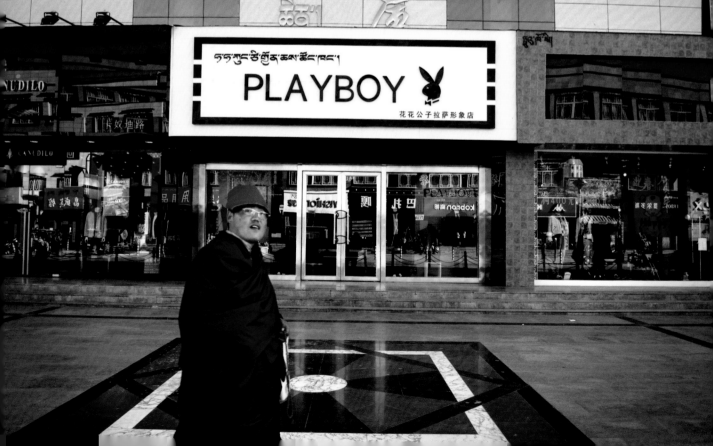

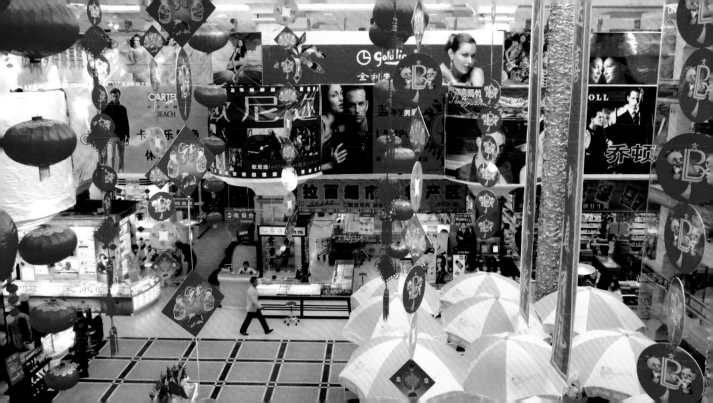

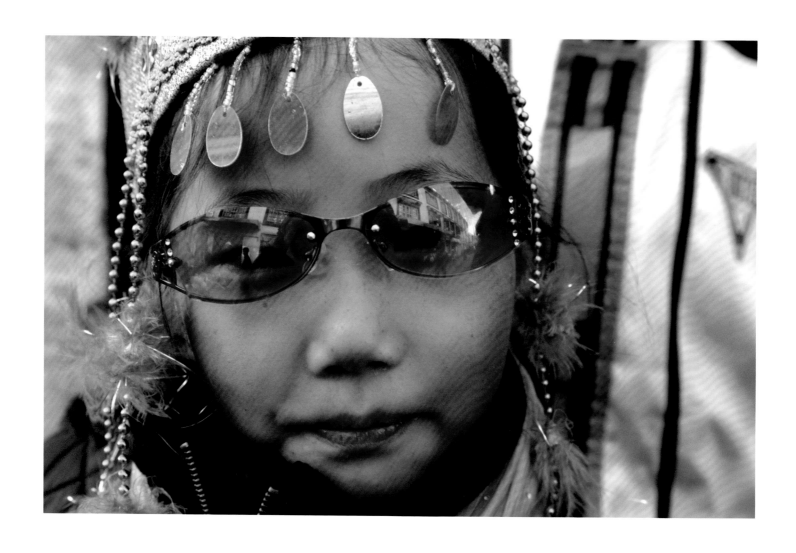

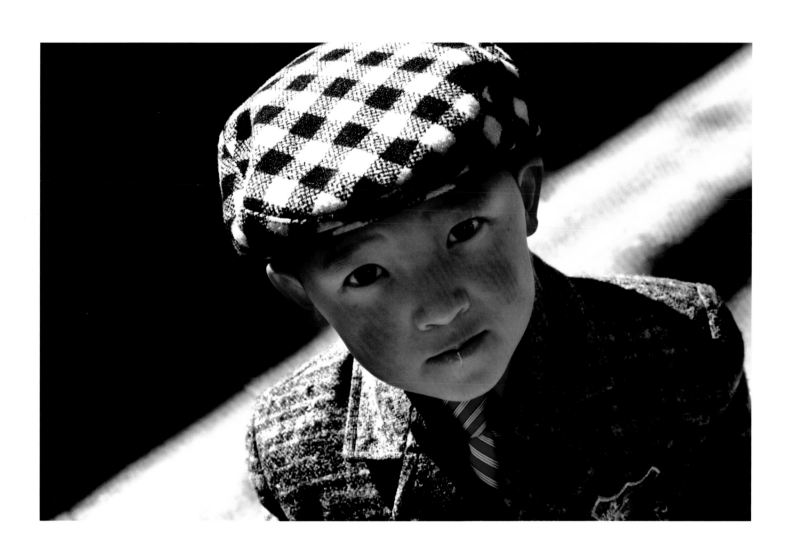

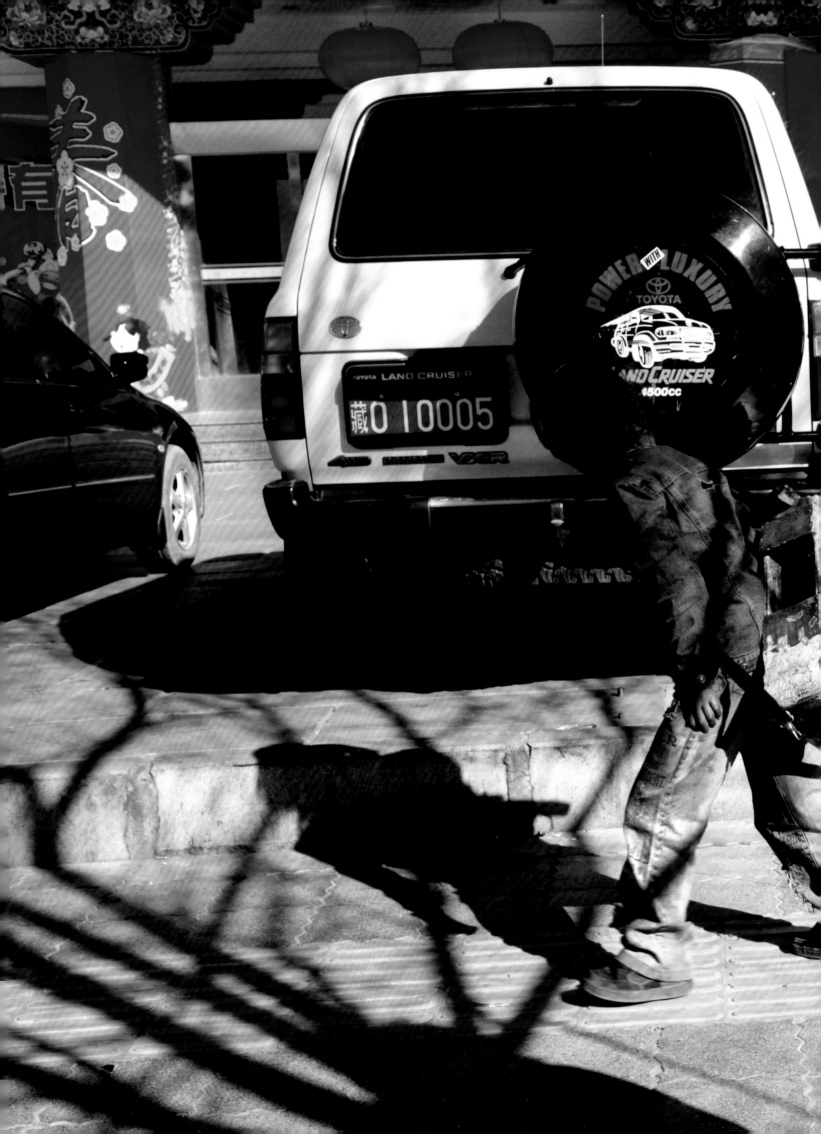

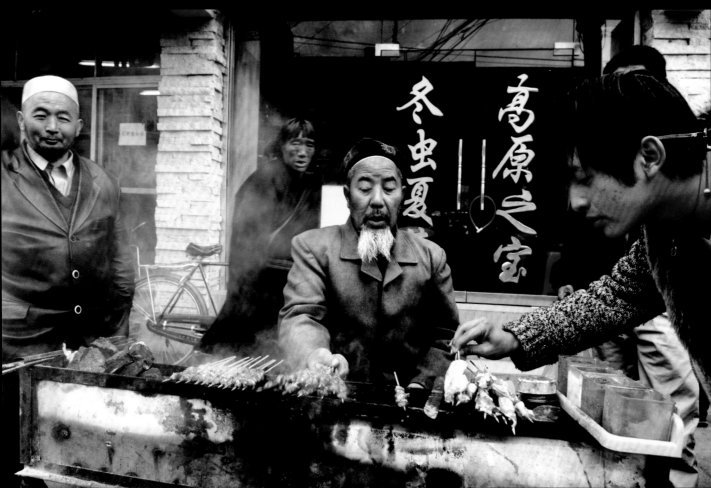

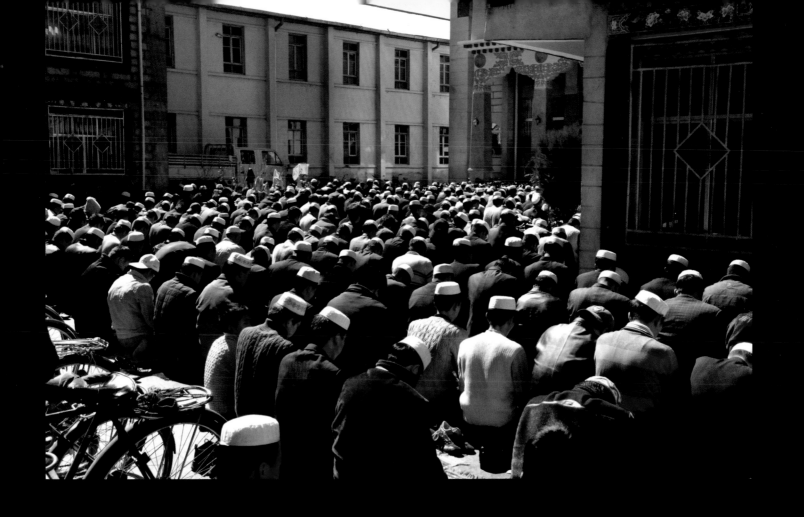

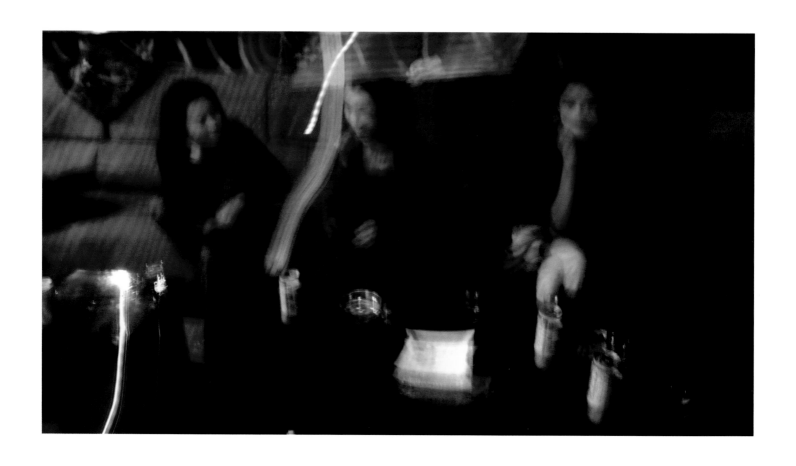

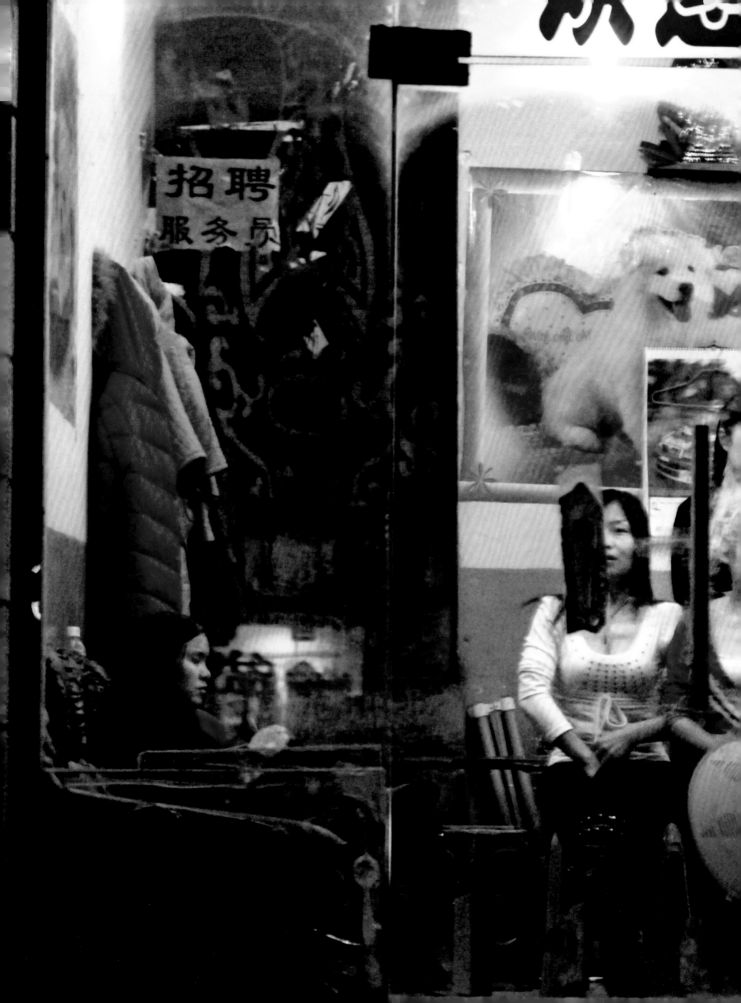

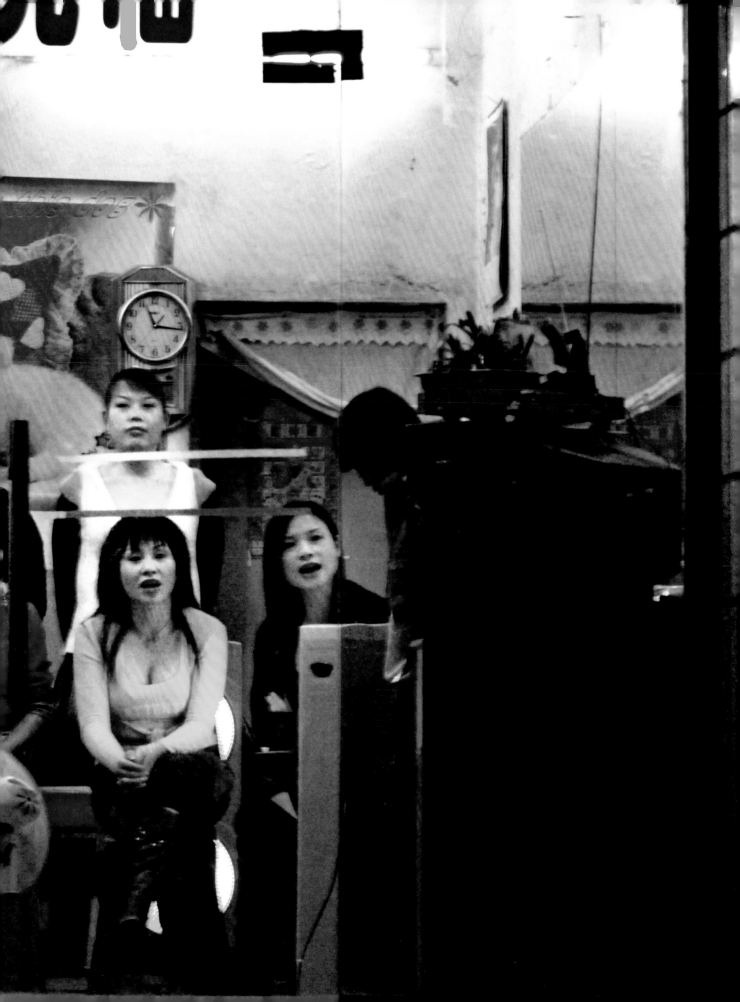

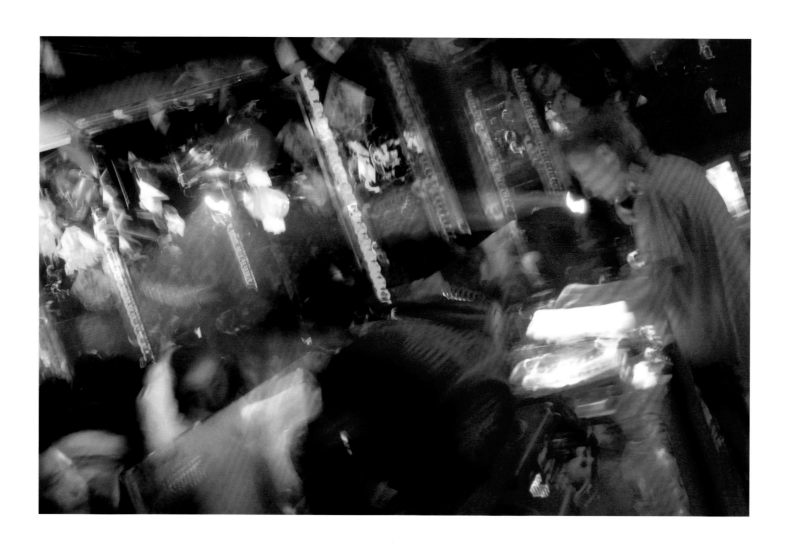

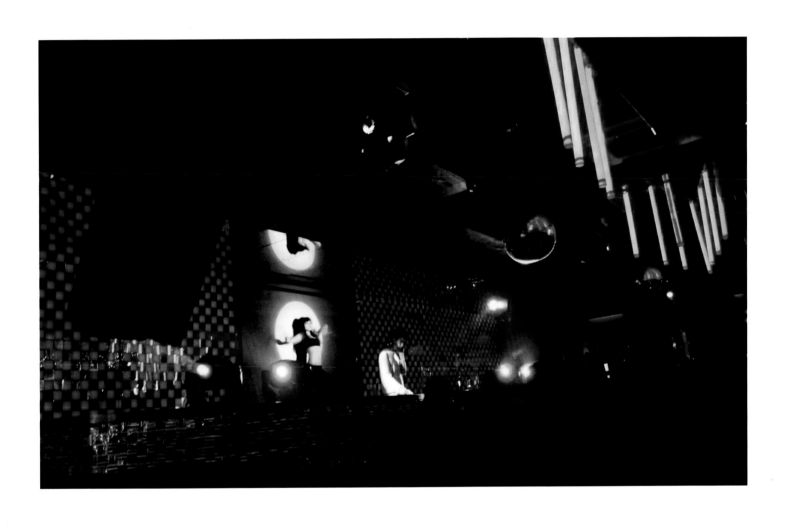

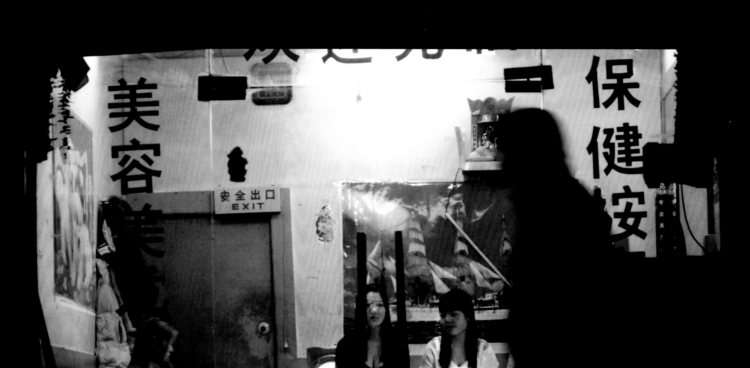

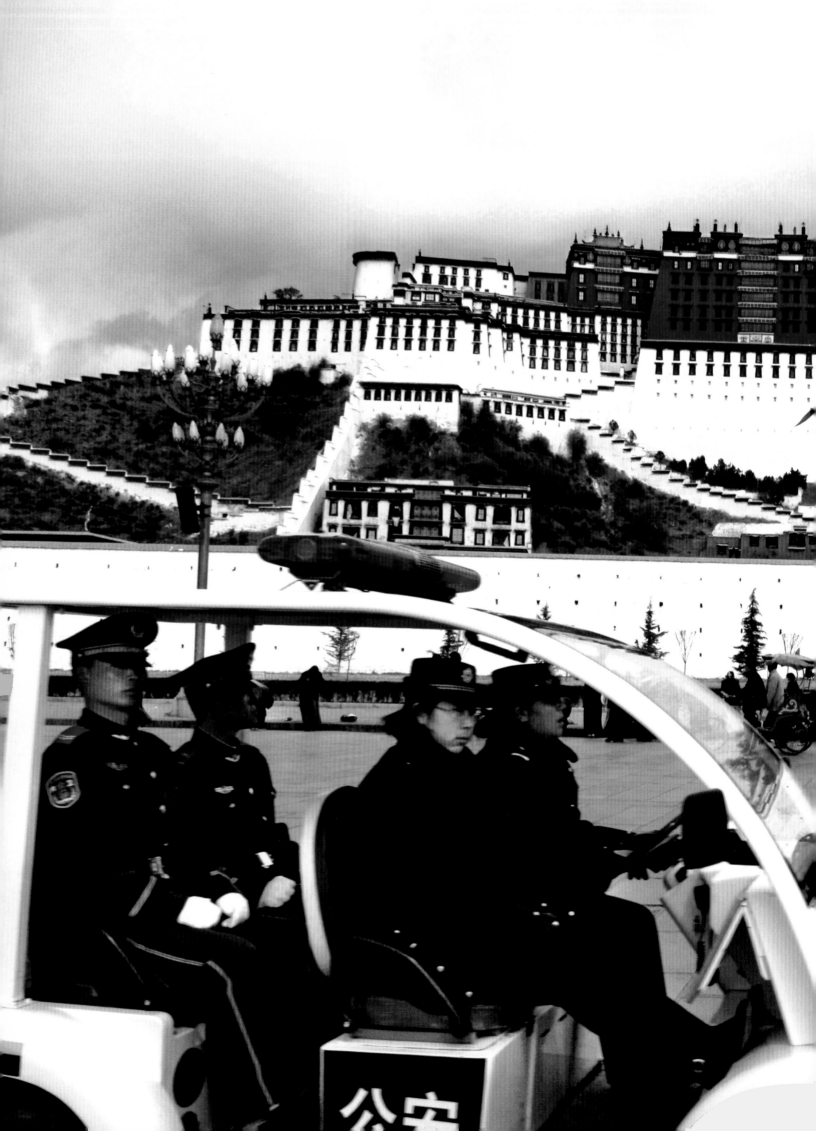

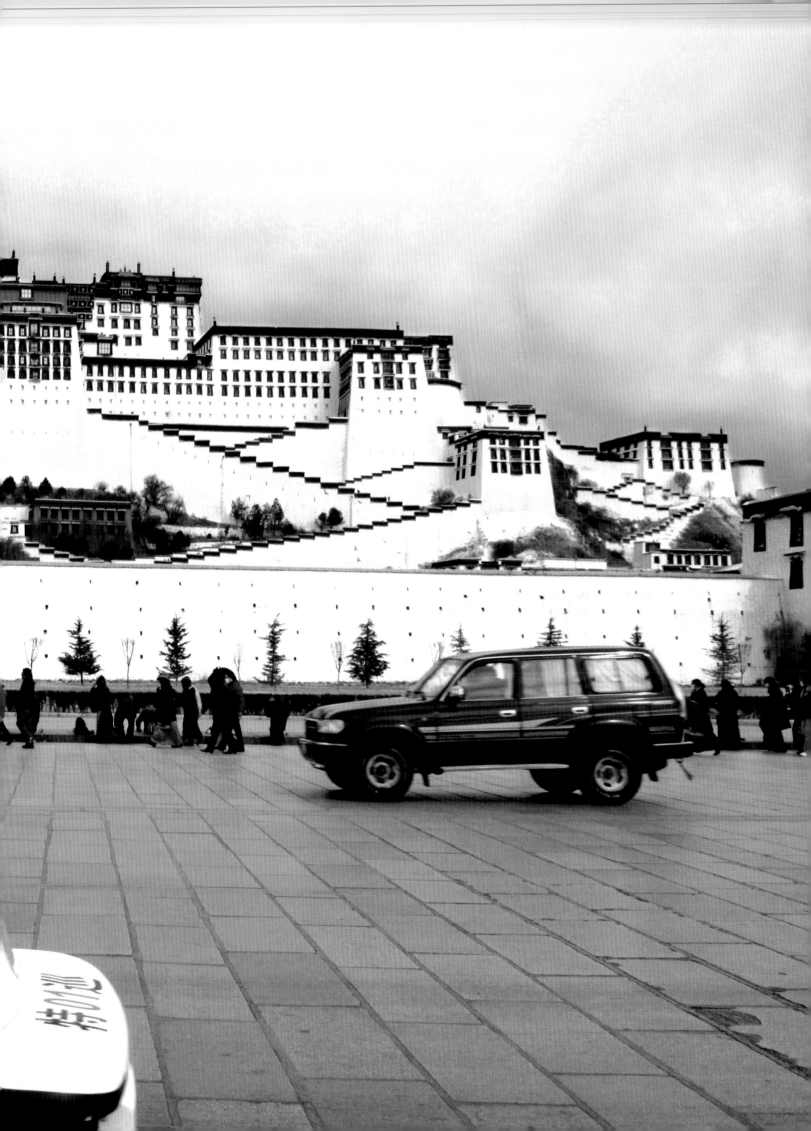

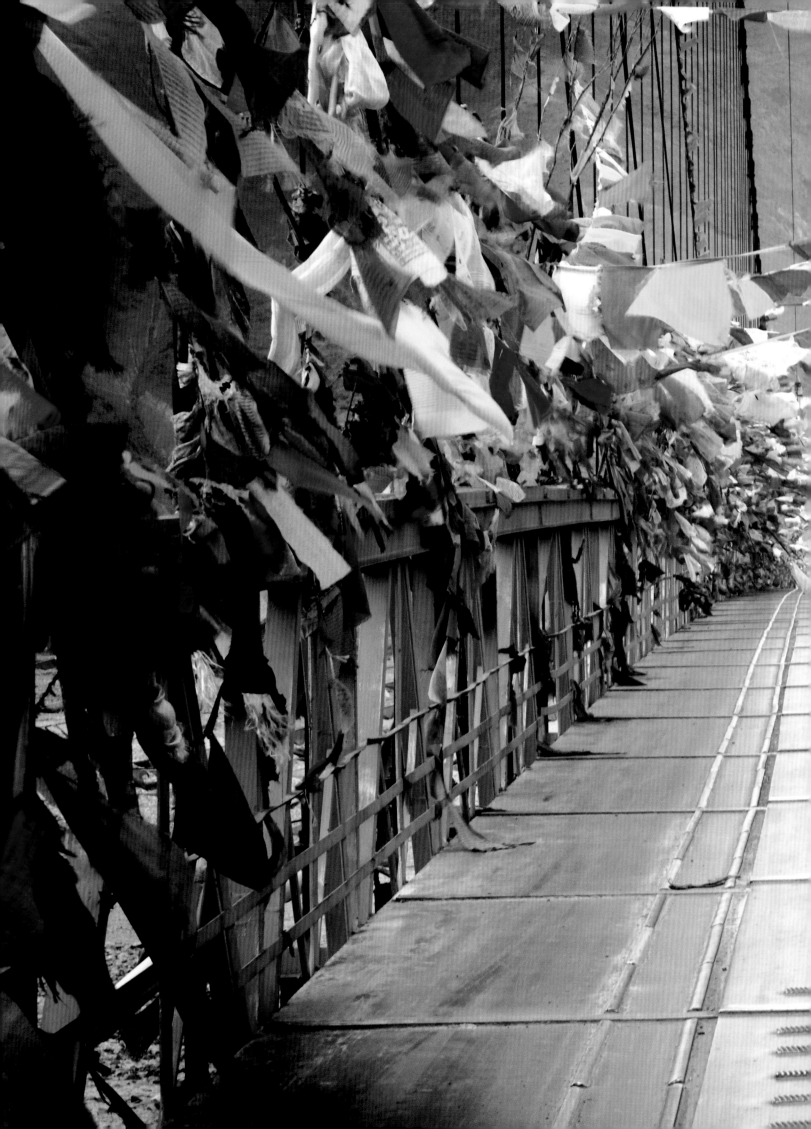

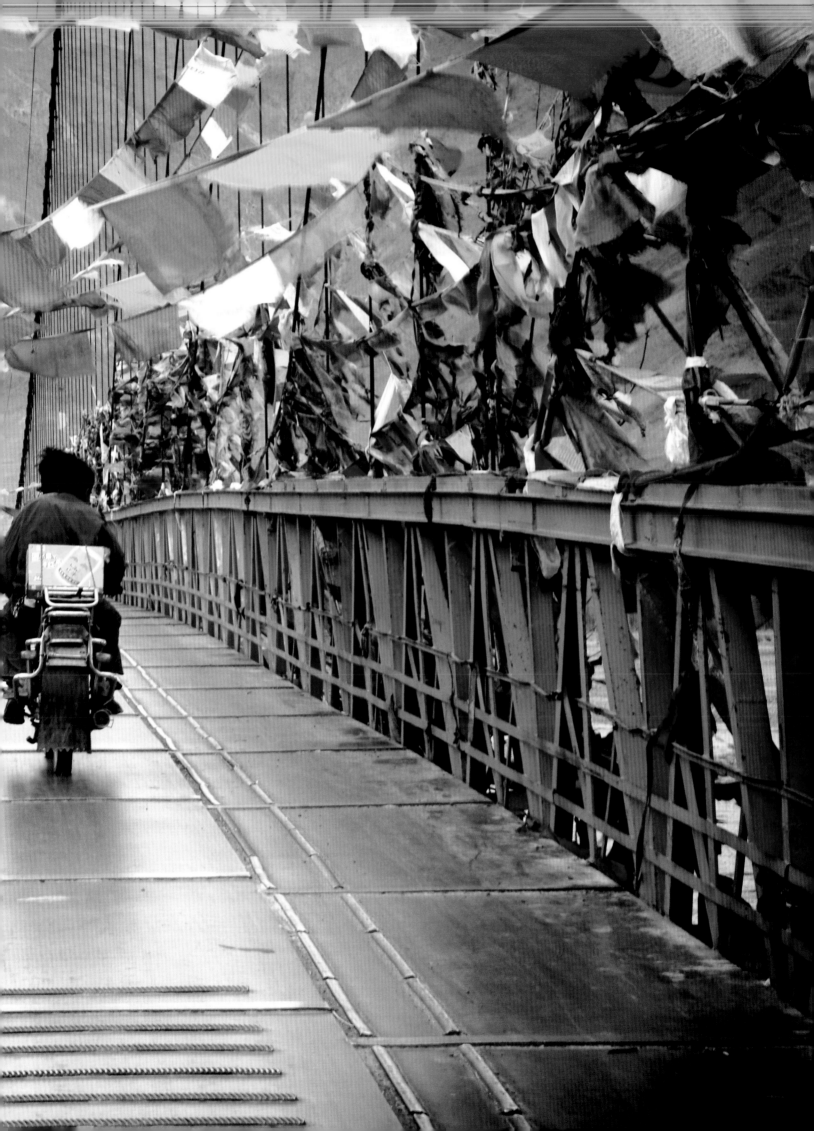

Patricio Estay, a French photographer of Chilean origin, was born in 1953. After graduating in ethno-musicology he pursued his interest in photojournalism, devoting himself to the socio-political aspects of his country's conflict. He produced his first professional reportage in 1973 at Santiago, during the coup d'état. This event was to have a profound influence on both his professional and private life. Indeed, the same year he was forced to take refuge in Brazil, where he lived as a political exile for eight years.

From the outset of his career, photography has been a potent tool in his work as a writer. The value Estay attributes to testimony and content, as well as the rich variety apparent in his images, are the primary qualities of a deeply personal point of view which has constantly characterized his career as a photojournalist.

In 1984, already highly appreciated as a photo-reporter, Estay moved to Paris.

In 1989 he returned to Chile, engaged by several international publications to report on the fall of the Pinochet government and the new democratic elections. There, he worked for the future president Patricio Aylwin managing his image during the election campaign; he would do likewise for future presidents Eduardo Frei (1994) and Michelle Bachelet (2005).

In 1990 he initiated a huge project on which he is still working, which led him to travel the world over documenting peoples whose lives are still closely tied to equestrian traditions.

In 1997 he received the European Fuji Press Award for his reportage *Lord of the Bush*, shot in Australia.

In 1999, inspired by his own experience as an exile, he became interested in the Dalai Lama and the exiled Tibetan community of Dharamsala.

In 2003 Estay founded the photographic press agency Nazca Pictures in Florence, expanding his activity across the whole multimedia sector.

Today, more than ever, Estay believes in the extraordinary expression of freedom, passion and life that can be conveyed through instinct and the essence of photography.

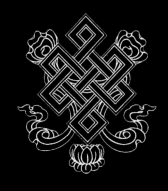

Gedhun Choekyi Nyima recognised by H.H. the Dalai Lama as the XIth Panchen Lama, the World's youngest political prisoner of conscience was born on Ap. 25th, 1989 in Lharizong, Tibet. Since his disappearance in 1995 by the Chinese authority, his whereabout is still unknown. As of April 1997, the 8th birthday of Gedhun Choekyi Nyima, on every Friday of each week until his release a yellow ribbon will be tied to this tree and a prayer said for the immediate release of the 11th reincarnation of the Panchen Lama from his imprisonment by communist China.

—Tibetan Women's Association

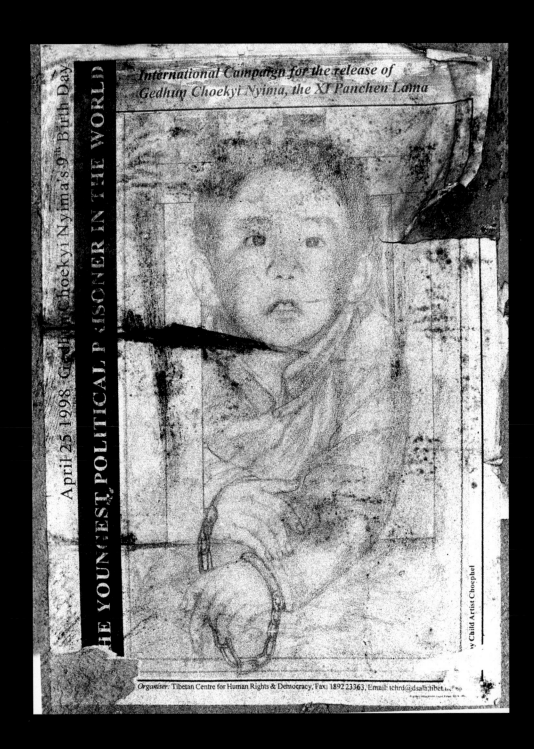

Gendhun Choekyi Nyima, born on 25 April 1989 in Nagchu, Tibet, was recognized in 1995 by the Dalai Lama as the eleventh reincarnation of the Panchen Lama and is considered to be the youngest political prisoner in the world. In May of the same year he was kidnapped by the Chinese authorities and replaced by Gyslysen Norbu, imposed on the Tibetan people as the new Panchen Lama.

For twelve years, Gendhun and his family have not been seen. The Chinese government has denied access to the boy both to foreign diplomats and representatives of the United Nations, declaring that he is pursuing his studies and has asked to be left in peace.

Enforce Human Rights. Free Gendhun Choekyi Nyima

INDEX

THE POTALA PALACE IN LHASA,
FORMER RESIDENCE OF THE DALAI LAMA
UP TO 1959. ON THE RIGHT THE CHINESE
FLAG

TIBETAN PILGRIM WITH HIS PRAYER WHEEL,
PRAYING AT THE JOKHANG TEMPLE IN
LHASA, THE MOST VENERATED HOLY
BUILDING IN TIBET

TIBETAN PILGRIM AT THE STUPA OF
THE DREPUNG MONASTERY IN LHASA
MAKES AN OFFERING TO BUDDHA.
IT IS SAID THAT BEFORE THE CHINESE
CAME, DREPUNG WAS THE LARGEST
MONASTERY IN THE WORLD WITH EIGHT
THOUSAND RESIDENT MONKS

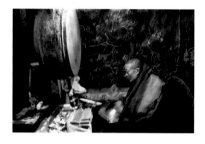

A MONK IS PRAYING IN THE THIRD CHAPEL
OF THE DREPUNG MONASTERY IN LHASA

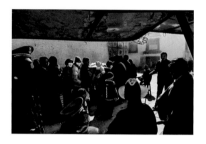

TIBETAN PILGRIMS DURING THE LOSAR
(TIBETAN NEW YEAR) QUEUING TO ENTER
THE JOKHANG TEMPLE, WATCHED OVER
BY CHINESE SOLDIERS

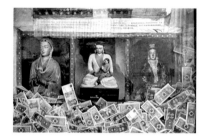

OFFERINGS TO TIBETAN GODS AT THE EXIT
OF THE POTALA PALACE IN LHASA

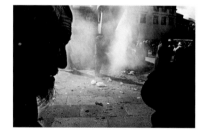

A TIBETAN PILGRIM TAKES PART IN THE
LOSAR (TIBETAN NEW YEAR)
CELEBRATION NEAR THE JOKHANG
TEMPLE IN LHASA

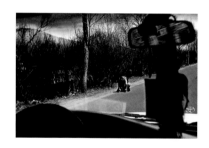

A TIBETAN WOMAN ON A PILGRIMAGE GOES
DOWN THE MAIN ROAD TO LHASA ON HER
HANDS AND KNEES

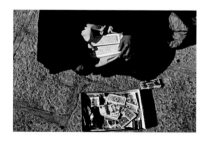

A TIBETAN MONK ON A PILGRIMAGE AT THE
DREPUNG MONASTERY IN LHASA RECEIVES
OFFERINGS FOR HIS PRAYERS

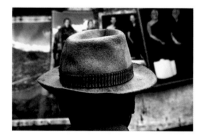

TIBETAN PILGRIM LOOKING AT OLD LAMA'S
PHOTOGRAPHS AT BARKHOR DISTRICT IN
LHASA

MONK AT THE GANDEN MONASTERY, FORTY
KILOMETRES AWAY FROM LHASA

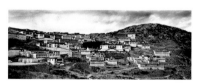

THE GANDEN MONASTERY, FORTY KILOMETRES
AWAY FROM LHASA, OVERLOOKS THE KYI-CHU
VALLEY. IT WAS FOUNDED IN 1409 AND
WAS THE FIRST GELUPKA MONASTERY. STILL
TODAY IT IS THE MAIN SEAT OF THIS ORDER

The Samye Monastery, in the vicinity of Lhasa. The first monastery to be built in Tibet, around 788, it was conceived to represent the Buddhist universe

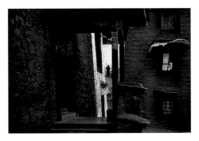

The Ganden Monastery, forty kilometres away from Lhasa, overlooks the Kyi-chu valley. It was founded in 1409 and was the first Gelupka Monastery. Still today it is the main seat of this order

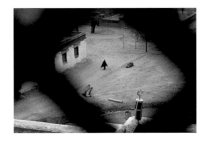

The Samye Monastery, in the vicinity of Lhasa

A monk at the Drepung Monastery in Lhasa

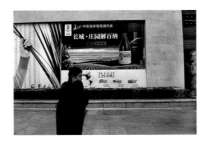

A monk crossing Mentsikhang Lu in Lhasa

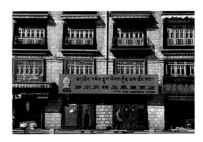

Beijing Donglu, one of Lhasa's major routes

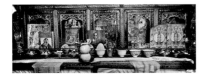

An altar devoted to His Holiness the Dalai Lama in a Tibetan house, Lhasa. This custom is officially prohibited by Chinese authorities

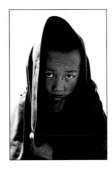

A young Buddhist monk in the Jokhang Temple in Lhasa

In order to leave Lhasa and reach the frontier, Tibetans will use any means of transport

After crossing the Himalayas for days and days, political refugees finally reach Kathmandu

Boudhanath, the largest Buddhist stupa in Nepal, a few kilometres north-east of Kathmandu. Since the fifteenth century it is the destination of pilgrimages from every part of Asia

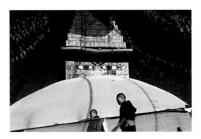

Boudhanath, the largest Buddhist stupa in Nepal

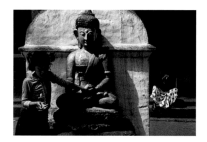

YOUNG TIBETAN EXILED GIRL OFFERING A
FLOWER TO BUDDHA IN THE VICINITY OF
KATHE SIMBHU STUPA IN KATHMANDU

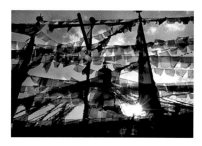

BOUDHANATH, THE LARGEST BUDDHIST
STUPA IN NEPAL, A FEW KILOMETRES NORTH-
EAST OF KATHMANDU. SINCE THE FIFTEENTH
CENTURY IT IS THE DESTINATION OF PILGRIMS
FROM EVERY PART OF ASIA

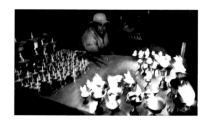

CANDLE SELLER. THE VOTIVE CANDLES
ARE OFFERED TO BOUDHANATH STUPA IN
KATHMANDU

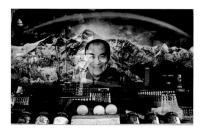

A PICTURE OF HIS HOLINESS THE DALAI
LAMA AT THE MEN-TSEE-KHANG, THE TIBETAN
MEDICAL & ASTROLOGICAL INSTITUTE HE
FOUNDED IN DHARAMSALA, INDIA

DHARAMSALA, INDIA, IN WINTER

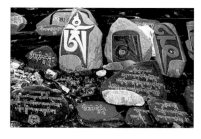

THE TIBETAN MANTRA "OM MANI PADME HUM"
PAINTED ON STONES IN DHARAMSALA, INDIA

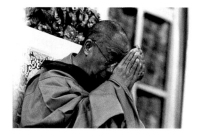

HIS HOLINESS THE DALAI LAMA
IN DHARAMSALA, INDIA

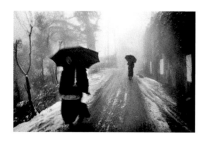

DHARAMSALA'S MAIN STREET.
DHARAMSALA IS THE POLITICAL SEAT
OF THE DALAI LAMA

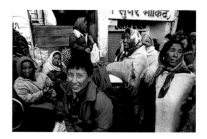

THESE EXILED CHILDREN HAVE JUST
REACHED DHARAMSALA, ARRIVING FROM
NEW DELHI TIBETAN REFUGEE CENTRE AFTER
CROSSING THE HIMALAYAS ON FOOT

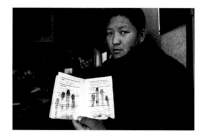

YOUNG TIBETAN NUN EXILED IN DHARAMSALA
SHOWING HER DOCUMENTS

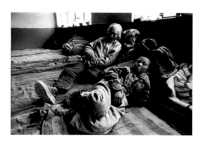

LOBSANG KHEDUP IS AN EXILED CHILD WHO
HAS JUST REACHED THE TIBETAN REFUGEE
CENTRE IN DHARAMSALA AFTER A TWENTY-
THREE-DAY WALK THROUGH THE HIMALAYAS,
ACCOMPANIED BY HIS GRANDFATHER

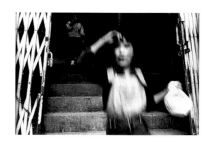

YOUNG TIBETAN EXILED GIRL JUST RECEIVED
SOME FOOD AT DHARAMSALA REFUGEE
CENTRE

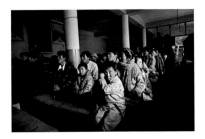

A GROUP OF YOUNG TIBETAN REFUGEES ARE
WELCOMED BY THE TIBETAN MINISTER OF
FOREIGN AFFAIRS AT THE REFUGEE CENTRE
IN DHARAMSALA

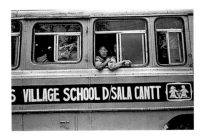

THE TIBETAN CHILDREN'S VILLAGE
SCHOOLBUS

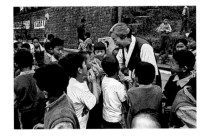

DALAI LAMA'S SISTER JETSUN PEMA IS
THE FORMER DIRECTOR OF THE TIBETAN
CHILDREN'S VILLAGE IN DHARAMSALA.
HERE SHE IS PORTRAYED WITH HER
YOUNG REFUGEES

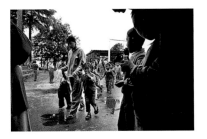

A GROUP OF CHILDREN AT THE TIBETAN
CHILDREN'S VILLAGE IN DHARAMSALA

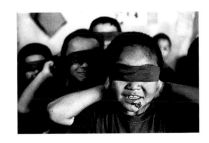

BEFORE STARTING LESSONS, KIDS
AT THE TIBETAN CHILDREN'S VILLAGE
IN DHARAMSALA PRAY WITH THEIR
TEACHER

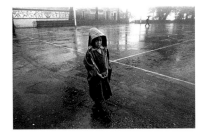

A YOUNG ORPHAN AT THE TIBETAN
CHILDREN'S VILLAGE IN DHARAMSALA

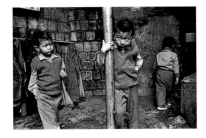

SULKY BOYS AFTER AN ARGUMENT
DURING PLAYTIME AT THE TIBETAN
CHILDREN'S VILLAGE IN DHARAMSALA

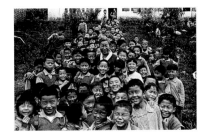

THEATRE ALLOWS EXILED CHILDREN TO
LEARN ABOUT THE HISTORY OF TIBET.
ON THE STAGE IS REPRESENTED THE
OPPRESSION TO WHICH THEIR PEOPLE
WERE SUBJECTED – BLINDFOLDED,
TORTURED, KILLED

DALAI LAMA'S SISTER JETSUN PEMA IS
THE FORMER DIRECTOR OF THE TIBETAN
CHILDREN'S VILLAGE IN DHARAMSALA.
HERE SHE IS PORTRAYED WITH HER YOUNG
REFUGEES

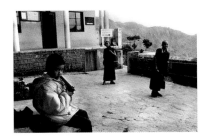

A YOUNG EXILED MONK IS PLAYING AT
THE KIRTI MONASTERY IN DHARAMSALA

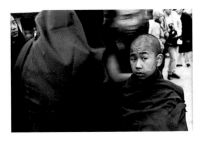

A YOUNG MONK AT THE NAMGYAL MONASTERY
IN MCLEOD GANJ

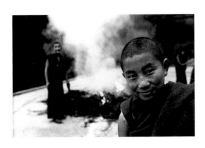

A YOUNG MONK AT THE NAMGYAL MONASTERY
IN MCLEOD GANJ

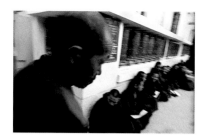

GATHERING OF MONKS AT THE TSUGLAG
KHANG TEMPLE IN DHARAMSALA ON THE
EVE OF THE CELEBRATION OF THE SIXTIETH
ANNIVERSARY OF THE DALAI LAMA'S
ENTHRONEMENT

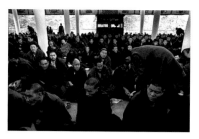

GATHERING OF MONKS AT THE NAMGYAL
MONASTERY IN MCLEOD GANJ ON
THE EVE OF THE CELEBRATION OF THE
SIXTIETH ANNIVERSARY OF THE DALAI
LAMA'S ENTHRONEMENT

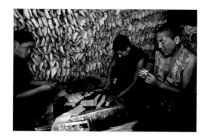

TIBETAN NUNS AT THE GEDEN CHOELING
MONASTERY IN MCLEOD GANJ COOK BISCUITS
FOR THE CELEBRATION OF THE LOSAR
(TIBETAN NEW YEAR)

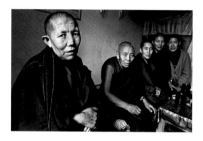

TIBETAN NUNS AT THE GEDEN CHOELING
MONASTERY IN MCLEOD GANJ – THE ELDEST
IN THE FOREGROUND

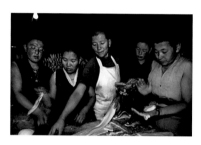

TIBETAN NUNS AT THE GEDEN CHOELING
MONASTERY IN MCLEOD GANJ COOK BISCUITS
FOR THE CELEBRATION OF THE LOSAR
(TIBETAN NEW YEAR)

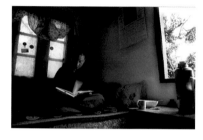

TIBETAN NUN STUDYING IN HER CELL
AT THE GEDEN CHOELING MONASTERY
IN MCLEOD GANJ

A MONK IS STUDYING AT THE NAMGYAL
MONASTERY IN MCLEOD GANJ

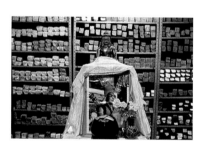

ANCIENT MANUSCRIPTS ON THE HISTORY
OF TIBET, PRESERVED AT THE TIBETAN
LIBRARY OF DHARAMSALA

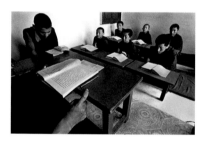

YOUNG MONKS STUDY BUDDHIST
PHILOSOPHY AT THE KIRTI MONASTERY IN
DHARAMSALA. KIRTI RINPOCHE HAD THIS
MONASTERY BUILT IN 1990 IN MEMORY OF
THE ORIGINAL TIBETAN TEMPLE, COMPLETELY
DESTROYED BY THE CHINESE IN 1959

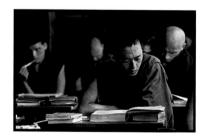

YOUNG MONKS STUDY AT THE KIRTI
MONASTERY IN DHARAMSALA

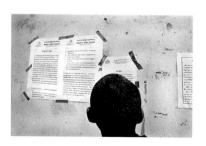

A MONK READING NOTICES ALONG
DHARAMSALA'S MAIN STREET

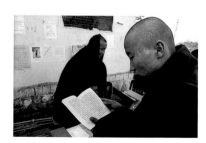

MONKS SELLING BUDDHIST PHILOSOPHY
BOOKS DURING THE LOSAR (TIBETAN
NEW YEAR) IN FRONT OF THE NAMGYAL
MONASTERY IN MCLEOD GANJ

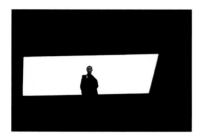

MONK AT NAMGYAL MONASTERY IN MCLEOD GANJ

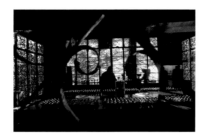

NAMGYAL MONASTERY IN MCLEOD GANJ

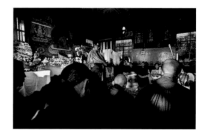

THE LOSAR (TIBETAN NEW YEAR) IS CELEBRATED BY KIRTI RINPOCHE AT THE KIRTI MONASTERY IN DHARAMSALA

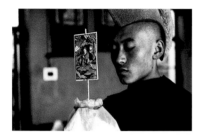

PREPARATIONS FOR THE LOSAR (TIBETAN NEW YEAR) AT THE KIRTI MONASTERY IN DHARAMSALA

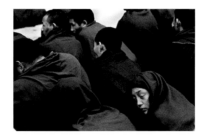

GATHERING OF MONKS AT THE NAMGYAL MONASTERY IN MCLEOD GANJ ON THE EVE OF THE CELEBRATION OF THE SIXTIETH ANNIVERSARY OF THE DALAI LAMA'S ENTHRONEMENT

LONGTAS, OR PRAYER BANNERS IN DHARAMSALA DURING THE LOSAR (TIBETAN NEW YEAR)

OGYEN TRINLEY DORJE, THE SEVENTEENTH KARMAPA IN DHARAMSALA

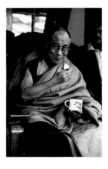

HIS HOLINESS THE DALAI LAMA IN DHARAMSALA

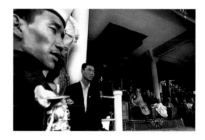

HIS HOLINESS THE DALAI LAMA IN DHARAMSALA DURING THE LOSAR (TIBETAN NEW YEAR)

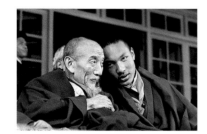

CHOBGYE TRICHEN RINPOCHE, THE TIBETAN GREAT LAMA, WITH THE SEVENTEENTH KARMAPA DURING THE CELEBRATION OF THE SIXTIETH ANNIVERSARY OF THE DALAI LAMA'S ENTHRONEMENT

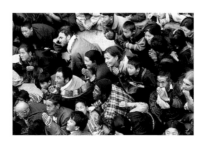

A LARGE CROWD OF PILGRIMS GATHERED IN DHARAMSALA, WAITING FOR THE WORDS OF WISDOM FROM HIS HOLINESS THE DALAI LAMA ON THE OCCASION OF THE LOSAR (TIBETAN NEW YEAR)

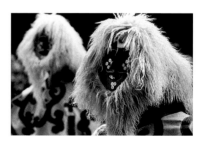

RITUAL DANCES IN TRADITIONAL TIBETAN COSTUME DURING THE CELEBRATION OF THE SIXTIETH ANNIVERSARY OF THE DALAI LAMA'S ENTHRONEMENT

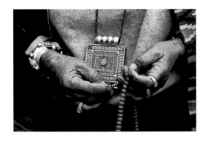

DETAIL OF TIBETAN JEWEL AND ROSARY

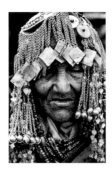

A TIBETAN WOMAN WEARS HER TRADITIONAL ADORNMENT ON THE OCCASION OF THE CELEBRATION OF THE SIXTIETH ANNIVERSARY OF THE DALAI LAMA'S ENTHRONEMENT

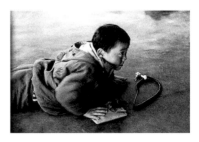

A YOUNG BOY PRAYS IN THE TSUGLAG KHANG TEMPLE IN DHARAMSALA

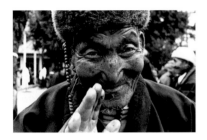

THIS PILGRIM JUST ARRIVED FROM TIBET ON THE OCCASION OF THE CELEBRATION OF THE SIXTIETH ANNIVERSARY OF THE DALAI LAMA'S ENTHRONEMENT

PREPARATIONS FOR THE LOSAR (TIBETAN NEW YEAR) AT THE KIRTI MONASTERY IN DHARAMSALA

Offerings to Buddha during the Losar (Tibetan New Year) at the Kirti Monastery in Dharamsala

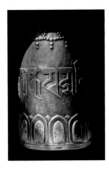

A wheel prayer at the Tsuglag Khang Temple in Dharamsala. Also called "Mani Korlo" (from Sanskrit, meaning "instrument for thinking"), it is continuously turned clockwise during the repetition of mantra

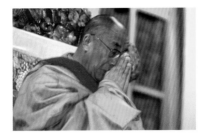

His Holiness the Dalai Lama at the Tsuglag Khang Temple in Dharamsala during a celebration of the Losar (Tibetan New Year). Tsuglag Khang is the main Buddhist temple outside of Tibet

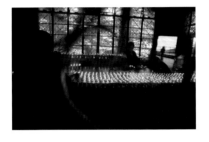

Preparations for the Losar (Tibetan New Year) at the Namgyal Monastery in McLeod Ganj

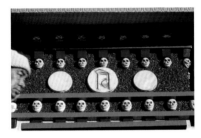

Pandem Lhamo's images sculpted on the façade of Neychuang Temple in Dharamsala

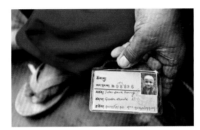

This is a badge that will allow Tulku Dawa Tsering, a young monk, to attend the "Teachings" of His Holiness the Dalai Lama at the Tsuglag Khang Temple in Dharamsala

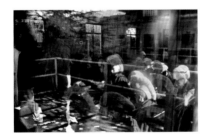

Monks praying during a celebration of the Losar (Tibetan New Year) at the Kirti Monastery in Dharamsala

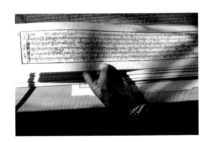

Young monk Tenzin Wargechuck's textbook at the Nechung Dorje Drayangling Monastery in Dharamsala

A monk taking part in a ceremony at the Lhagyal-Ri Temple during the Losar (Tibetan New Year)

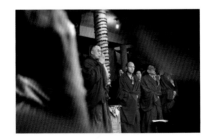

Celebrating the Dalai Lama's seventieth birthday at the Tsuglag Khang Temple in Dharamsala

His Holiness the Dalai Lama during a celebration of the Losar (Tibetan New Year) at the Tsuglag Khang Temple in Dharamsala

Nuns from Dharamsala and others arrived from India, Nepal and Tibet attend the "Teachings" of His Holiness the Dalai Lama at Tsuglag Khang Temple in Dharamsala

Celebrating (in the rain) the Dalai Lama's seventieth birthday at the Tsuglag Khang Temple in Dharamsala

Celebrating the Dalai Lama's seventieth birthday at the Tsuglag Khang Temple in Dharamsala

The celebration of the Dalai Lama's seventieth birthday has just finished

At dawn, a monk walking to one of Dharamsala's temples to pray

Monks walking along McLeod Ganj streets

Monks doing some shopping in McLeod Ganj; located some eight kilometres from Dharamsala, McLeod Ganj is the seat of the exiled Tibetan Government and the official residence of the XIV Dalai Lama

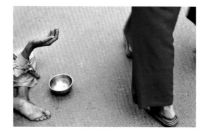

A large number of beggars and cripples populate the streets of McLeod Ganj

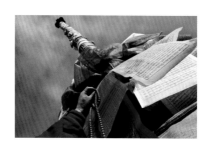

The "Tarchen", the extremely high flagpole with its prayer banners, is placed in front of the Jokhang Temple in Lhasa, the most venerated sacred building in Tibet

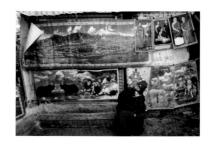

A Buddhist nun taking a rest in a corner of Barkhor, the most renown pilgrimage circuit in Lhasa

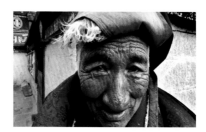

A Tibetan pilgrim in the square facing the Jokhang Temple in Lhasa, the most venerated sacred building in Tibet

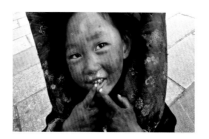

Tibetan child in the square facing the Jokhang Temple in Lhasa, the most venerated sacred building in Tibet

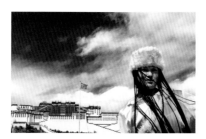

A Chinese young woman wears a traditional Tibetan costume. In the background the Potala Palace, former residence of the Dalai Lama. The Communist flag is a waving reminder of the Chinese rule on this land

BANK NOTES LEFT AS AN OFFERING ON ONE OF THE WALLS OF THE GANDEN MONASTERY. IT WAS FOUNDED IN 1409 AND WAS THE FIRST GELUPKA MONASTERY. STILL TODAY IT IS THE MAIN SEAT OF THIS ORDER

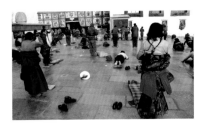

PILGRIMS AT PRAYER IN FRONT OF THE JOKHANG TEMPLE IN LHASA

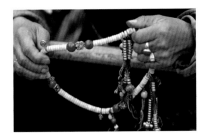

TIBETAN ROSARY

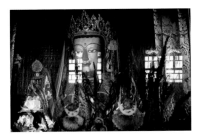

STATUE OF BUDDHA IN THE MANI LHAKHANG TEMPLE, IN THE AREA OF BARKHOR, LHASA

THE "ENDLESS KNOT" REPRESENTS THE UNION OF WISDOM AND METHOD (TIBETAN: "THAB-SHES, ZUNG-BREL"), THE UNION OF FEMALE AND MALE ENERGY, INFINITE LOVE, INFINITE LIFE. THIS TIBETAN SYMBOL IS DEPICTED ON A CURTAIN OF ONE OF THE CORRIDORS IN THE POTALA PALACE, FORMER RESIDENCE OF THE DALAI LAMA

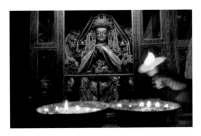

STATUE OF BUDDHA IN THE DREPUNG MONASTERY. IT SEEMS THAT BEFORE THE CHINESE INVASION, DREPUNG WAS THE LARGEST MONASTERY IN THE WORLD, WITH EIGHT THOUSAND RESIDENT MONKS

A TIBETAN BELIEVER AT PRAYER AT THE JOKHANG MONASTERY IN LHASA, THE MOST VENERATED HOLY BUILDING IN TIBET

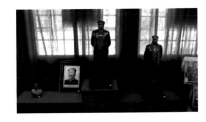

IN THIS SHOP, ARRANGED INSIDE NORBULINGKA PALACE, FORMER SUMMER RESIDENCE OF THE DALAI LAMA, TIBETAN ROSARIES AS WELL AS STATUETTES FEATURING MAO TSE-TUNG CAN BE FOUND

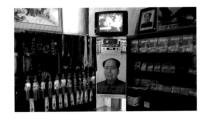

IN THIS SHOP, ARRANGED INSIDE NORBULINGKA PALACE, FORMER SUMMER RESIDENCE OF THE DALAI LAMA, TIBETAN ROSARIES AS WELL AS STATUETTES FEATURING MAO TSE-TUNG CAN BE FOUND

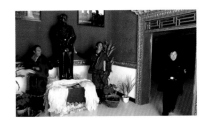

TIBETAN PILGRIMS, WATCHED OVER BY CHINESE POLICE, POSE NEAR THE STATUE OF MAO TSE-TUNG ARRANGED AT THE ENTRANCE TO THE NORBULINGKA PALACE, FORMER SUMMER RESIDENCE OF THE DALAI LAMA

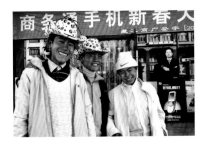

YOUNG TIBETANS OF KHAMPA ORIGIN, FASHIONED IN WESTERN STYLE, TAKE A WALK AROUND JOKHANG SQUARE

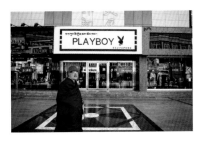

A BUDDHIST MONK IS TAKING A WALK IN LHASA COMMERCIAL DISTRICT

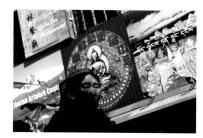

A Tibetan pilgrim in the Barkhor district. A Chinese advertising poster depicting Buddha can be seen in the background

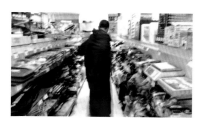

A Tibetan monk in the Lhasa Store shopping centre, located in front of the Potala Palace, former residence of the Dalai Lama

The Lhasa Store shopping centre, located in front of the Potala Palace, former residence of the Dalai Lama

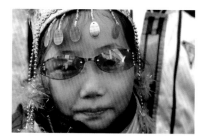

A Tibetan girl outfitted in Western fashion in Lhasa

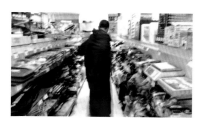

A young Tibetan boy, elegantly dressed on the occasion of the Losar (Tibetan New Year) in Lhasa

Homeless Tibetan children in Lhasa's Chinese residential area

The Chinese immigration flow towards Lhasa is constantly increasing, fuelled by the new railway line connecting Beijing to the Tibetan capital

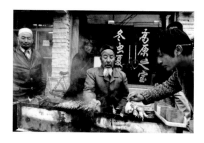

A barbecue at Mustafa's, a Chinese Muslim who serves both Chinese and Tibetan customers

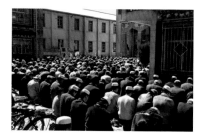

Chinese Muslims praying in front of Lhasa's mosque

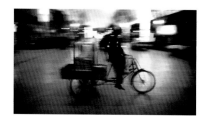

A Chinese Muslim is riding his bicycle along Mentsikhang Lu in Lhasa

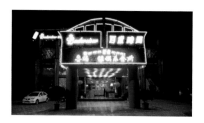

Karaoke Himalaya, one of the most popular bars in Lhasa where prostitution has almost become a "legal" business

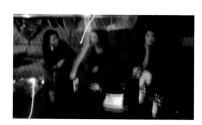

Young Chinese and Tibetan prostitutes waiting for clients in a karaoke bar, Lhasa

YOUNG CHINESE AND TIBETAN
PROSTITUTES WAITING FOR CLIENTS
IN A KARAOKE BAR, LHASA

A CHINESE PROSTITUTE WITH A TIBETAN
CLIENT IN A KARAOKE BAR, LHASA

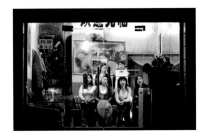

PROSTITUTES IN THE SHOP WINDOW AT
THE RED LIGHT BAR, FOOD MARKET
ROAD, LHASA

THE TANG G CLUB IS ONE OF THE
MOST POPULAR DISCOTHÈQUES
AMONG YOUNG TIBETANS; HERE THEY
CONSUME ENORMOUS AMOUNTS OF
ALCOHOL AND DRUGS

A PAIR OF CHINESE HOSTESSES OF
THE TANG G CLUB, SPONSORED BY
CARLSBERG CHILL BEER

BABILA CLUB IS ONE OF THE LARGEST
AND MOST MODERN COMPLEXES
IN LHASA NIGHT-LIFE, AMONG THE
FAVOURITES OF YOUNG TIBETANS AND
CHINESE. EVERY THIRTY MINUTES HALF-
NAKED CHINESE GIRLS TAKE TURNS IN
DANCING TO THE MUSIC

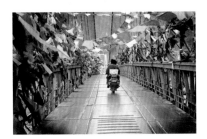

PROSTITUTES IN THE SHOP WINDOW AT
THE RED LIGHT BAR, FOOD MARKET
ROAD, LHASA

MOST OF LHASA SEX SHOPS ARE
LOCATED IN THE AREA OF LINGKHOR

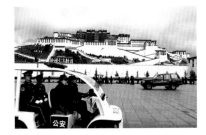

CHINESE POLICE AND SOLDIERS IN
FRONT OF THE POTALA PALACE, FORMER
RESIDENCE OF THE DALAI LAMA,
WATCHING OVER TIBETAN PILGRIMS

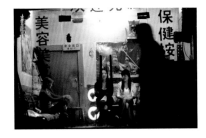

TWO CHINESE SOLDIERS RIDE THEIR
MOTORBIKE ON A LHASA BRIDGE
DECORATED WITH LONGTAS, THE
TIBETAN PRAYER BANNERS